Christmas 1982

To Nicholas
and Karin,
In honor of the
events of 1982:
 November, a wedding!
 December, the anniversary
 of a child's
 birthday!
This European catalogue
of photos and images
reminds me of the
style and color you
two evoke in your
own life and the
lives of others.
 With love and
 friendship.
 "Guillermo"

EUROPEAN

PHOTOGRAPHY

EIGHTY·TWO

EIGHTY·THREE

EUROPEAN

PHOTOGRAPHY

EIGHTY·TWO

EIGHTY·THREE

The second annual of European editorial, book, poster, advertising and unpublished photography. Edited by Edward Booth-Clibborn

Le second annuaire européen de photographies de presse, du livre, de l'affiche, de la publicité et d'oeuvres non publiées. Edité par Edward Booth-Clibborn

Das zweite Jahrbuch der europäischen Redaktions-, Buch-, Plakat-, Werbe- und unveröffentlichten Fotografie. Herausgegeben von Edward Booth-Clibborn

EUROPEAN PHOTOGRAPHY 12 Carlton House Terrace London

Edited by Edward Booth·Clibborn

Book designed by David Hillman and Bruce Mau, Pentagram

Editorial production: Deirdre Morrow

The exhibition of the photography in this book will be shown at The National Film Theatre,
London

The captions and photography in this book have been supplied by the entrants. Whilst every
effort has been made to ensure accuracy, European Photography do not, under any
circumstances, accept responsibility for errors or omissions.

No part of this book may be reproduced in any manner whatsoever without written
permission.

Cover photograph by Arthur Elgort, reproduced from English "Vogue" with the kind
permission of The Condé Nast Publications Limited.©

Maquettistes du livre David Hillman et Bruce Mau, Pentagram

Rédactrice du texte: Deirdre Morrow

L'exposition d'oeuvres d'art de ce livre aura lieu à The National Film Theatre, Londres

Les légendes et les oeuvres d'art figurant dans ce livre ont été fournies par les personnes
inscrites. Bien que tout ait été fait pour en assurer l'exactitude European Photography
n'accepte aucune responsabilité en cas d'erreurs ou d'omissions.

Aucune partie de ce livre ne peut être reproduite en aucune façon sans autorisation écrite.

Photographie de couverture par Arthur Elgort, reproduite de "Vogue" édition anglaise avec
l'aimable autorisation de Condé Nast Publications Limited.©

Buch gestaltet von David Hillman und Bruce Mau, Pentagram

Textredaktion: Deirdre Morrow

Die Ausstellung der in diesem Buch gezeigten Fotos findet statt im National Film Theatre,
London

Die textlichen Angaben zu den Abbildungen und die Vorlagen dazu wurden uns von den
Einsendern zur Verfügung gestellt. Der genauen Wiedergabe wurde größte Sorgfalt
gewidmet; European Photography kann jedoch unter keinen Umständen die
Verantwortung für Fehler oder Auslassungen ubernehmen.

Die Wiedergabe dieses Buches vollständig oder in Auszügen in jedweder Form ist ohne
schriftliche Genehmigung nicht gestattet.

Umschlag-Foto von Arthur Elgort, abgedruckt aus der englischen "Vogue"Ausgabe mit
freundlicher Genehmigung von The Condé Nast Publications Limited.©

European Photography Call for Entries Copyright © 1982
The following companies hold the exclusive distribution rights for European Photography
82/83:

France: Société Nouvelle de Distribution, Paris

USA/Canada: Harry N Abrams Inc., New York
ISBN 0-8109-0866-2

UK and the rest of the world:
D&AD/European Illustration,
12 Carlton House Terrace, London SW1 5AH
Tel: 01-839 2464

Printed in Japan by Dai Nippon. Paper: 157GSM coated
Typeface: Helvetica Light Condensed
Filmset by: Filmcomposition, London

Published by Polygon Editions S.A.R.L., Basel
Copyright© 1982 Polygon Editions S.A.R.L.

C O N T E N T S

Introduction · Introduction · Einleitung **7**

Jury · Le Jury · Die Jury **9**

Editorial · Magazines et journaux · Redaktions-Fotografie **17**

Photography for newspapers, magazines and all forms of periodical publications.

Photographies pour des journaux, des magazines et des périodiques de toutes sortes.

Fotografie für Zeitungen, Zeitschriften und andere regelmäßig erscheinende Veröffentlichungen aller Art.

Books · Livres · Bücher **147**

Photography for book jackets, paperback covers and all types of illustrated books, fiction and non fiction.

Photographies pour des jaquettes de livres reliés, des couvertures de livres de poche, et toutes sortes de livres illustrés, romans ou autres.

Fotografie für Schutzumschläge, Paperback-Umschläge und Bücher aller Art, Romane und Sachbücher.

Advertising and Posters · Publicité et Affiches · Werbung und Plakate **161**

Photography for advertisements and posters.

Photographies pour la publicité et pour des affiches.

Fotografie für Werbung und Plakate.

Design · Design · Design **191**

Photography for calendars, diaries, direct mail announcements, greetings cards, packaging, promotional mailing, record sleeves, stationery, technical and industrial catalogues.

Photographies pour des calendriers, des agendas, des lettres circulaires, des cartes de voeux, des emballages, des livrets de promotion par poste, des pochettes de disques, de la papeterie, des catalogues techniques et industriels.

Fotografie für Kalender, Agenden, Werbesendungen, Grußkarten, Verpackungsartikel, Industriekataloge, Schallplattenhüllen, Briefköpfe, Prospekte.

Unpublished Work · Oeuvres Non Publiées · Unveröffentlichte Arbeiten **215**

Personal work by students and professionals and commissioned but unpublished photography.

Travaux personnels de professionnels et d'étudiants, et des photographies commandées mais non publiées.

Persönliche Arbeiten von Berufskünstlern und Studenten, und in Auftrag gegebene, aber nicht veröffentlichte Fotografie.

Index · Index · Verzeichnis **235**

A year ago, when I introduced the first edition of EUROPEAN PHOTOGRAPHY, I wrote of how, in the hands of a gifted expert, the camera can be used to create photographic images which may well stand the test of time and come to be considered not just as the master-works of eminent craftsmen, but as works of art. I made no claim then about the content of the first edition of EUROPEAN PHOTOGRAPHY, just as I make no claim now about the content of this second annual. However, I cannot help but be moved by some of the work you'll find in the following pages, and cannot help but be struck by what I think is a significant aspect of the overall tone and content of this book.

Selected as they are from photographs commisssioned for, and published in, the mass media, the images in EUROPEAN PHOTOGRAPHY needs must consist, in the main, of 'editorial photography' and 'advertising photography.' What strikes me is that the editorial work is so much more exciting than the advertising work, and for a while this puzzled me.

On the one hand, advertising photography is, in many cases, a kind of map of the landscape of the mind; an interpretation, through film and onto paper, of something which someone (usually an advertising art director) has seen in his mind's eye.

On the other hand, editorial photography frequently relies for its impact not only on the photographer being in the right place at the right time, but on his- or her- ability to capture that electrifying moment when all the elements of the observed scene fuse together in the viewfinder's frame and a great picture is made.

The puzzling thing is this. While the photographer working for an advertiser can create a sense of excitement by orchestrating the elements of his subject, the photographer working for a magazine or newspaper—even one with a book in mind—frequently has only what is in front of him, his technical expertise and that fickle element, the light, with which to make his picture. To my mind it is, perhaps, this element of chance which produces great editorial photography—and great photojournalism—and which excites our imaginations so much. There is a much stronger "how did he do it?" factor in editorial photography, if only because one can see that most advertising photographs have been conceived in the mind rather than snatched from the world.

Within these pages you will find several examples of what I am talking about. In many cases the advertising photographs create a mood or express an idea in a masterly way. Equally, many of the editorial photographs capture moments in time, or segments of landscape, in ways which say more about man's life experience than ever could be said so succinctly in words. In particular, I would draw your attention to the bleak images of Auschwitz by Harald Nadolny, and the evocative photographs of life in Poland, produced by Bruno Barbey. Both these sets of pictures are remarkable. The first works on our minds through its very lack of people. The second creates a lasting impression because it carries with it the features of a nation. What interests me about them both is that they have about them that aura of chance, an almost indefinable chutzpha which makes me say "Here is a great picture of an unrepeatable moment".

Perhaps it is this (what Cartier-Bresson called "capturing life in a little box") which excites me so. Certainly, I hope you will share my excitement as you look through the pages of this, the second edition of EUROPEAN PHOTOGRAPHY.

EDWARD BOOTH-CLIBBORN.

Il y a un an, lorsque j'ai présenté la première édition de EUROPEAN PHOTO-GRAPHY, j'ai expliqué comment, aux mains d'un expert doué, l'appareil de photographie peut servir à créer des images photographiques susceptibles de résister au temps et être considérées non seulement comme les chefs d'oeuvre d'éminents artisans, mais aussi comme des oeuvres d'art. Je n'ai rien prétendu à ce moment-là quant au contenu de cette première édition de EUROPEAN PHOTOGRAPHY, de même que je ne prétends rien quant au contenu de ce second annuaire. Toutefois, il m'est impossible de ne pas être ému par certaines des oeuvres que vous trouverez aux pages qui suivent, et je ne peux qu'être frappé par ce que je considère être un aspect significatif du ton d'ensemble et du contenu de ce livre.

Sélectionnées à partir de photographies commandées pour les mass media et publiées par eux, les images dans EUROPEAN PHOTOGRAPHY doivent nécessairement consister, en grande partie, en photographies de presse et photographies de publicité. Ce qui me frappe c'est que les oeuvres de presse sont tellement plus captivantes que celles de publicité, et pendant quelque temps j'en suis resté perplexe.

D'un côté, la photographie de publicité est, dans bien des cas, une sorte de carte du paysage de l'esprit; une interprétation, à travers film et sur papier de quelque chose que quelqu'un (généralement un directeur artistique de publicité) a déjà en tête.

D'un autre côté, la photographie de presse compte fréquemment pour son impact non seulement sur le fait que le photographe est à la bonne place au bon moment, mais sur son pouvoir de saisir ce moment captivant quand tous les éléments de la scène observée se confondent dans le cadre du viseur et une grande photo est produite.

Voici l'énigme. Alors que le photographe qui travaille pour la publicité est en mesure de créer une atmosphère de surexcitation en rassemblant les éléments de son sujet, le photographe qui travaille pour un magazine ou un journal—même celui qui pense à un livre—n'a souvent que ce qui se présente devant lui, son expertise technique et cet élément fuyant, la lumière, pour produire sa photo.

Dans mon esprit c'est, peut-être, cet élément de hasard qui crée la grande photographie de presse—et le grand photojournalisme—et qui excite tellement notre imagination. Il y a un facteur beaucoup plus grand "comment a-t-il réussi cela" dans la photographie de presse, ne serait-ce que parce que l'on voit que la plupart des photographies de publicité ont été conçues dans la tête et non arrachées au monde.

A l'intérieur de ces pages vous trouverez plusieurs exemples de ce que je décris. Dans bien des cas les photographies de publicité créent une atmosphère ou expriment une idée de façon magistrale. De même, beaucoup de photographies de presse capturent des moments dans le temps, ou des fragments de paysage qui peuvent en dire plus sur l'expérience de vie d'un homme qu'il ne serait jamais possible de dire aussi succinctement avec des paroles. En particulier, je voudrais attirer votre attention sur les mornes images d'Auschwitz par Harald Nadolny, et les photographies évocatrices de la vie en Pologne, produites par Bruno Barbey. Ces deux séries de photographies sont remarquables. Les premières nous parlent par leur manque de personnages. Les secondes créent une impression qui dure car elles imposent la physionomie d'une nation. Ce qui m'intéresse dans les deux cas c'est qu'elles ont toutes les deux cette aura d'imprévu, une presque indéfinissable chutzpah, qui me fait dire "Voici un grand tableau d'un moment qui ne se reproduira jamais.'

C'est peut-être ceci (ce que Cartier-Bresson appelait "Capturer la vie dans une petite boîte") qui m'excite tellement. Certainement j'espère que vous partagerez mon excitation au fur et à mesure que vous regarderez les pages de cette seconde édition de EUROPEAN PHOTOGRAPHY.

EDWARD BOOTH-CLIBBORN

Vor einem Jahr, in meiner Einleitung zur ersten Ausgabe der EUROPEAN 7 PHOTOGRAPHY, schrieb ich, daß die Kamera, in den Händen eines begabten Experten, fotografische Eindrücke erzeugen kann, die der Vergänglichkeit der Zeit gewachsen sind und die vielleicht eines Tages nicht nur als Meisterwerke eines Handwerks sondern als Kunstwerke anerkannt werden. Ich habe damals keine Behauptungen aufgestellt über den Inhalt der ersten EUROPEAN PHOTOGRAPHY Ausgabe und will das auch für diese zweite Ausgabe nicht tun. Trotzdem muß ich bekennen, daß mich einige der auf den nachfolgenden Seiten erscheinenden Arbeiten berührt haben, indem sie Zeugnis dafür sind, was meiner Meinung nach ein wichtiger Aspekt des Tonfalls und des Inhalts dieses Buches ist.

Da die Auswahl der Fotos sich auf solche beschränkt, die von den Massenmedien beauftragt und veröffentlicht wurden, besteht die Mehrzahl der Abbildungen in EUROPEAN PHOTOGRAPHY aus 'Redaktions-Fotografie' und Werbe-Fotografie'. Es fiel mir dabei auf, daß die redaktionellen Arbeiten viel anregender waren als die Werbefotos, und eine Zeitlang erschien mir das rätselhaft.

Einerseits ist die Werbe-Fotografie in vielen Fällen eine Art Gemütslandschaft; eine Interpretation einer geistigen Vorstellung (normalerweise die des Art Direktors), dokumentiert auf Papier durch das Medium Film.

Andererseits ist die Ausdruckskraft der Redaktions-Fotografie oft nicht allein davon abhängig, daß ein Fotograf zum richtigen Zeitpunkt zur Stelle war, sondern ebenso von seiner- oder ihrer-Fähigkeit, genau den entscheidenden Moment abzufangen, in dem im Sucher alle Elemente der beoachteten Szene zusammentreffen und eine hervorragende Aufname entsteht.

Die rätselhafte Tatsache ist diese: Während der in der Werbung arbeitende Fotograf einen Eindruck von Aufregung durch das sorgfältige Zusammenspiel verschiedener Elemente hervorrufen kann, muß sich der im Auftrag von Zeitungen oder Zeitschriften arbeitende Fotograf—selbst wenn er dabei ein Buch im Sinn hat—oft mit dem begnügen, was sich ihm bietet und sich auf seine technischen Fähigkeiten und die launischen Lichtverhältnisse verlassen.

Für mich ist es vielleicht gerade dieses Element des Zufalls, das durch bemerkenswerte Redaktionsfotos—und hervorragenden Fotojournalismus allgemein—unsere Einbildungskraft anregt. Im Bereich der Redaktions-Fotografie ergibt sich viel öfter die Frage "wie hat er das nur gemacht?," selbst wenn das oft nur darauf zurückgeht, daß die meisten Werbefotos ganz offensichtlich gedanklicher Vorbereitung und nicht dem täglichen Leben entstammen.

Auf den nachfolgenden Seiten werden Sie mehrere Beispiele finden, die meine eben beschriebene Meinung unterstreichen. In vielen Fällen umschreiben die Werbefotos eine Stimmung oder sind meisterhafter Ausdruck einer Idee. Gleichfalls bewahren die Redaktionsfotos Zeitmomente oder Landschaftsabschnitte auf eine Art und Weise, die mehr über die Lebenserfahrungen des Menschen aussagt, als jemals so eindrucksvoll in Worte gefaßt werden konnte. Insbesondere möchte ich hinweisen auf die trostlosen Eindrücke aus Auschwitz von Harold Nadolny und die eindrucksvollen Fotos des täglichen Lebens in Polen von Bruno Barbey. Beide Fotoserien sind bemerkenswert; die erste, weil sie uns gerade durch die Abwesenheit von Menschen zu denken gibt, und die zweite, weil sie den Gemütszustand einer Nation in sich trägt. Von besonderem Interesse ist bei beiden die Atmosphäre des Zufalls, diese kaum definier-bare Chuzpe, so daß man nur sagen kann "das ist ein Abbild eines nicht wiederkehrenden Augenblicks."

Vielleicht ist es dieses (was Cartier-Bresson bezeichnet hat als "das Leben in einem kleinen Kasten gefangen") das mich so beeindruckt. Ich hoffe deshalb, daß sie meine Begeisterung teilen beim Durchblättern dieser zweiten Ausgabe der EUROPEAN PHOTOGRAPHY.

EDWARD BOOTH-CLIBBORN

E U R O P E A N

P H O T O G R A P H Y

T H E J U R Y

CHRISTOPHER ANGELOGLOU

WOLFGANG BEHNKEN

MAURICE CORIAT

DAVID HILLMAN

JOCELYN KARGÈRE

Christopher Angeloglou first became involved with photography while studying at Cambridge where he edited "Image", a photographic news magazine with national distribution, and worked for "Varsity" as a photographer.
He joined "The Sunday Times" in 1962, working on the newly launched Colour Supplement, primarily as a photographer and then as Picture Editor. After he had worked as overall Photographic Editor of the newspaper and the magazine he made a short foray into publishing before working for Time-Life in Paris. When "Life" closed in 1971 he returned to London as Deputy Editor of the "Telegraph Magazine". Since then he has worked in book publishing and has started a photographic magazine for amateurs. In 1980 Harold Evans asked him to return to "The Sunday Times" where he is an Assistant Editor with responsibility for photography.

Christopher Angeloglou a commencé à s'intéresser à la photographie lorsqu'il était étudiant à Cambridge où il dirigeait "Image", magazine photographique d'actualités à distribution nationale, et où it travaillait comme photographe pour "Varsity."
Il est entré au "Sunday Times" en 1962, pour travailler au supplément en couleurs, qui venait d'être créé, d'abord comme photographe puis comme Directeur de la Photographie. Après avoir été Directeur général de photographie au journal et au magazine, il s'est lancé brièvement dans la publication avant d'entrer à Time-Life à Paris. Après la cessation de publication de "Life" en 1971 il est rentré à Londres pour devenir Directeur adjoint du magazine du "Telegraph." Il a, depuis, travaillé dans l'édition de livres et a lancé un magazine photographique pour amateurs. En 1980 Harold Evans lui a demandé de revenir au "Sunday Times" où il est Directeur adjoint avec responsabilité de la Photographie.

Christopher Angeloglou begann seine fotografische Laufbahn während seines Studiums in Cambridge, wo er als Redakteur für das national vertriebene fotografische Nachrichtenmagazin "Image" und als Fotograf für "Varsity" arbeitete.
1962 begann er bei der "Sunday Times", hauptsächlich als Fotograf und später als Bildredakteur für die soeben herausgegebene Farbbeilage der Zeitung. Nach einer Zeitlang als Foto-Redakteur, mit Verantwortlichkeit für Zeitung und Magazin, und kurzer Tätigkeit im Verlagswesen führte sein Weg nach Time-Life in Paris. Nach Auflösung der Zeitschrift "Life" im Jahre 1971 kehrte er nach London zurück und wurde stellvertretender Redakteur des "Telegraph Magazins."
Seitdem war er im Verlagswesen tätig und etablierte eine Zeitschrift für Amateur-Fotografen. 1980 kehrte er auf Bitte von Harold Evans zur "Sunday Times" zurück, wo er derzeitig in der Redaktion mit besonderer Verantwortlichkeit für Fotografie tätig ist.

Wolfgang Behnken studied visual communications at the Wuppertal College of Applied Art, during which time he won an award for his film about children's education. After leaving college he worked for an advertising agency on the Social Democrats' General Election campaign. He then moved to "Stern Magazine," where he currently works as Art Director.

Wolfgang Behnken a étudié les communications visuelles au College d'Art Appliqué de Wuppertal, et pendant ce temps il a gagné un prix pour son film sur l'éducation des enfants. Après avoir quitté le collège il a travaillé pour une agence de publicité en faveur de la campagne des Sociaux Démocrates pour l'Election Génèrale. Il est ensuite entré à "Stern Magazine," où il travaille actuellement comme Directeur Artistique.

Wolfgang Behnken hat visuelle Kommunikation an der Hochschule für angewandte Kunst in Wuppertal studiert und gewann während dieser Zeit eine Auszeichnung für seinen Film über Kindererziehung. Nach Abschluß seiner Ausbildung arbeitete er für eine Werbeagentur an der Wahlkampagne der Sozialdemokraten. Danach wechselte er über zum "Stern," wo er derzeitig als Art Direktor tätig ist.

Maurice Coriat studied painting, design and etching at art schools in Oran and Paris.
In 1970 he became Art Director of "Zoom" magazine, leaving in 1980 to form his own company. He has worked as the Art Director on many press publications, and has designed numerous books and magazines dealing with a wide variety of subjects. He is a consultant to "Photo" magazine.

Maurice Coriat a étudié la peinture, le design et la gravure aux écoles des Beaux Arts d'Oran et de Paris.
En 1970 il devient Directeur Artistique du magazine "Zoom," le quittant en 1980 pour créer sa propre compagnie. Il a travaillé comme directeur artistique pour de nombreuses publications de presse et a établi le design de nombre de livres et magazines traitant d'une grande variété de sujets. Il est conseiller du magazine "Photo."

Maurice Coriat hat Malerei, Grafik und Radierung an Kunstschulen in Oran und Paris studiert.
1970 wurde er Art Direktor bei der Zeitschrift "Zoom" und gründete 1980 seine eigene Firma. Er hat als Art Direktor an vielen Presseveröffentlichungen gearbeitet und zahlreiche Bücher und Zeitschriften vieler verschiedener Interessenbereiche gestaltet. Er ist Berater für die Zeitschrift "Photo."

The youngest of the Pentagram partners, David Hillman was born in Oxford in 1943. After graduating from the London School of Printing he started as an assistant at "The Sunday Times Magazine," later becoming editor of the Environmental Section of the magazine, while at the same time embarking on a redesign of the "Sunday Times" newspaper.

In 1968 he joined "Nova" magazine as its Art Director and, two years later, also became Deputy Editor. During his seven years with "Nova" the magazine won five awards from the Designers and Art Directors Association. He started his own design practice in 1975, before spending a year with the Wolff Olins design company. In 1977 he was commissioned to design the new French daily newspaper, "Le Matin de Paris."

He joined Pentagram in 1978. As a member of the partnership he has sustained his editorial activities, but has also been engaged in packaging design and corporate identity programmes for clients such as Lucas and Ideal-Standard Europe.

He has designed several books, including three European Illustration Annuals, the first annual of European Photography and "The English Sunrise," a book which won a Silver and a Gold Award from the Designers and Art Directors Association of London.

Le plus jeune des associés Pentagram, David Hillman est né à Oxford en 1943. Après avoir obtenu son diplôme à la London School of Printing, il a débuté comme assistant à "The Sunday Times Magazine," pour devenir ensuite directeur de la section Environnement du magazine, s'embarquant par la même occasion dans la refonte du journal "Sunday Times."

En 1968 il entre au magazine "Nova" comme Directeur Artistique et, deux ans plus tard, devient également Rédacteur Adjoint. Pendant ses sept années avec "Nova" le magazine reçoit cinq prix de l'Association des Designers et Directeurs Artistiques. Il inaugure son propre cabinet de design en 1975, avant de passer une année auprès de la compagnie de design Wolf Olins. En 1977 il est chargé de la présentation d'un nouveau quotidien français, "Le Matin de Paris."

Il entre à Pentagram en 1978. Comme membre de l'association il a poursuivi ses activités éditoriales, mais il s'est également occupé de la création d'un design d'empaquetage et de programmes d'identité commerciale pour des clients tels que Lucas Industries et Ideal-Standard Europe.

Il est le designer de plusieurs livres, y compris trois éditions de l'annuaire European Illustration, le premier annuaire de European Photography et de "The English Sunrise," livre qui a gagné un prix d'or de la Designers and Art Directors Association de Londres.

David Hillman, geboren 1943 in Oxford, ist der jüngste der Pentagram Partner. Nach Abschluß seiner Ausbildung an der London School of Printing begann er als Assistent beim "Sunday Times Magazin," wurde später Redakteur der Sparte für Umweltfragen und begann zur gleichen Zeit die Umgestaltung der "Sunday Times" Zeitung.

1968 wurde er Art Direktor bei der Zeitschrift "Nova" und zwei Jahre später stellvertretender Redakteur. Im Laufe seiner sieben Jahre bei "Nova" gewann die Zeitschrift fünf Auszeichnungen der Designers and Art Directors Association. Er gründete seine eigene Design-Agentur im Jahre 1975 und verbrachte danach ein Jahr bei der Design-Agentur Wolff Olins. 1977 wurde er mit der Gestaltung der neuen französischen Tageszeitung "Le Matin de Paris" beauftragt.

Seit 1978 ist er bei Pentagram. Während er sich weiterhin redaktionellen Aufgaben widmet, hat er sich als Partner ebenso mit Verpackungsdesign und Firmenidentitäts-Programmen beschäftigt für Kunden wie Lucas Industries und Ideal Standard Europe.

Er hat mehrere Bücher gestaltet, darunter drei European Illustration Jahrbücher, das erste European Photography Jahrbuch, sowie "The English Sunrise," ein Buch, das die Silber- und Goldauszeichnung der Designers and Art Directors Association gewann.

14

Jocelyn Kargère was born in Paris in 1936. Educated in America and France he began his professional life working on "Vogue" and "Glamour" magazines in New York.
In 1962 he returned to his native France to work for six years as Art Director on "Mademoiselle Age Tendre" and "Cuisine" magazines and, from 1967 to 1970, as Art Director on "Science" magazine, published by Editions Pierre Berrès. Since 1970 M. Kargère has been Art Director of the French edition of "Vogue." For the past two years he has also held the post of Professor of Photography and Aesthetics at the Paris American Academy.

Jocelyn Kargère est né à Paris en 1936. Elevé en Amérique et en France il a commencé sa vie professionnelle en travaillant pour les magazines "Vogue" et "Glamour" à New York.
En 1962 il est rentré dans sa France natale et a travaillé pendant six ans comme Directeur Artistique des magazines "Mademoiselle Age Tendre" et "Cuisine" et, de 1967 à 1970, comme Directeur Artistique du magazine "Science", publié par les Editions Pierre Bérès.
Depuis 1970 M. Kargère est Directeur Artistique de l'édition française de "Vogue." Depuis deux ans il détient également le poste de professeur de photographie et d'esthétique à la Paris American Academy.

Jocelyn Kargère, 1936 in Paris geboren und ausgebildet in Amerika und Frankreich, begann seine Berufslaufbahn bei "Vogue" und "Glamour" in New York.
1962 kehrte er nach Frankreich zurück, arbeitete sechs Jahre lang als Art Direktor für "Mademoiselle Age Tendre" und "Cuisine" und von 1967 bis 1970 als Art Direktor für die Zeitschrift "Science," herausgegeben von Editions Pierre Berrès.
Seit 1970 ist M. Kargère Art Direktor der französischen "Vogue" Ausgabe und wurde vor zwei Jahren zum Professor für Fotografie und Ästhetik an der Amerikanischen Akademie in Paris ernannt.

E D I T O R I A L

This section includes photography for newspapers, magazines and all forms of periodical publications.

MAGAZINES ET JOURNAUX Cette section comprend des photographies pour des journaux, des magazines et des périodiques de toutes sortes.

REDAKTIONS-FOTOGRAFIE Dieser Abschnitt umfaßt Fotografie für Zeitungen, Zeitschriften und andere regelmäßig erscheinende Veröffentlichungen aller Art.

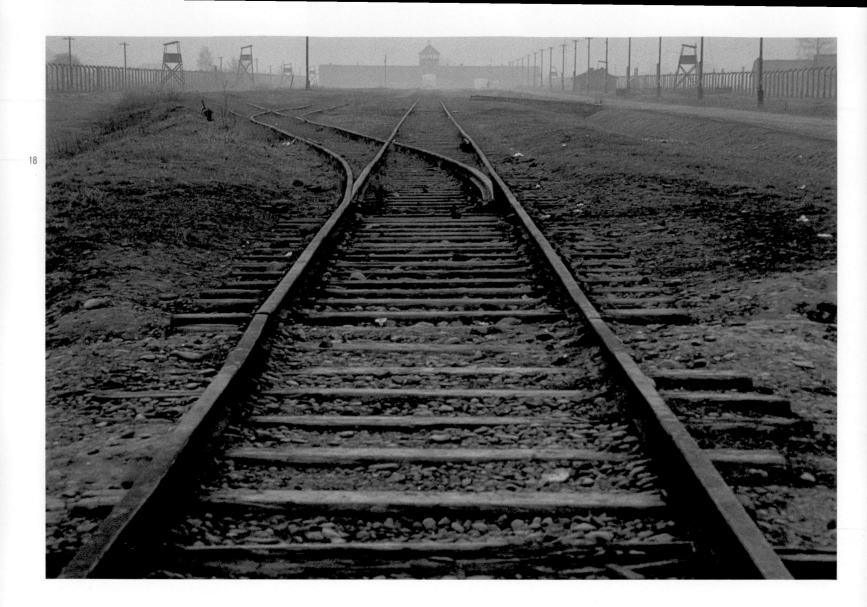

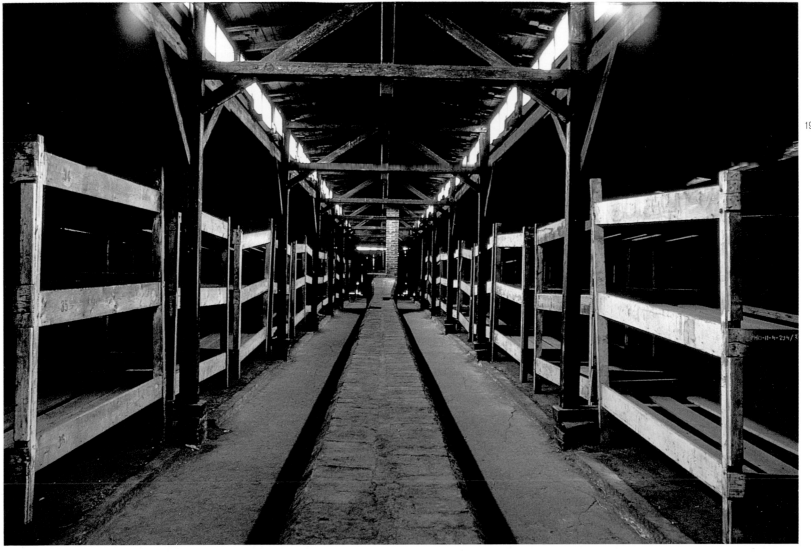

18-21	Photographer HARALD NADOLNY	Photographe HARALD NADOLNY	Fotograf HARALD NADOLNY
	Designer NORBERT KLEINER	Maquettiste NORBERT KLEINER	Gestalter NORBERT KLEINER
	Art Director ROLF GILLHAUSEN	Directeur Artistique ROLF GILLHAUSEN	Art Direktor ROLF GILLHAUSEN
	Publishing Company GRUNER & JAHR AG & CO.	Editeur GRUNER & JAHR AG & CO.	Verleger GRUNER & JAHR AG & CO.
	Double-page spreads from a feature on Auschwitz, "Der Weg in die Hölle" (The route to the inferno); "Stern," March 1981.	Photographies sur deux pages d'un article sur Auschwitz, "Der Weg in die Hölle" (Le chemin des enfers); "Stern," mars 1981.	Doppelseiten für eine Reportage über Auschwitz, "Der Weg in die Hölle"; im "Stern," März 1981.

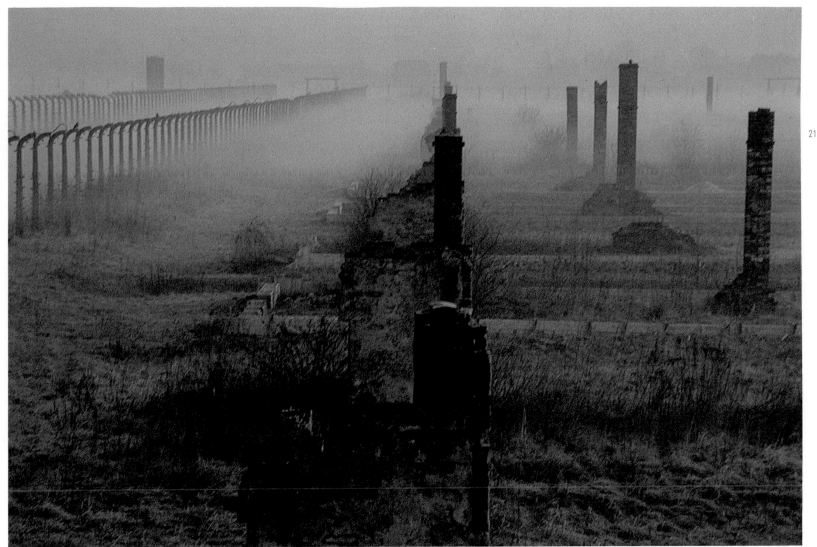

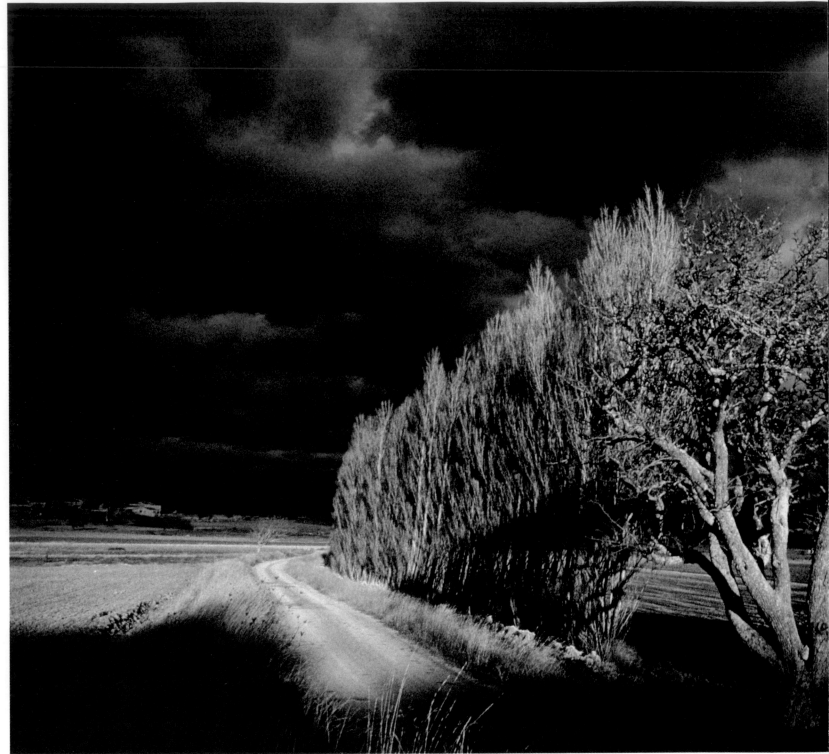

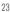

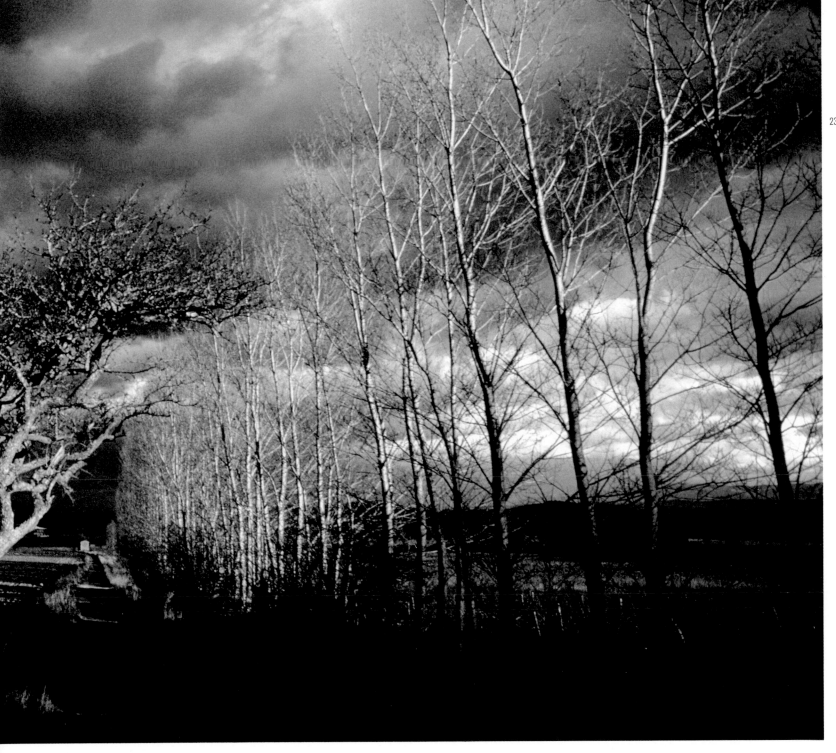

22, 23 Photographer DENNIS STOCK	Photographe DENNIS STOCK	Fotograf DENNIS STOCK
Designer PETER DASSE	Maquettiste PETER DASSE	Gestalter PETER DASSE
Publishing Company GRUNER & JAHR AG & CO.	Editeur GRUNER & JAHR AG & CO.	Verleger GRUNER & JAHR AG & CO.
"Provence", a feature by Peter Grubbe in "Geo", May 1981.	"Provence", un article de Peter Grubbe dans "Geo", mai 1981.	"Provence", eine Reportage von Peter Grubbe in "Geo", Mai 1981.

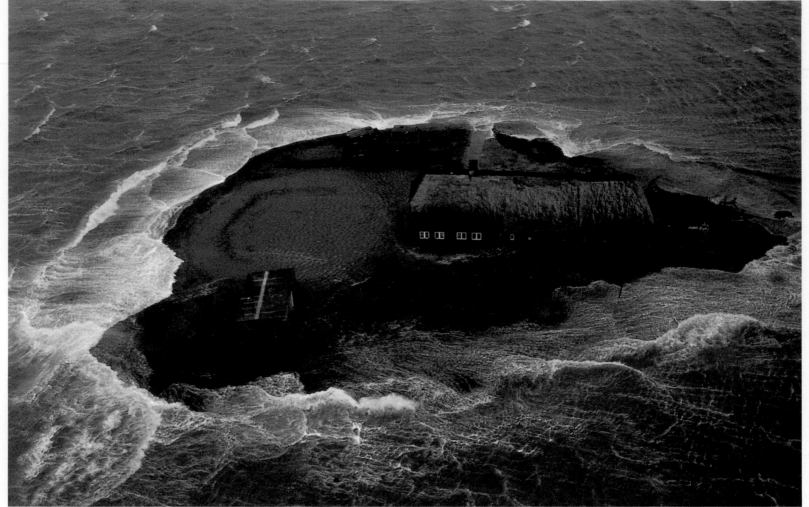

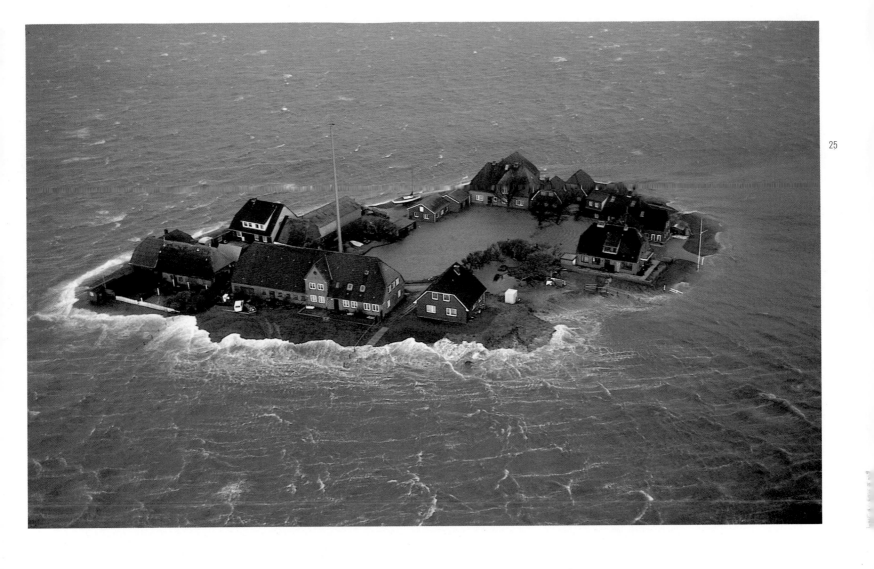

24, 25 Photographer HANS SILVESTER

Designers FRANZ BRAUN/ERWIN EHRET

Publishing Company GRUNER & JAHR AG & CO.

Double-page spreads of Hamburg, West Germany, for a feature "Sturmflut" (Tidal wave), by Alexander Rost in "Geo", January 1982.
24 "How many years does the sea need?"
25 "Only the mast keeps up the connection to the mainland."

Photographe HANS SILVESTER

Maquettistes FRANZ BRAUN/ERWIN EHRET

Editeur GRUNER & JAHR AG & CO.

Photographies en deux pages de Hambourg, Allemagne de l'Ouest, pour un article "Sturmflut" (Raz de marée), par Alexander Rost dans "Geo", janvier 1982.
24 "De combien d'années la mer a-t-elle besoin?"
25 "Seul le mât conserve un rapport avec la terre ferme."

Fotograf HANS SILVESTER

Gestalter FRANZ BRAUN/ERWIN EHRET

Verleger GRUNER & JAHR AG & CO.

Doppelseitige Aufnahmen von Hamburg für die Reportage "Sturmflut" von Alexander Rost, in "Geo", Januar 1982.
24 "Wie viele Jahre braucht die See?"
25 "Nur der Mast hält noch die Verbindung mit dem Festland."

Photographer PHILIP SAYER

Art Director ROBERT PRIEST

Picture Editor JENNIFER CRANDALL

Publishing Company ESQUIRE PUBLISHING CO.

Photograph of Bradford, Yorkshire; one of a series used in conjunction with a feature by Guy Martin on the Yorkshire Ripper in "Esquire", January 1981.

Photographe PHILIP SAYER

Directeur Artistique ROBERT PRIEST

Directeur de Photographie JENNIFER CRANDALL

Editeur ESQUIRE PUBLISHING CO.

Photographie de Bradford, Yorkshire; une d'une série utilisée en conjonction avec un article de Guy Martin sur le "Yorkshire Ripper" dans "Esquire", janvier 1981.

Fotograf PHILIP SAYER

Art Direktor ROBERT PRIEST

Bildredakteur JENNIFER CRANDALL

Verleger ESQUIRE PUBLISHING CO.

Foto von Bradford, Yorkshire; innerhalb einer Serie eingesetzt im Zusammenhang mit einer Reportage von Guy Martin über den "Yorkshire Ripper" in "Esquire", Januar 1981.

26, 27 ▶

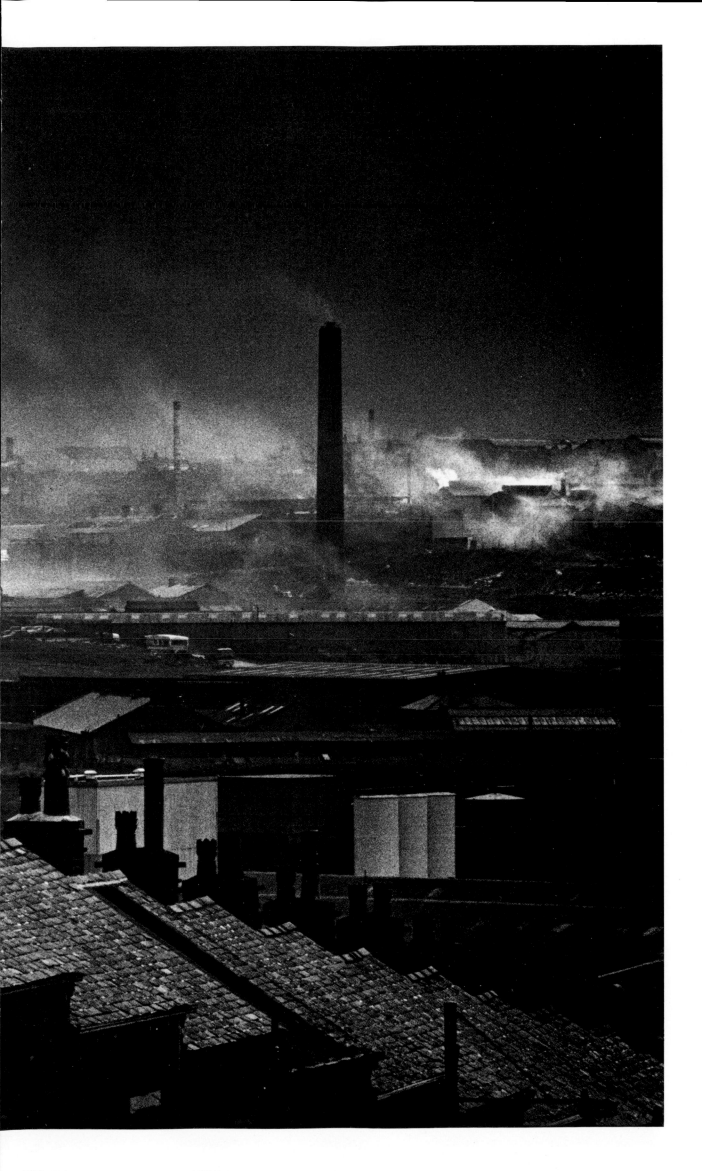

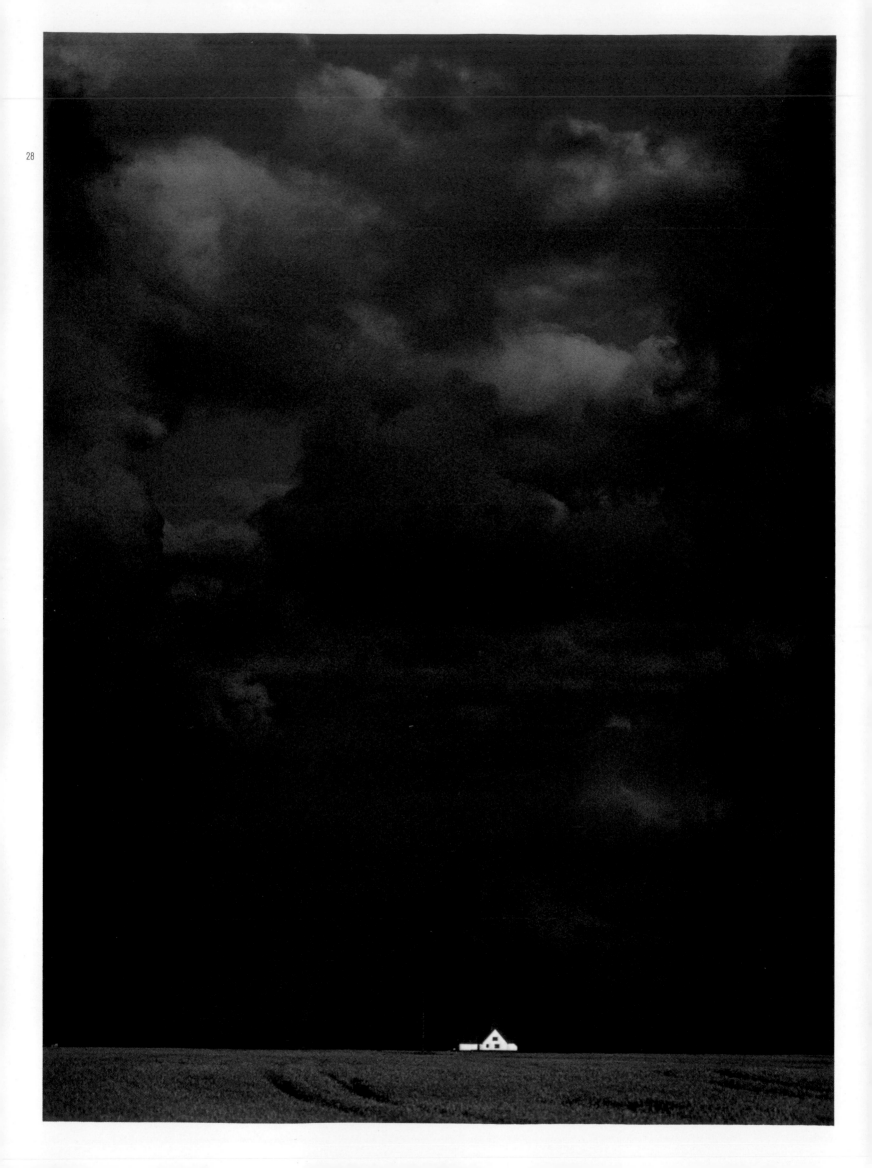

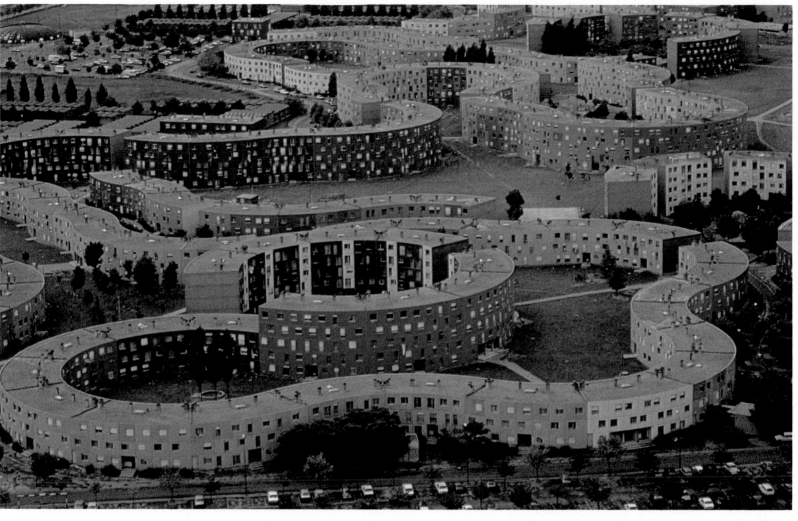

29 Photographer JEAN MOUNICQ	Photographe JEAN MOUNICQ	Fotograf JEAN MOUNICQ
Designer ANDREAS KRELL	Maquettiste ANDREAS KRELL	Gestalter ANDREAS KRELL
Publishing Company GRUNER & JAHR AG & CO.	Editeur GRUNER & JAHR AG & CO.	Verleger GRUNER & JAHR AG & CO.
"Stadtplanung" (Paris 2000), (Town planning [Paris 2000]); photographed over La Grande Bourne, 95 kilometres south of Paris, for a feature by Klaus Harpprecht in "Geo", December 1981.	"Stadtplanung" (Paris 2000), (Urbanisme [Paris 2000]); Photographie prise au dessus de La Grande Bourne, à 95 kilomètres au sud de Paris, pour un article de Klaus Harpprecht dans "Geo", décembre 1981.	"Stadtplanung" (Paris 2000); fotografiert über La Grande Bourne, 95 Kilometer südlich von Paris, für eine Reportage von Klaus Harpprecht in "Geo", Dezember 1981.
◀**28** Photographer HEINZ TEUFEL	Photographe HEINZ TEUFEL	Fotograf HEINZ TEUFEL
Designer ANDREAS KRELL	Maquettiste ANDREAS KRELL	Gestalter ANDREAS KRELL
Publishing Company GRUNER & JAHR AG & CO.	Editeur GRUNER & JAHR AG & CO.	Verleger GRUNER & JAHR AG & CO.
Taken in Nordfriesland, West Germany, for a feature by Günter Kunert, "Nolde"; in "Geo".	Photographies prises dans la Frise Septentrionale, Allemagne de l'Ouest, pour un article de Günter Kunert, "Nolde"; dans "Geo".	Aufgenommen in Nordfriesland für eine Reportage von Günter Kunert, "Nolde"; in "Geo".

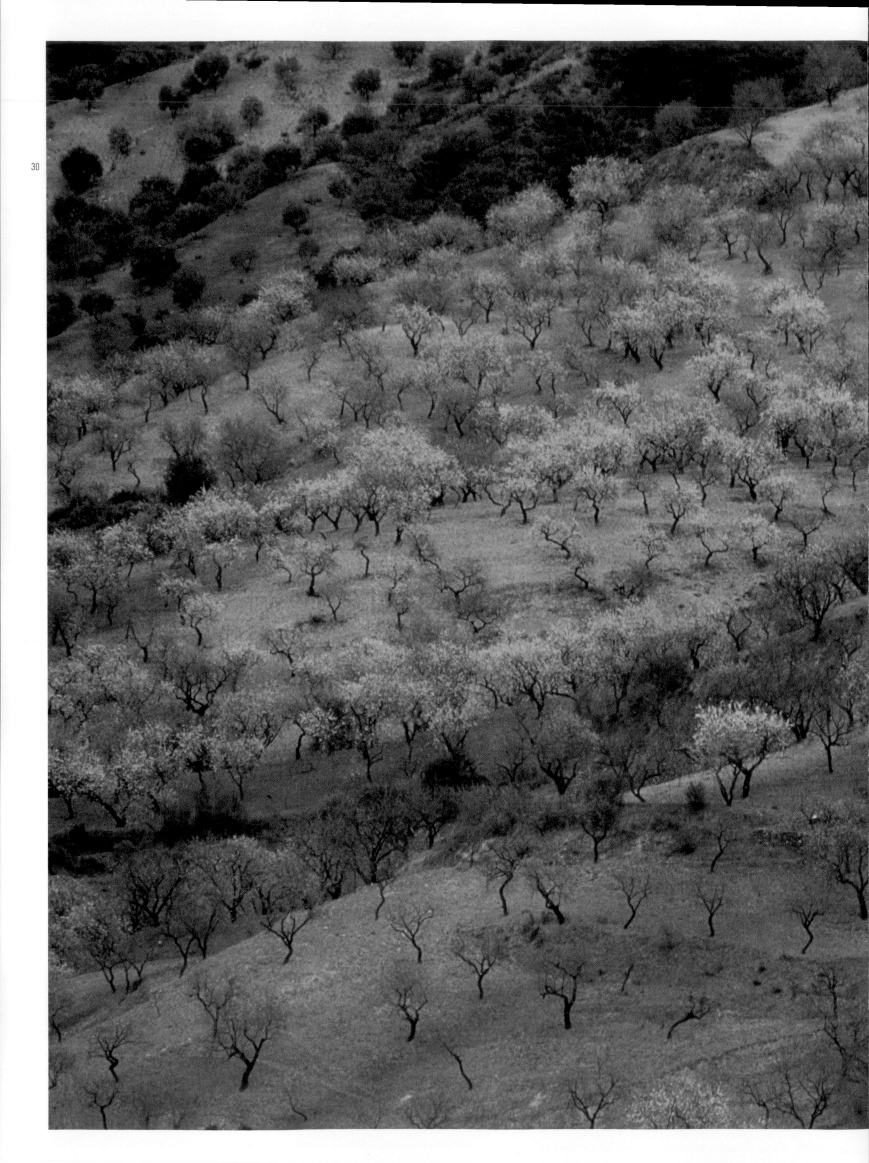

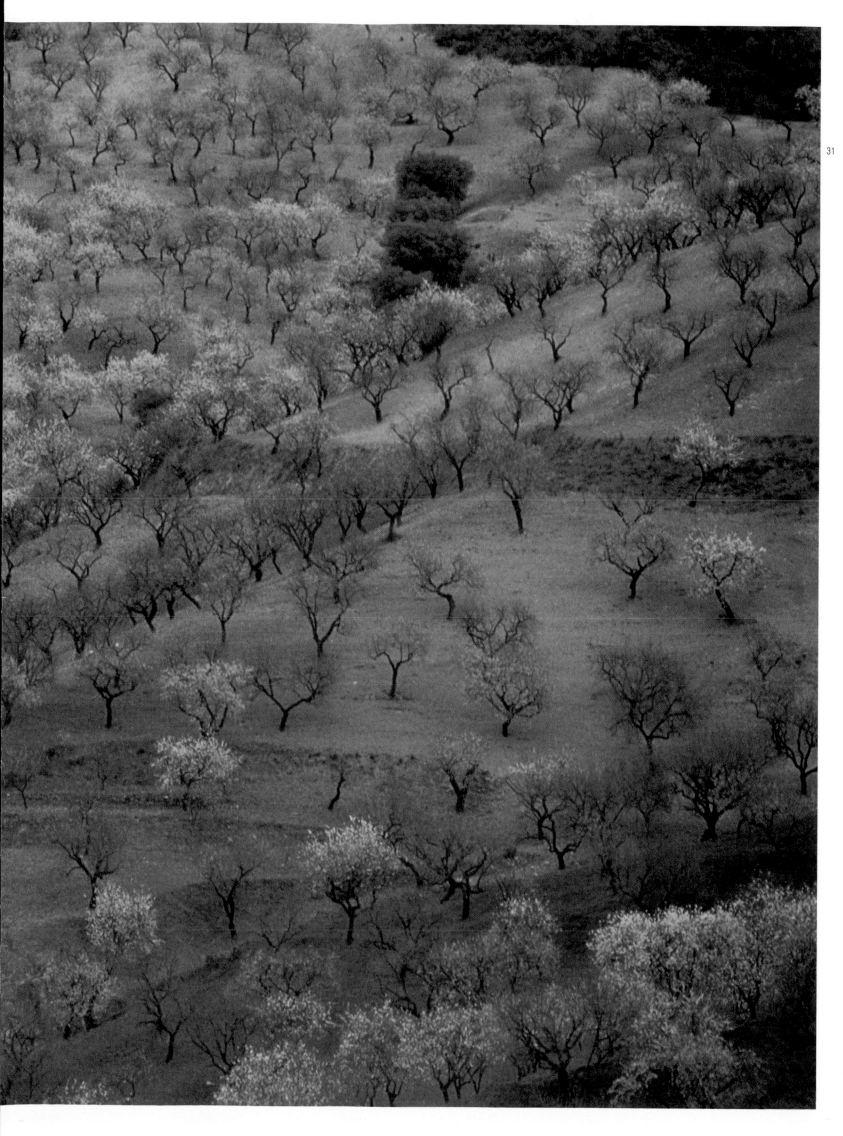

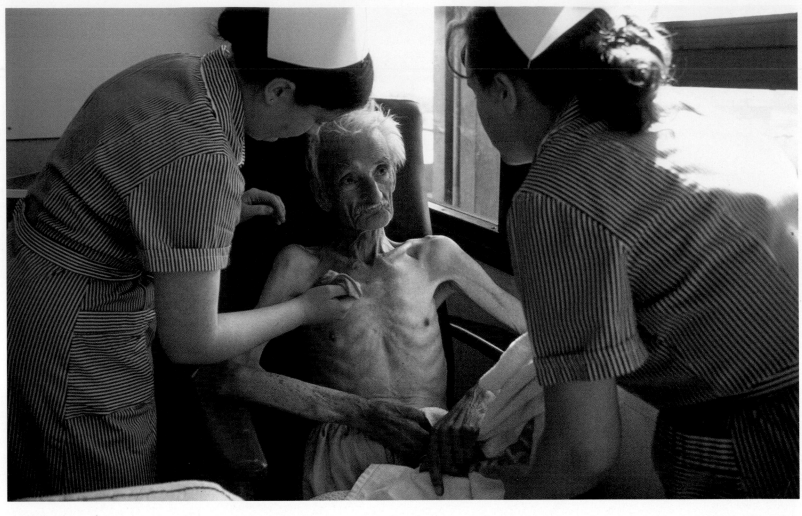

◄ 30, 31

Photographer HANS SILVESTER	Photographe HANS SILVESTER	Fotograf HANS SILVESTER
Designer ERWIN EHRET	Maquettiste ERWIN EHRET	Gestalter ERWIN EHRET
Publishing Company GRUNER & JAHR AG & CO.	Editeur GRUNER & JAHR AG & CO.	Verleger GRUNER & JAHR AG & CO.
Double-page spread of almond trees in Spain for "Sierra Nevada", a feature by Benno Kroll in "Geo", August 1981.	Photographie sur deux pages d'amandiers en Espagne pour "Sierra Nevada", un article de Benno Kroll dans "Geo", août 1981.	Doppelseitige Aufnahme von Mandelbäumen in Spanien für "Sierra Nevada", eine Reportage von Benno Kroll in "Geo", August 1981.

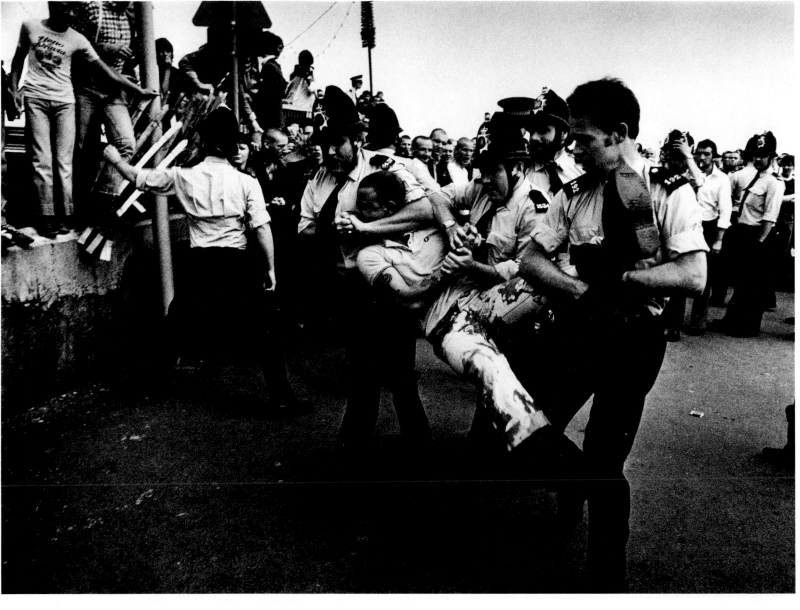

32, 33	Photographer DON McCULLIN	Photographe DON McCULLIN	Fotograf DON McCULLIN
	Designer JOHN TENNANT	Maquettiste JOHN TENNANT	Gestalter JOHN TENNANT
	Art Director MICHAEL RAND	Directeur Artistique MICHAEL RAND	Art Direktor MICHAEL RAND
	Publishing Company TIMES NEWSPAPERS LIMITED	Editeur TIMES NEWSPAPERS LIMITED	Verleger TIMES NEWSPAPERS LIMITED
	Double-page spreads from a feature by Ian Jack, "British Youth," in "The Sunday Times Magazine," November 1981. 32 Teenage nurses with octogenarian patient in Liverpool. 33 Skinheads and police clash in Southend.	Photographies sur deux pages d'un article de Ian Jack, "British Youth," (La jeunesse britannique), dans "The Sunday Times Magazine," novembre 1981. 32 Infirmières adolescentes avec un malade octogénaire à Liverpool. 33 Conflit entre skinheads et la police à Southend.	Doppelseiten für eine Reportage von Ian Jack, "British Youth," (Die britische Jugend), in "The Sunday Times Magazine," November 1981. 32 Jugendliche Krankenschwestern mit einem achtzigjährigen Patienten in Liverpool. 33 Skinheads und Polizei bei einem Krawall in Southend.

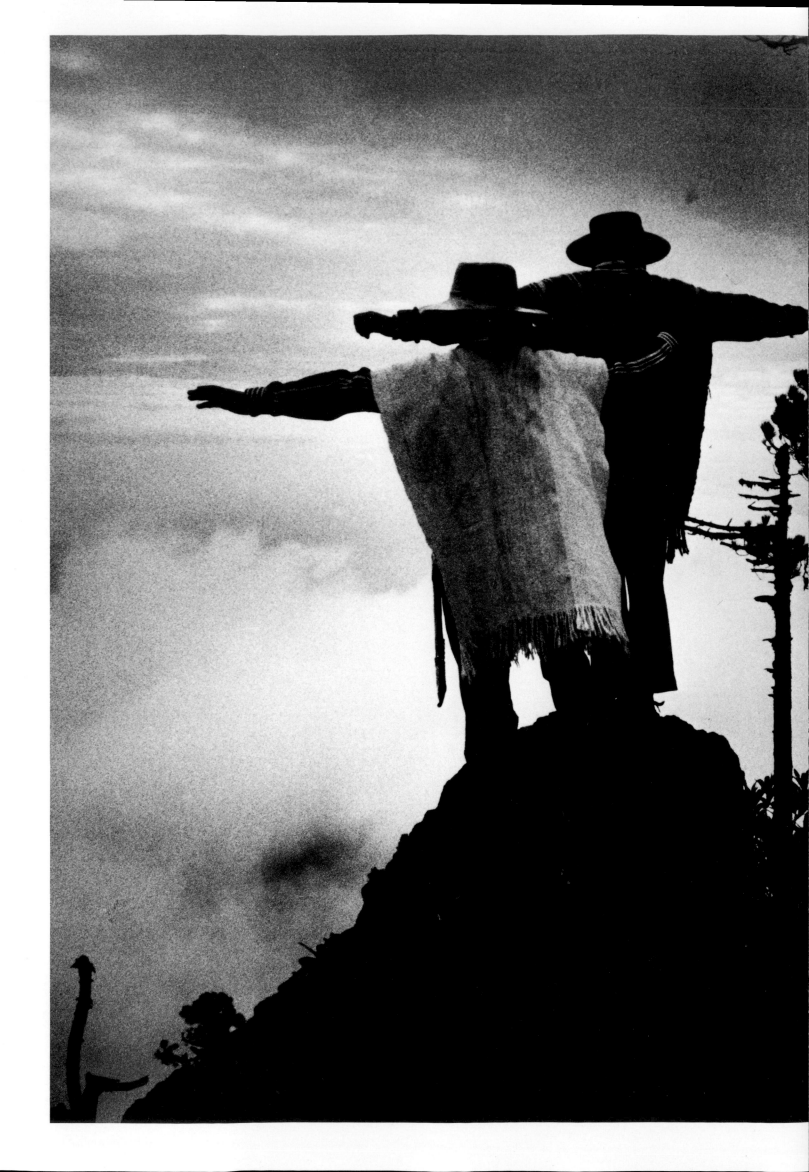

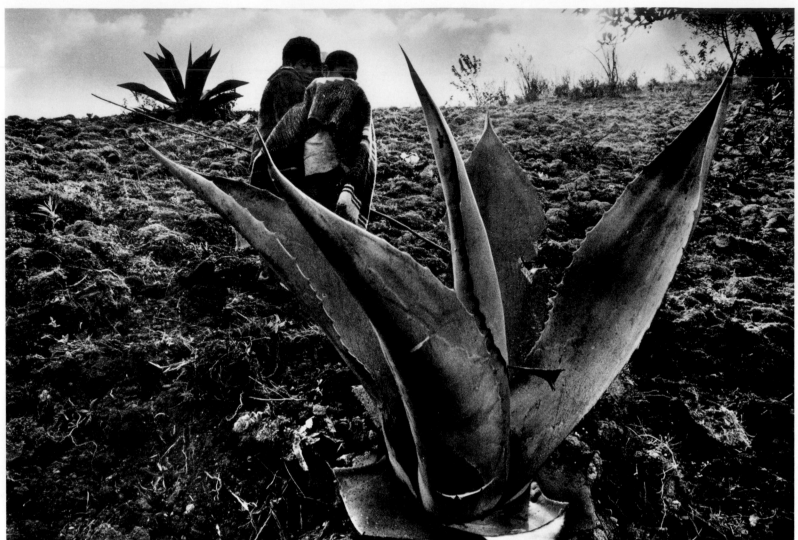

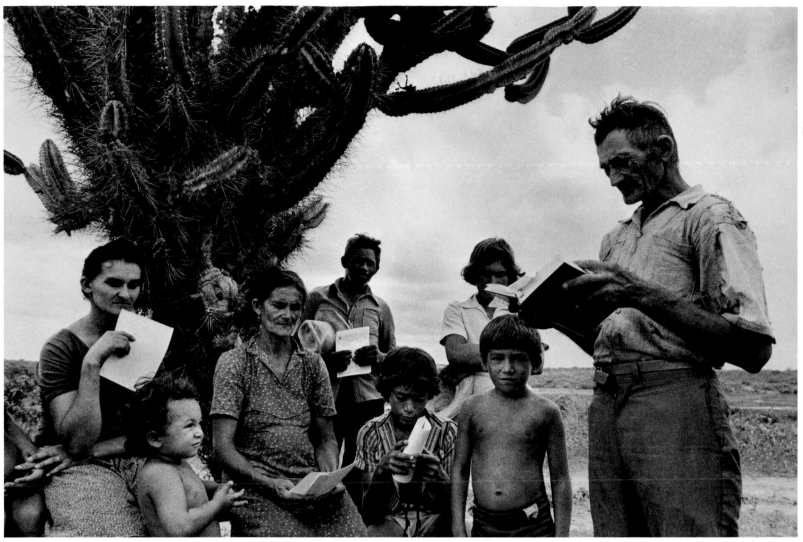

34-40	Photographer SEBASTIAO SALGADO Jr.	Photographe SEBASTIAO SALGADO Jr.	Fotograf SEBASTIAO SALGADO Jr.
	Publishing Company PUBLICATIONS PAUL MONTEL	Editeur PUBLICATIONS PAUL MONTEL	Verleger PUBLICATIONS PAUL MONTEL
	A series of photographs from a feature on the photographer's work, "Un Nouveau parmi les Grands," (A Newcomer among the Great); in "Photo," February 1982. 34, 35 Oaxaca, Mexico 36 Oaxaca, Mexico 37 Sertao region, near Creteus, Brazil 38, 39 Hualtla de Jimenez, Mexico 40 North East Brazil	Série de photographies tirées d'un article sur l'oeuvre du photographe, "Un Nouveau parmi les Grands," dans "Photo," février 1982. 34, 35 Oaxaca, Mexique 36 Oaxaca, Mexique 37 Région de Sertao, près de Creteus, Brésil. 38, 39 Hualtla de Jimenez, Mexique 40 Au nord est du Brésil.	Eine Serie von Fotos für eine Reportage über das Werk des Fotografen, "Un Nouveau parmi les Grands" (Ein Neuling unter den Großen), in "Photo," Februar 1982. 34, 35 Oaxaca, Mexiko 36 Oaxaca, Mexiko 37 Das Sertao Gebiet, in der Nähe von Creteus, Brasilien 38, 39 Hualtla de Jimenez, Mexiko 40 Der Nordosten Brasiliens

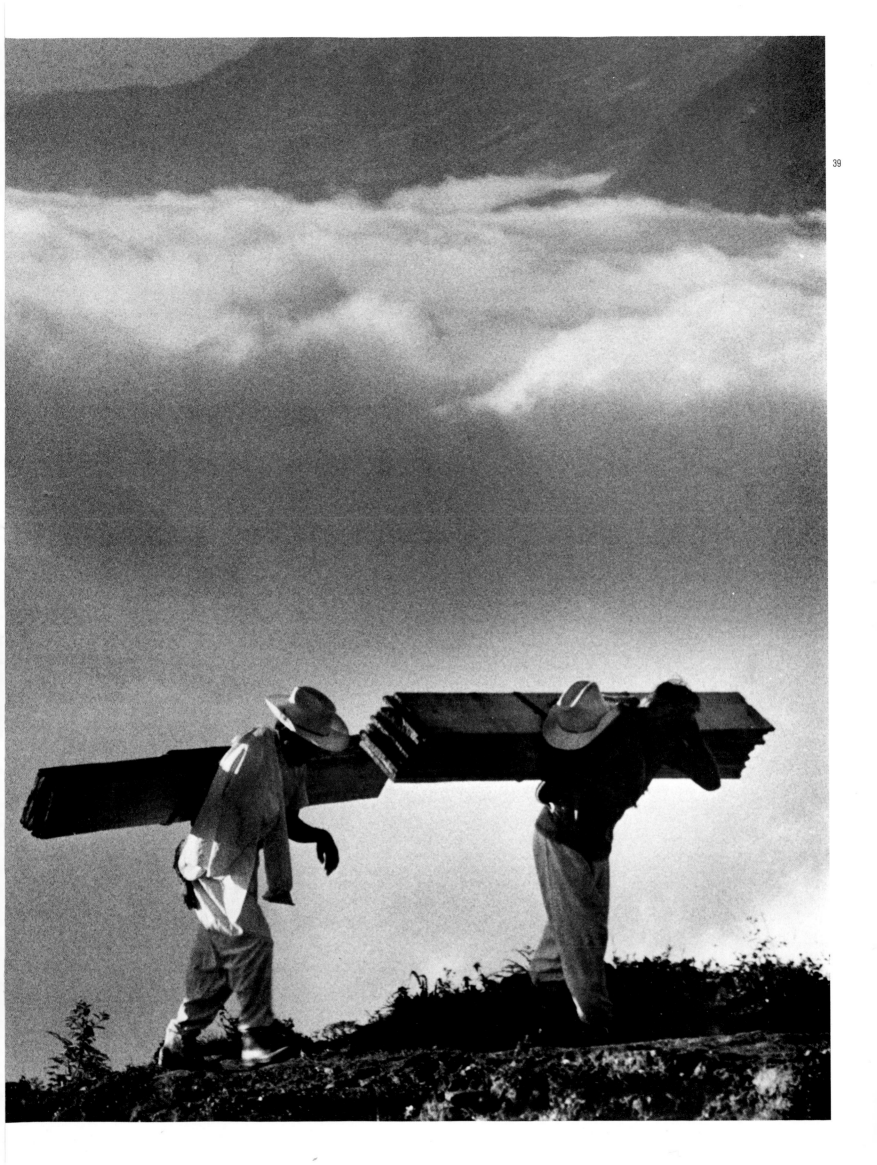

42-45	Photographer WILFRIED BAUER	Photographe WILFRIED BAUER	Fotograf WILFRIED BAUER
	Designer FRANZ EPPING	Maquettiste FRANZ EPPING	Gestalter FRANZ EPPING
	Art Director ROLF GILLHAUSEN	Directeur Artistique ROLF GILLHAUSEN	Art Direktor ROLF GILLHAUSEN
	Publishing Company GRUNER & JAHR AG & CO.	Editeur GRUNER & JAHR AG & CO.	Verleger GRUNER & JAHR AG & CO.

"Verbannte Dichter," (Banned poets); a series of articles by Jürgen Serke in "Stern," September, October and November 1981.
42 Wladimir Woinowitsch—"The guilt of the victim"
43 Czeslaw Milosz—"A Polish miracle"
44 Reiner Kunze—"The voice out of the silence"
45 Pavel Kohout—"A winner learning how to lose"

"Verbannte Dichter," (Poètes bannis); série d'articles par Jürgen Serke dans "Stern," septembre, octobre et novembre 1981.
42 Wladimir Woinowitsch—"La culpabilité de la Victime"
43 Czeslaw Milosz—"Un miracle polonais"
44 Reiner Kunze—"La voix sortie du silence"
45 Pavel Kohout—"Un gagnant apprend à perdre"

"Verbannte Dichter"; eine Reihe von Artikeln von Jürgen Serke, im "Stern," September, Oktober und November 1981.
42 Wladimir Woinowitsch—"Die Schuld des Opfers"
43 Czeslaw Milosz—"Ein polnisches Wunder"
44 Reiner Kunze—"Die Stimme aus der Stille"
45 Pavel Kohout—"Ein Sieger lernt verlieren"

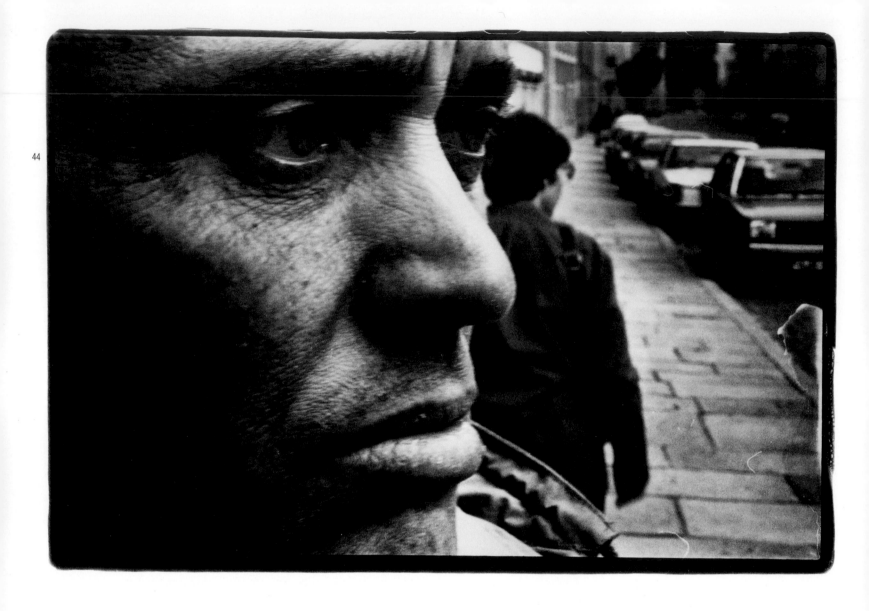

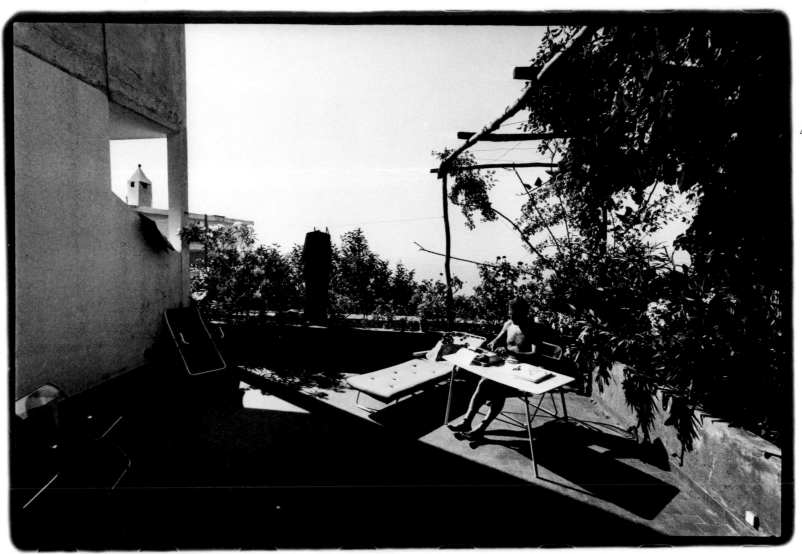

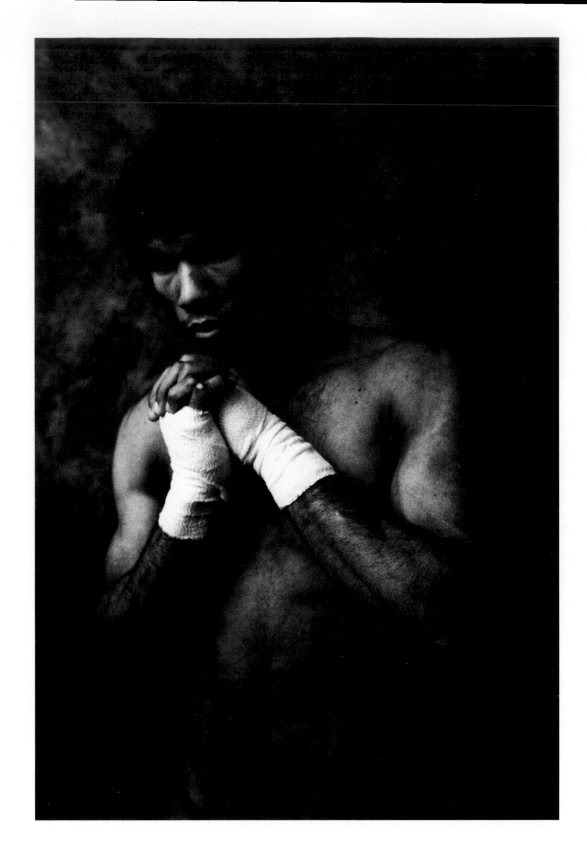

46 Photographer JAMES A. FOX

Publishing Company PUBLICATIONS PAUL MONTEL

One of a series of portraits of boxers published in
"Photo," March 1982.

Photographe JAMES A. FOX

Editeur PUBLICATIONS PAUL MONTEL

Un d'une série de portraits de boxeurs publiés dans
"Photo," mars 1982.

Fotograf JAMES A. FOX

Verleger PUBLICATIONS PAUL MONTEL

Aufnahme innerhalb einer Serie von Portraits von
Boxern, veröffentlicht in "Photo," März 1982.

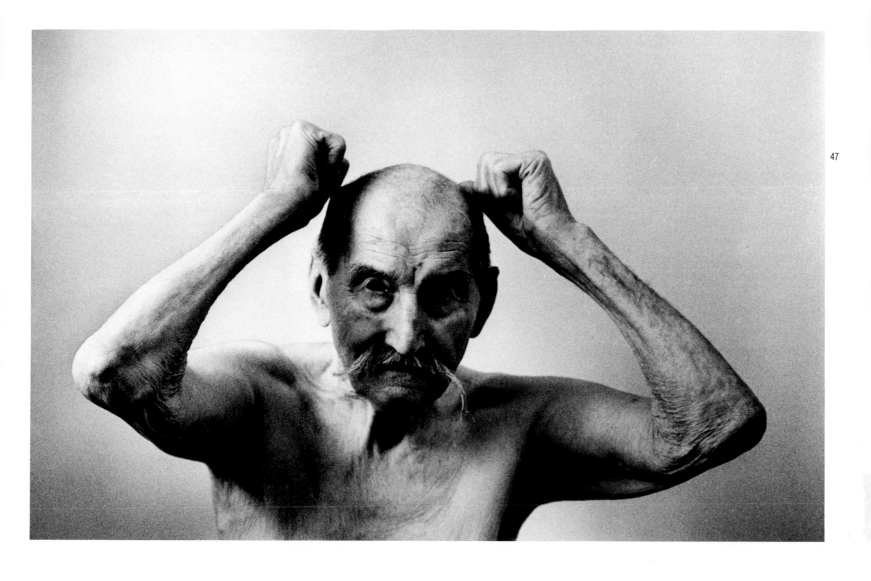

47 Photographer GERD LUDWIG

Designer KARIN GERLACH

Art Director MANFRED MANKE

Publishing Company
ZEITVERLAG GERD BUCERIUS KG

Photographe GERD LUDWIG

Maquettiste KARIN GERLACH

Directeur Artistique MANFRED MANKE

Editeur
ZEITVERLAG GERD BUCERIUS KG

Fotograf GERD LUDWIG

Gestalter KARIN GERLACH

Art Direktor MANFRED MANKE

Verleger
ZEITVERLAG GERD BUCERIUS KG

Double-page spread of Friedrich Janz, aged 105, demonstrating his biceps; from a feature by Peter Sager, "Die Kraft von hundert Jahren," (The strength of a hundred years); "Zeitmagazin," July 1981.

Photographie sur deux pages de Friedrich Janz, agé de 105 ans, montrant ses biceps; d'un article de Peter Sager, "Die Kraft von hundert Jahren," (La force de cent ans); "Zeitmagazin," juillet 1981.

Doppelseitige Aufnahme von Friedrich Janz, 105 Jahre alt, in einer Demonstration seiner Muskelkraft; für eine Reportage von Peter Sager "Die Kraft von hundert Jahren," im "Zeitmagazin," Juli 1981.

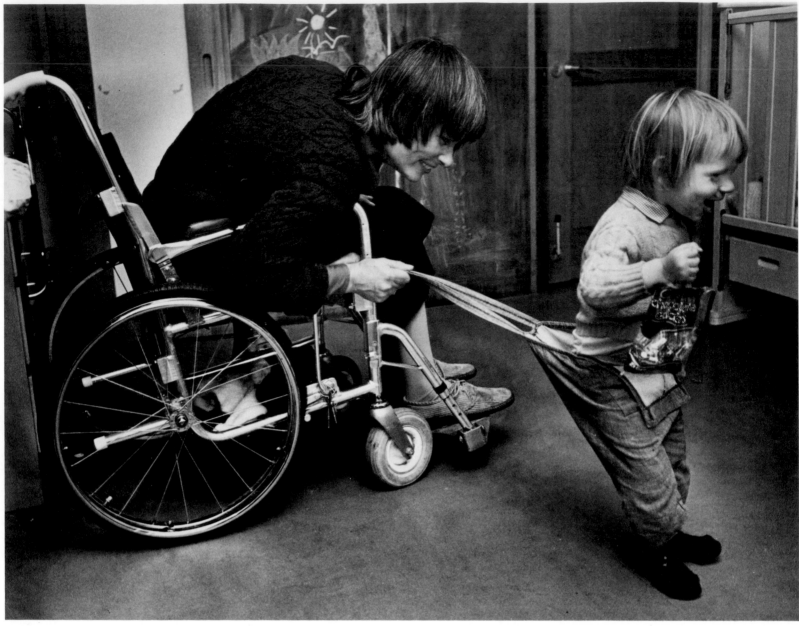

48 Photographer CAMILLA JESSEL

Art Director MICHAEL HARDY

Publishing Company
THE SUNDAY TELEGRAPH LIMITED

Part of a feature, "Disability as a Way of Life," by Harry
Fieldhouse; in "The Telegraph Sunday Magazine,"
January 1981.

Photographe CAMILLA JESSEL

Directeur Artistique MICHAEL HARDY

Editeur
THE SUNDAY TELEGRAPH LIMITED

Partie d'un article "Disability as a Way of Life"
(L'infirmité comme mode de vie), par Harry
Fieldhouse; dans "The Telegraph Sunday Magazine,"
janvier 1981.

Fotograf CAMILLA JESSEL

Art Direktor MICHAEL HARDY

Verleger
THE SUNDAY TELEGRAPH LIMITED

Teil einer Reportage, "Disability as a Way of Life"
(Körperbehinderung als eine Lebensart), von Harry
Fieldhouse; in "The Telegraph Sunday Magazine,"
Januar 1981.

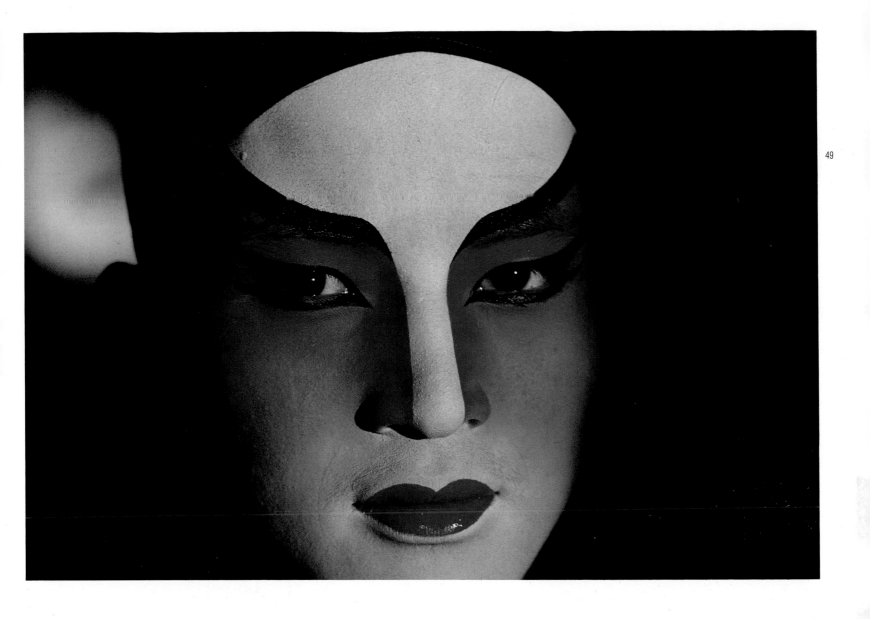

49 Photographer GUIDO MANGOLD	Photographe GUIDO MANGOLD	Fotograf GUIDO MANGOLD
Designer PETER DASSE	Maquettiste PETER DASSE	Gestalter PETER DASSE
Publishing Company GRUNER & JAHR AG & CO.	Editeur GRUNER & JAHR AG & CO.	Verleger GRUNER & JAHR AG & CO.
"Ein Hit seit tausend Jahren", (A hit for the past thousand years); travelling Chinese opera troupe photographed in Thailand for a feature by Johannes Schaaf in "Geo".	"Ein Hit seit tausend Jahren", (Un succès depuis mille ans); troupe d'opéra itinérante chinoise photographiée au Thailande pour un article de Johannes Schaaf dans "Geo".	"Ein Hit seit tausend Jahren"; eine Wandertruppe der chinesischen Oper, fotografiert in Thailand für eine Reportage von Johannes Schaaf in "Geo".

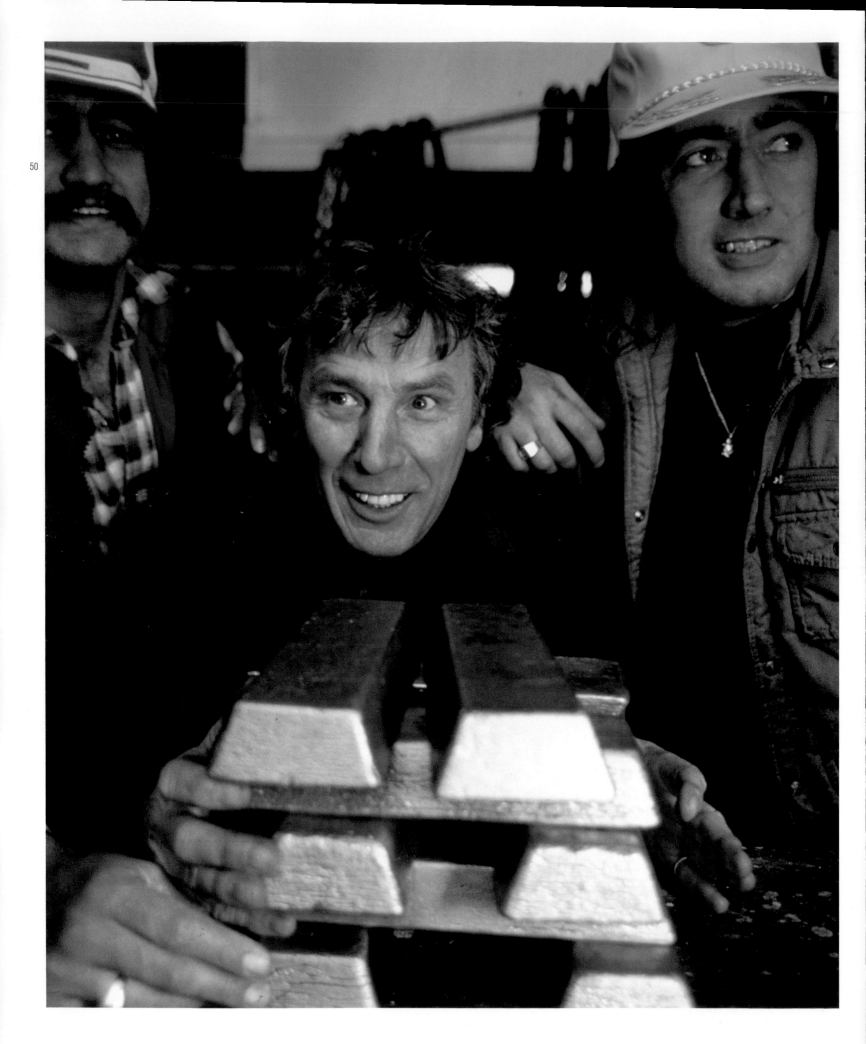

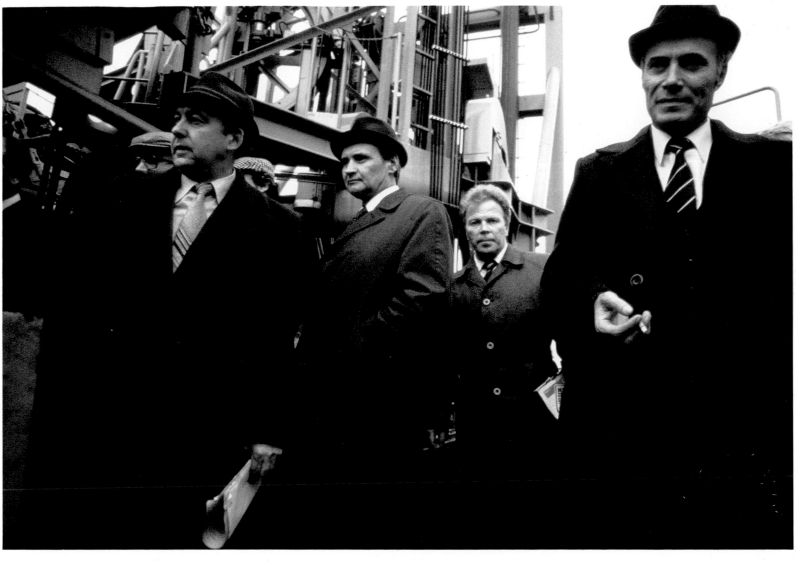

50, 51	Photographer IAN YEOMANS	Photographe IAN YEOMANS	Fotograf IAN YEOMANS
	Designer JOHN TENNANT	Maquettiste JOHN TENNANT	Gestalter JOHN TENNANT
	Art Director MICHAEL RAND	Directeur Artistique MICHAEL RAND	Art Direktor MICHAEL RAND
	Publishing Company TIMES NEWSPAPERS LIMITED	Editeur TIMES NEWSPAPERS LIMITED	Verleger TIMES NEWSPAPERS LIMITED

"Gold Fever: The Full Story of HMS Edinburgh", a feature by Barrie Penrose chronicling the recovery of £40,000,000 of Russian gold from the Barents Sea; in "The Sunday Times Magazine", November 1981.
50 Keith Jessop, originator of the operation, on board the salvage vessel "Stephaniturm" with ten of the recovered gold bars.
51 Welcoming committee of Russians on board the "Stephaniturm" in Murmansk.

"Gold Fever: The Full Story of HMS Edinburgh" (La fièvre de l'or: l'histoire complète de HMS Edinburgh) un article de Barrie Penrose détaillant la récupération de £40.000.000 d'or russe de la Mer de Barents; dans "The Sunday Times Magazine", novembre 1981.
50 Keith Jessop, initiateur de l'opération, à bord du navire de relevage "Stephaniturm" avec dix des barres relevées.
51 Comité d'accueil de Russes à bord du "Stephaniturm" à Mourmansk.

"Gold Fever: The Full Story of HMS Edinburgh" (Goldfieber: Die Geschichte der HMS Edinburgh), eine Reportage von Barrie Penrose über die Bergung von £40.000.000 russischem Golds aus der Barents-See; in "The Sunday Times Magazine", November 1981.
50 Keith Jessop, Urheber der Operation, an Bord des Bergungsschiffes "Stephaniturm" mit zehn der wiederentdeckten Goldbarren.
51 Das russische Willkommens-Komitee an Bord der "Stephaniturm" in Murmansk.

	Photographer ROGER PERRY	Photographe ROGER PERRY	Fotograf ROGER PERRY	**52, 53 ▶**
	Designer JOHN TENNANT	Maquettiste JOHN TENNANT	Gestalter JOHN TENNANT	
	Art Director MICHAEL RAND	Directeur Artistique MICHAEL RAND	Art Direktor MICHAEL RAND	
	Picture Editor BRUCE BERNARD	Directeur de Photographie BRUCE BERNARD	Bildredakteur BRUCE BERNARD	
	Publishing Company TIMES NEWSPAPERS LIMITED	Editeur TIMES NEWSPAPERS LIMITED	Verleger TIMES NEWSPAPERS LIMITED	

Photographed in York, England, for a feature "The Strange Case of the Chaplin Twins" by Neil Lyndon; in "The Sunday Times Magazine", June 1981.

Photographie prise à York, Angleterre, pour un article "The Strange Case of the Chaplin Twins" (Le cas étrange des jumeaux Chaplin) par Neil Lyndon: dans "The Sunday Times Magazine", juin 1981.

Aufgenommen in York, England, für die Reportage "The Strange Case of the Chaplin Twins" (Die sonderbare Welt der Chaplin Zwillinge) von Neil Lyndon; in "The Sunday Times Magazine", Juni 1981.

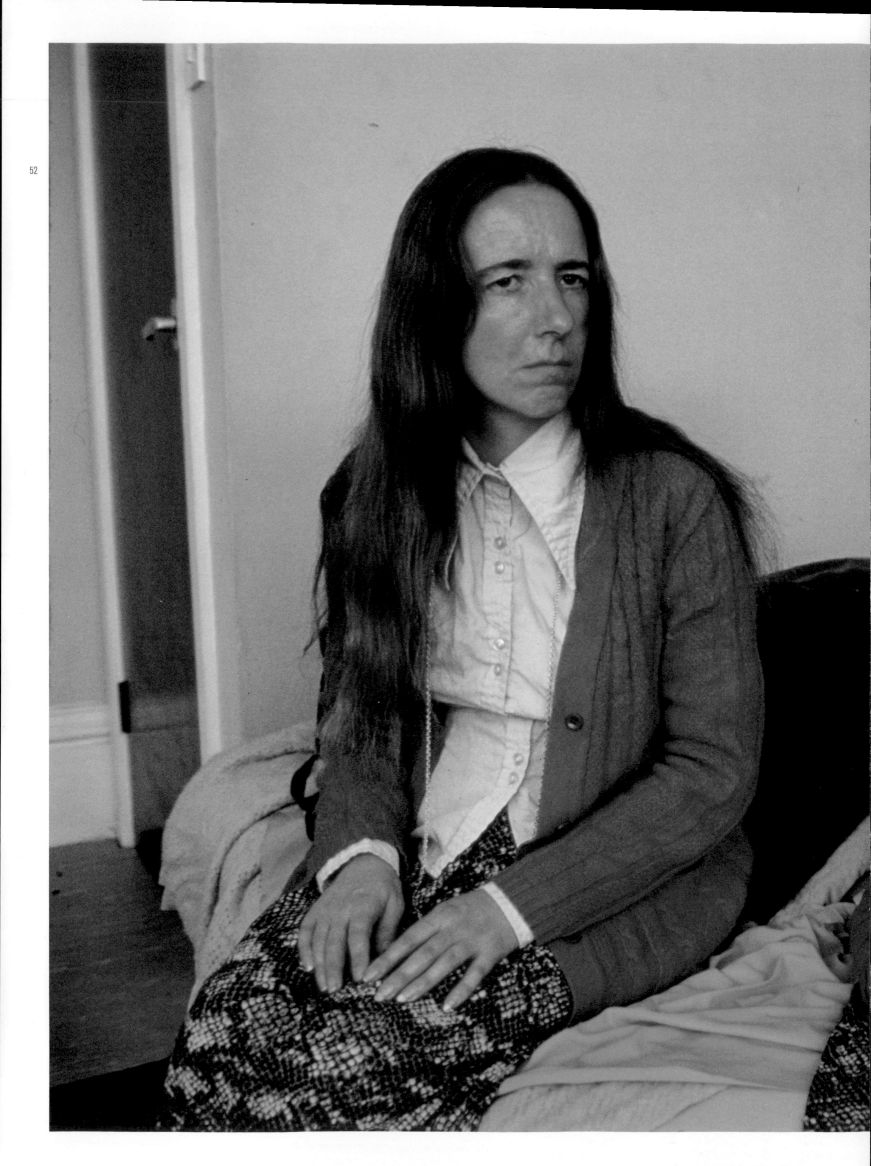

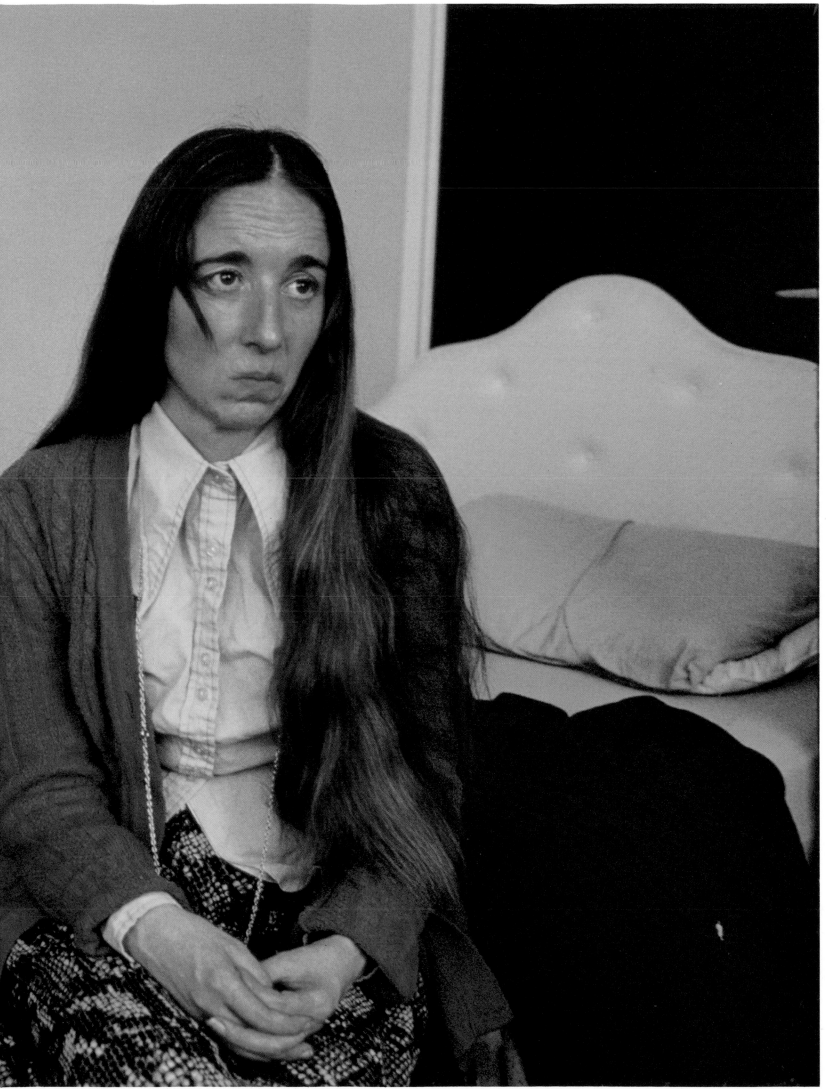

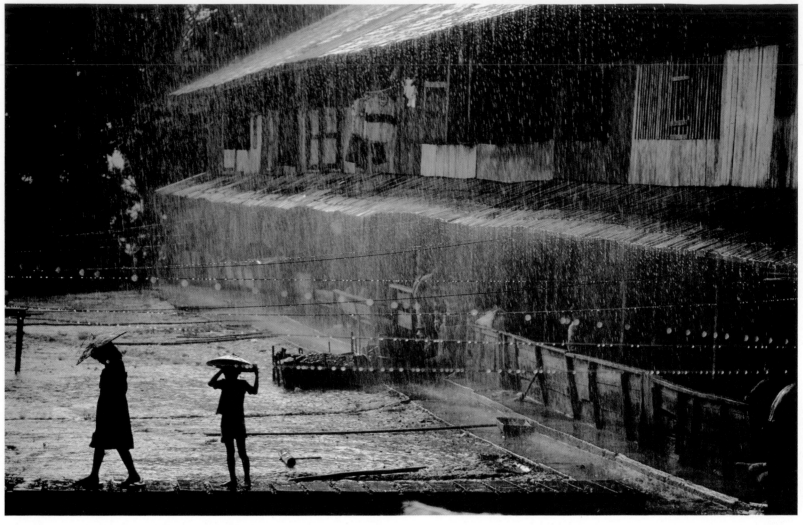

54 Photographer REINHARD EISELE

Designer FRANZ BRAUN

Publishing Company GRUNER & JAHR AG & CO.

Photographed in Uma Daro, Borneo, for a feature "Höhere Gewalten," (Superior forces), from a special issue of "Geo" concerning the weather.

Photographe REINHARD EISELE

Maquettiste FRANZ BRAUN

Editeur GRUNER & JAHR AG & CO.

Photographie prise à Uma Daro, Borneo, pour un article "Höhere Gewalten," (Forces supérieures), d'un numéro spécial de "Geo" concernant le temps.

Fotograf REINHARD EISELE

Gestalter FRANZ BRAUN

Verleger GRUNER & JAHR AG & CO.

Fotografiert in Uma Daro, Borneo, für die Reportage "Höhere Gewalten," aus einer "Geo" Sonderausgabe über das Wetter.

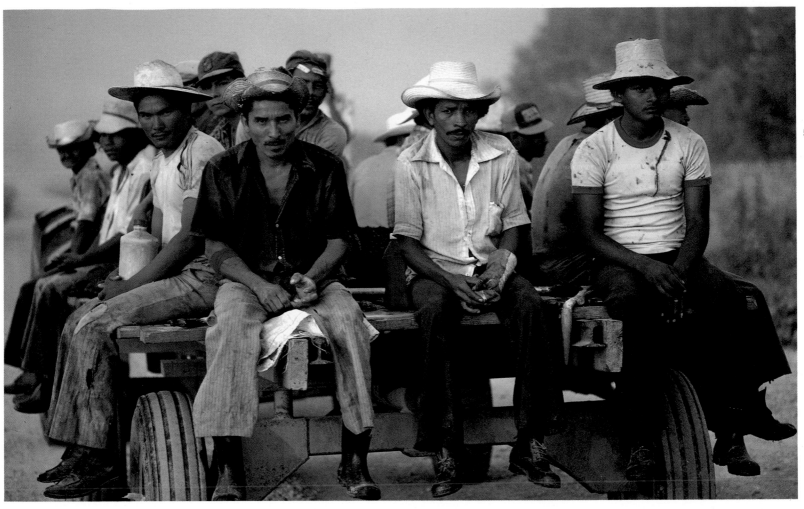

55 Photographer ALAIN LE GARSMEUR | Photographe ALAIN LE GARSMEUR | Fotograf ALAIN LE GARSMEUR

Designer DAVID ASHMORE | Maquettiste DAVID ASHMORE | Gestalter DAVID ASHMORE

Publishing Company THE OBSERVER MAGAZINE | Editeur THE OBSERVER MAGAZINE | Verleger THE OBSERVER MAGAZINE

Banana plantation workers in Honduras photographed for a feature by Norman Lewis, "Enslaved to the Banana"; in "The Observer Magazine," November 1981.

Ouvriers des plantations de bananes au Honduras photographiés pour un article par Norman Lewis, "Enslaved to the Banana" (Esclavage de la banane); dans "The Observer Magazine," novembre 1981.

Arbeiter auf einer Bananenplantage in Honduras, aufgenommen für eine Reportage von Norman Lewis, "Enslaved to the Banana" (Der Banane unterjocht); in "The Observer Magazine," November 1981.

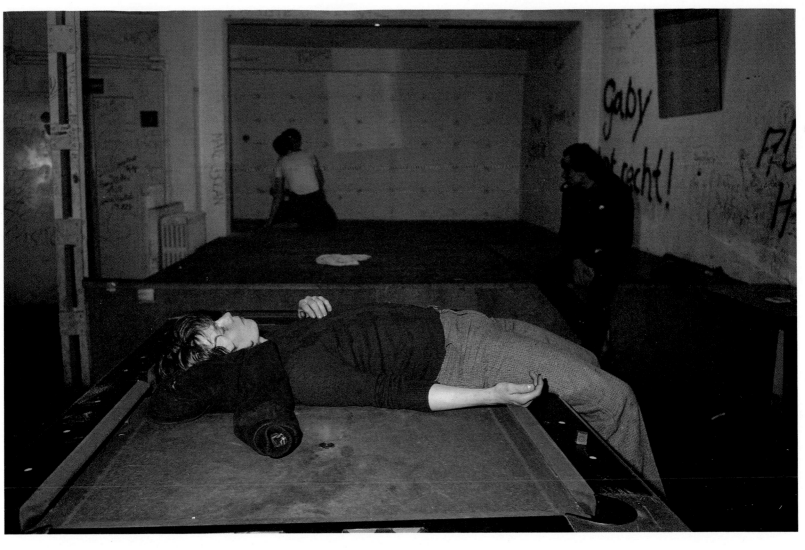

56, 57 Photographer ANNE KOCH

Designer WOLF DAMMANN

Art Director WOLFGANG BEHNKEN

Publishing Company GRUNER & JAHR AG & CO.

"Samstag Nacht in Deutschland", (Saturday night in Germany), from a feature by Evelyn Holst in "Stern", March 1981.
56 "Goethe was good, but these boys and girls aren't bad either".
57 "A real rocker doesn't part with his leather jacket, even when totally drunk".

Photographe ANNE KOCH

Maquettiste WOLF DAMMANN

Directeur Artistique WOLFGANG BEHNKEN

Editeur GRUNER & JAHR AG & CO.

"Samstag Nacht in Deutschland", (Samedi soir en Allemagne), d'un article par Evelyn Holst dans "Stern", mars 1981.
56 "Goethe était bien, mais ces garçons et filles ne sont pas mal non plus".
57 "Un vrai rocker ne quitte pas son blouson de cuir, même en état d'ivresse totale".

Fotograf ANNE KOCH

Gestalter WOLF DAMMANN

Art Direktor WOLFGANG BEHNKEN

Verleger GRUNER & JAHR AG & CO.

"Samstag Nacht in Deutschland", für eine Reportage von Evelyn Holst, im "Stern", März 1981.
56 "Goethe war gut, aber diese Jungs und Mädel sind auch nicht schlecht".
57 "Ein echter Rocker trennt sich selbst im Vollrausch nicht von seiner Ledkrjacke".

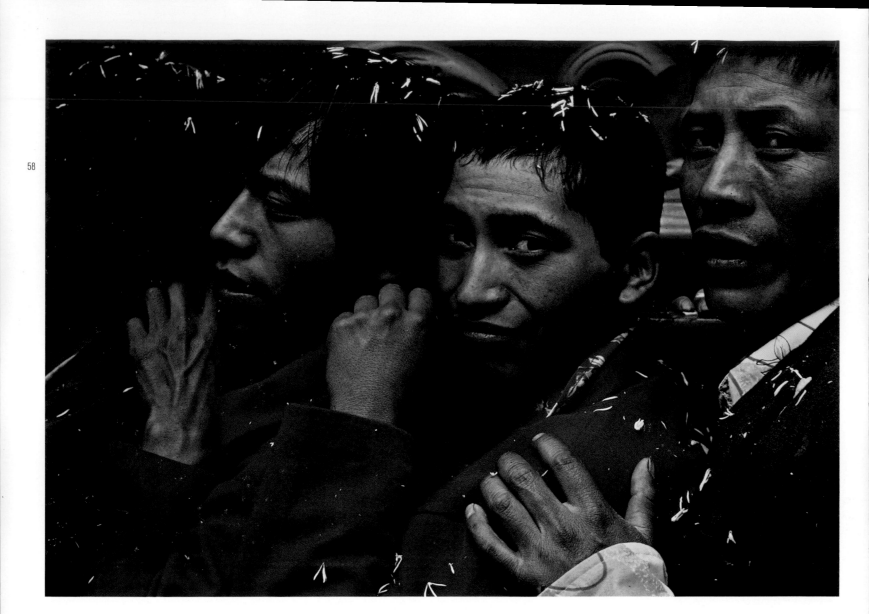

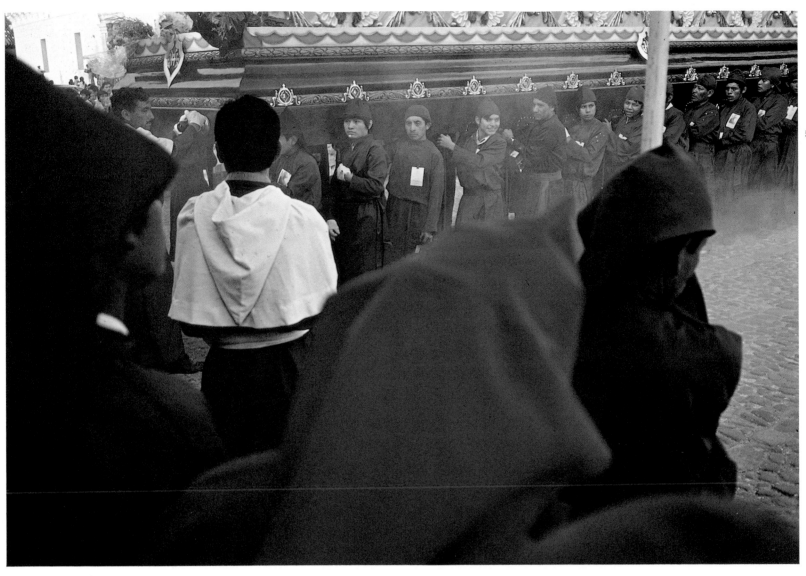

58, 59 Photographer GILLES PERESS

Publishing Company PUBLICATIONS PAUL MONTEL

Double-page spreads from a feature "Le Guatemala de Gilles Peress", (Gilles Peress' Guatemala), published in "Photo," January 1982.

Photographe GILLES PERESS

Editeur PUBLICATIONS PAUL MONTEL

Photographies sur deux pages d'un article "Le Guatemala de Gilles Peress", publiées dans "Photo," janvier 1982.

Fotograf GILLES PERESS

Verleger PUBLICATIONS PAUL MONTEL

Doppelseiten für die Reportage "Das Guatemala des Gilles Peress," veröffentlicht in "Photo," Januar 1982.

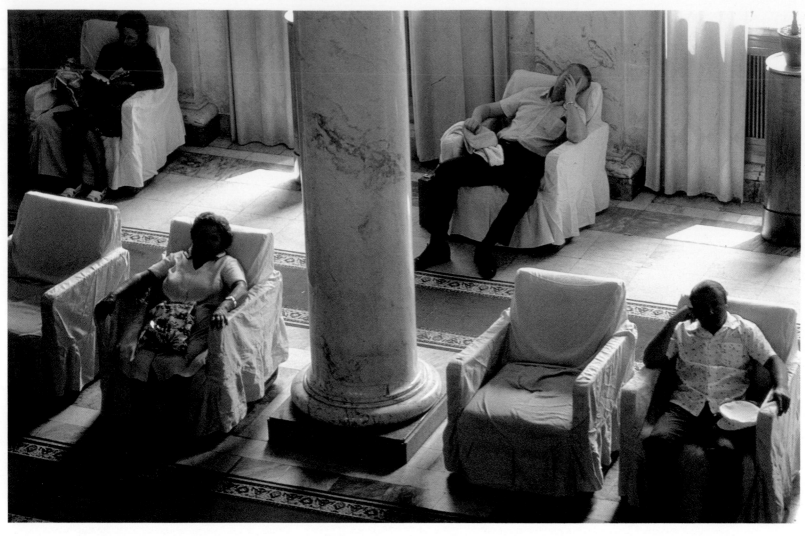

60, 61 Photographer PETER MARLOW

Designer JOHN TENNANT

Art Director MICHAEL RAND

Publishing Company TIMES NEWSPAPERS LIMITED

"Russia on Holiday", a feature by Roger Cooper in "The Sunday Times Magazine", September 1981.
60 Waiting for treatment at a Black Sea spa.
61 Hydrogen sulphide water treatment.

Photographe PETER MARLOW

Maquettiste JOHN TENNANT

Directeur Artistique MICHAEL RAND

Editeur TIMES NEWSPAPERS LIMITED

"Russia on Holiday" (La Russie en vacances), article de Roger Cooper dans "The Sunday Times Magazine", septembre 1981.
60 Attendant les soins dans une station thermale de la Mer Noire.
61 Soins aux eaux d'hydrogène sulfuré.

Fotograf PETER MARLOW

Gestalter JOHN TENNANT

Art Direktor MICHAEL RAND

Verleger TIMES NEWSPAPERS LIMITED

"Russia on Holiday" (Rußland auf Urlaub), eine Reportage von Roger Cooper in "The Sunday Times Magazine", September 1981.
60 Warten auf die Behandlung in einem Kurort am Schwarzen Meer.
61 Schwefelwasserstoff-Behandlung.

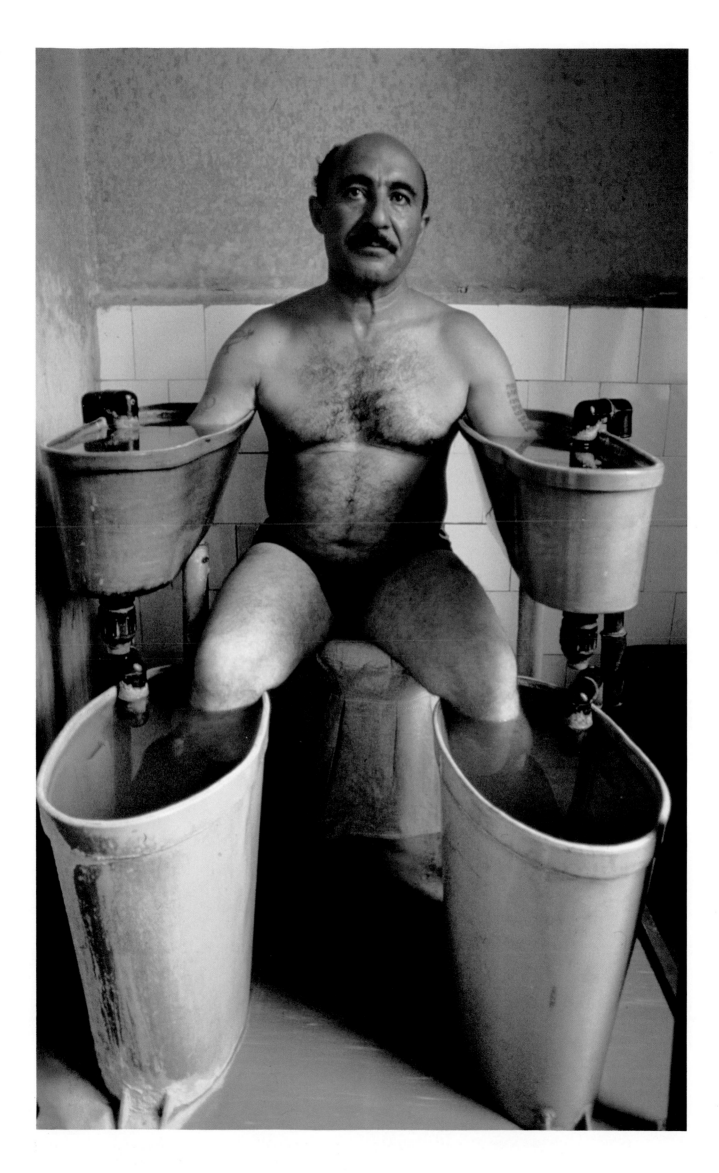

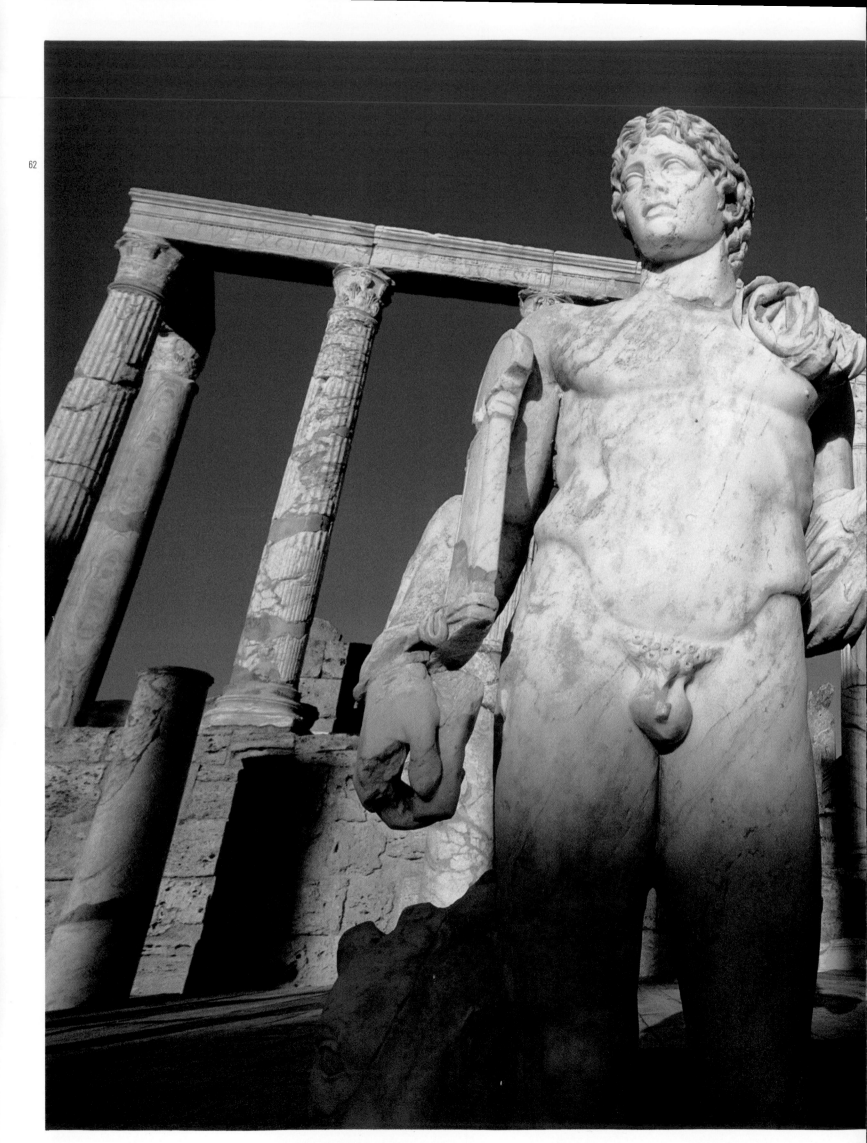

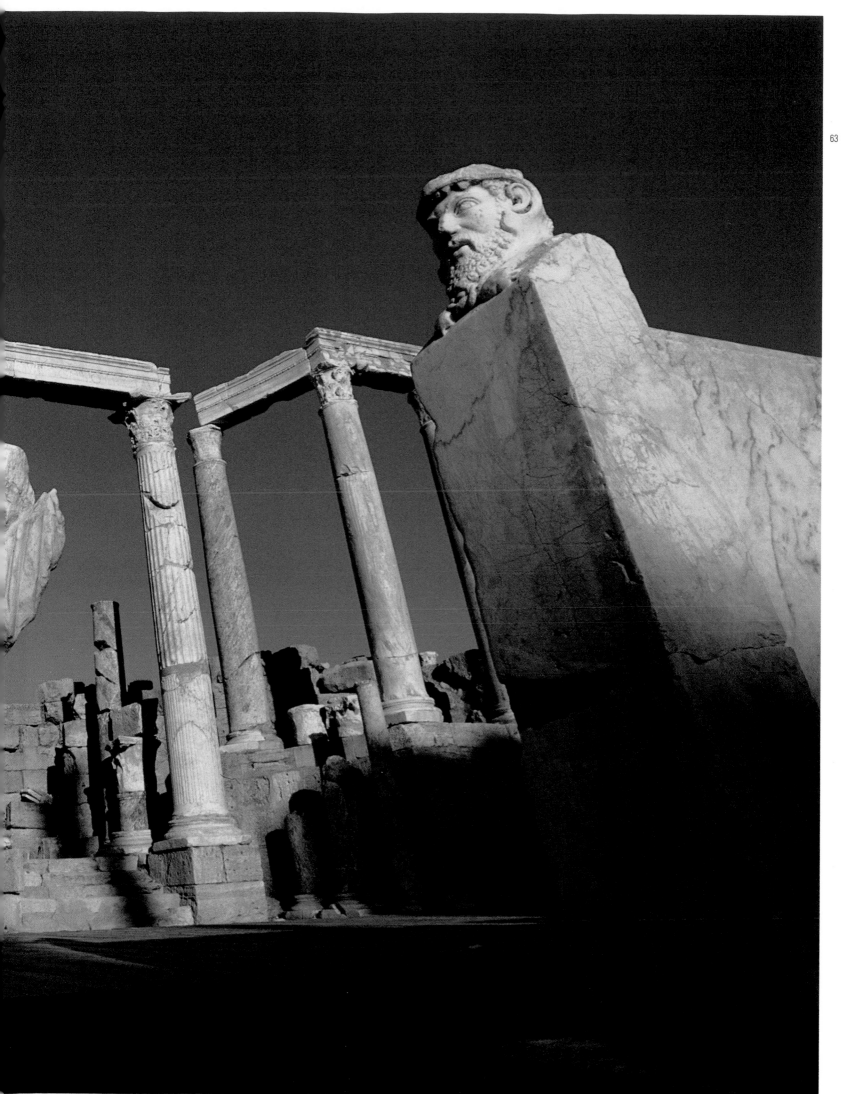

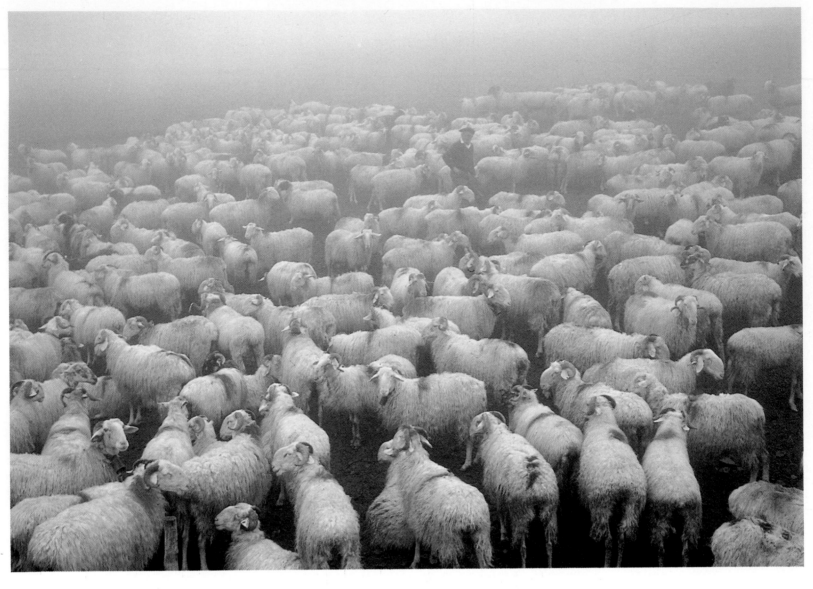

◄ **62, 63** Photographer ROBERT LEBECK

Designer HERBERT SUHR

Art Director ROLF GILLHAUSEN

Publishing Company GRUNER & JAHR AG & CO.

Photographe ROBERT LEBECK

Maquettiste HERBERT SUHR

Directeur Artistique ROLF GILLHAUSEN

Editeur GRUNER & JAHR AG & CO.

Fotograf ROBERT LEBECK

Gestalter HERBERT SUHR

Art Direktor ROLF GILLHAUSEN

Verleger GRUNER & JAHR AG & CO.

After years of neglect the Roman ruins of Leptis Magna are being restored. From a "Stern" supplement on Colonel Ghadafi's Libya.

Après des années d'abandon les ruines romaines de Leptis Magna commencent à être restaurées. D'un numéro supplémentaire de "Stern" sur la Libie du Colonel Khadafi.

Nach Jahren der Verwahrlosung werden die römischen Relikte in Leptis Magna restauriert. Aus einer "Stern" Beilage über Ghadafis Libyen.

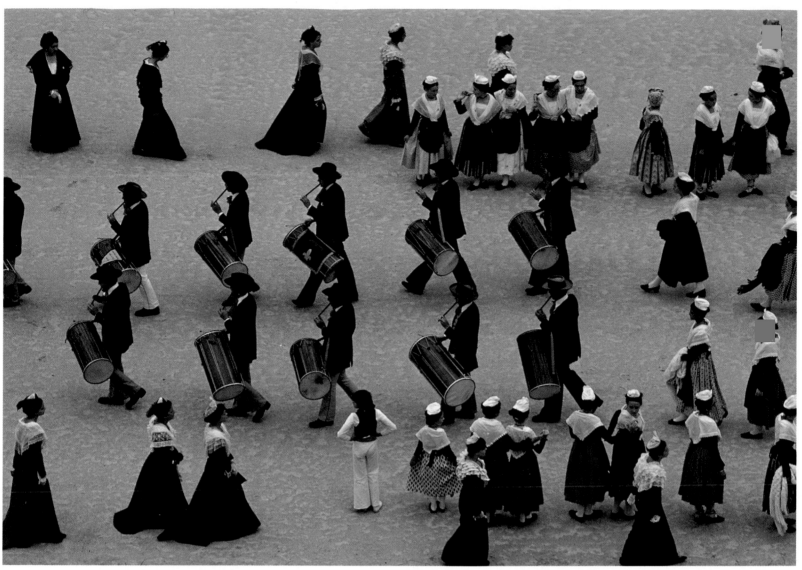

64, 65 Photographer HANS SILVESTER

Publishing Company PUBLICATIONS PAUL MONTEL

Double-page spreads from a feature "L'homme dans le paysage," (Man in landscape); "Photo," December 1981.
64 Sainte Engrâce, Pays Basque, France.
65 Arlesian women and musicians of Provence, Arles, France.

Photographe HANS SILVESTER

Editeur PUBLICATIONS PAUL MONTEL

Photographie sur deux pages tirée d'un article "L'homme dans le paysage," dans "Photo," décembre 1981.
64 Sainte Engrâce, Pays Basque, France.
65 Arlésiennes et musiciens de Provence, Arles, France

Fotograf HANS SILVESTER

Verleger PUBLICATIONS PAUL MONTEL

Doppelseiten für die Reportage "L'homme dans le paysage" (Der Mensch in der Landschaft); "Photo," Dezember 1981.
64 Sainte Engrâce, Pays Basque, Frankreich.
65 Frauen und Musiker der Provence, Arles, Frankreich.

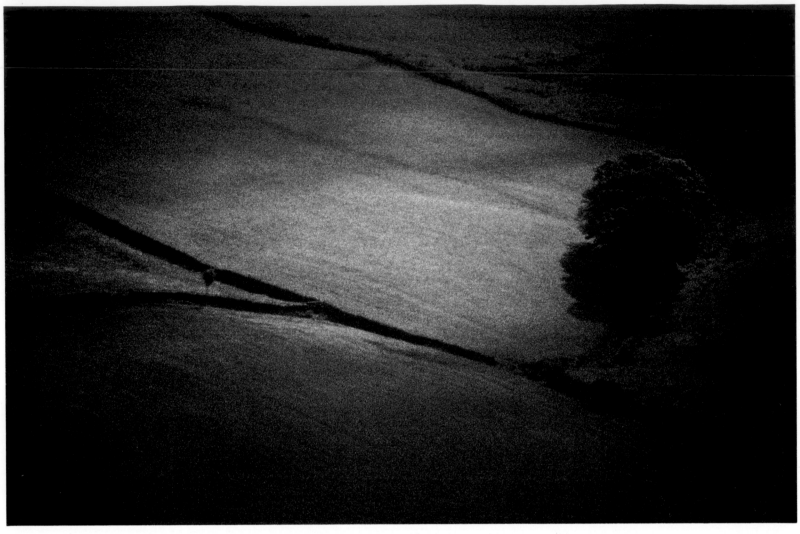

66 Photographer JOHN CLARIDGE

Photographe JOHN CLARIDGE

Fotograf JOHN CLARIDGE

Designer PETER HAYWARD

Maquettiste PETER HAYWARD

Gestalter PETER HAYWARD

Publishing Company
HAYMARKET PUBLISHING LIMITED

Editeur
HAYMARKET PUBLISHING LIMITED

Verleger
HAYMARKET PUBLISHING LIMITED

Taken in Yorkshire and used as part of a 5 page
feature on the photographer's work with text by Nigel
Skelsey which appeared in the magazine
"SLR Camera."

Prises dans le Yorkshire et utilisées pour un article de
cinq pages sur l'oeuvre du Photographe avec un texte
de Nigel Skelsey, qui a paru dans le magazine
"SLR Camera."

Aufgenommen in Yorkshire und eingesetzt innerhalb
einer 5-seitigen Reportage über das Werk des
Fotografen mit Text von Nigel Skelsey, erschienen in
der Zeitschrift "SLR Camera."

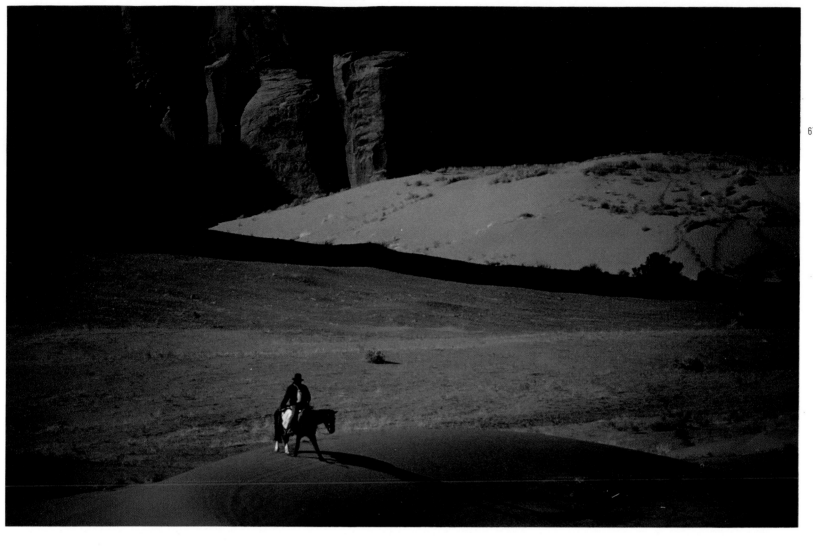

Photographer JOHN CLARIDGE	Photographe JOHN CLARIDGE	Fotograf JOHN CLARIDGE
Art Director MAURICE CORIAT	Directeur Artistique MAURICE CORIAT	Art Direktor MAURICE CORIAT
Publishing Company ZOOM MAGAZINE	Editeur ZOOM MAGAZINE	Verleger ZOOM MAGAZINE
Taken in the Arizona desert and published in "Zoom", with text by Michel Maingois.	Prise dans le désert de l'Arizona et publiée dans "Zoom", avec un texte de Michel Maingois.	Aufgenommen in der Wüste Arizonas und veröffentlicht in "Zoom", mit Text von Michel Maingois.

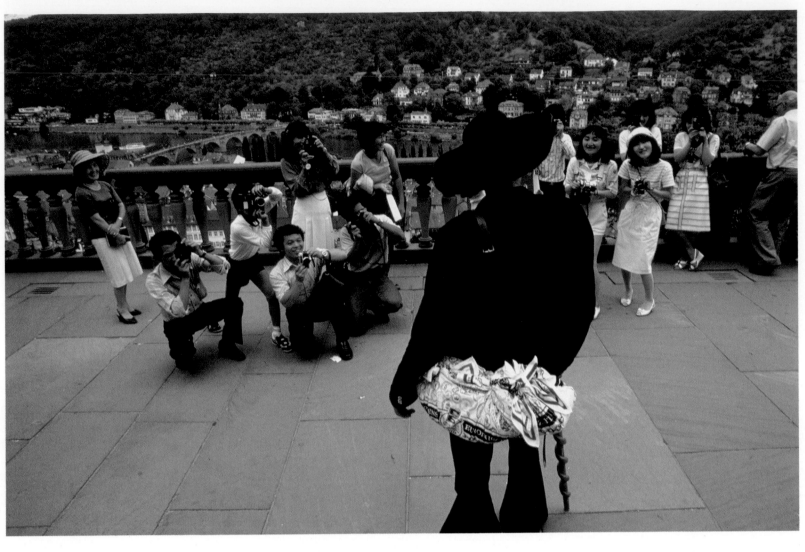

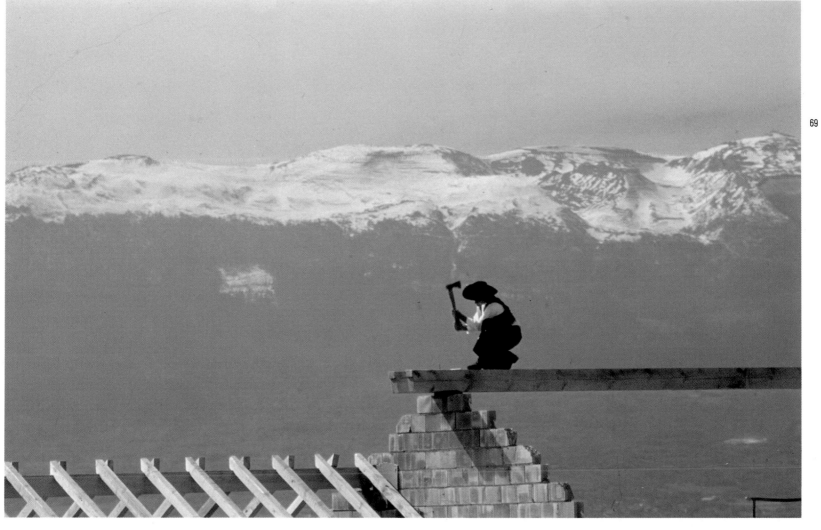

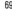

68, 69	Photographer MICHAEL LANGE	Photographe MICHAEL LANGE	Fotograf MICHAEL LANGE
	Designer JAN GÖRLICH	Maquettiste JAN GÖRLICH	Gestalter JAN GÖRLICH
	Art Director WOLFGANG BEHNKEN	Directeur Artistique WOLFGANG BEHNKEN	Art Direktor WOLFGANG BEHNKEN
	Publishing Company GRUNER & JAHR AG & CO.	Editeur GRUNER & JAHR AG & CO.	Verleger GRUNER & JAHR AG & CO.
	Double-page spreads from "Wanderburschen", (Travelling men), a feature in "Stern", October 1981. 68 "Walking stick and hat suit him well" 69 "For travelling men work is relaxation"	Photographies sur deux pages de "Wanderburschen", (Les hommes du voyage), article dans "Stern", octobre 1981. 68 "La canne et le chapeau lui vont bien" 69 "Pour les hommes qui voyagent le travail est une récréation"	Doppelseiten für "Wanderburschen", eine Reportage im "Stern", Oktober 1981. 68 "Stock und Hut steht ihm gut" 69 "Arbeit ist für Wanderburschen Erholung"

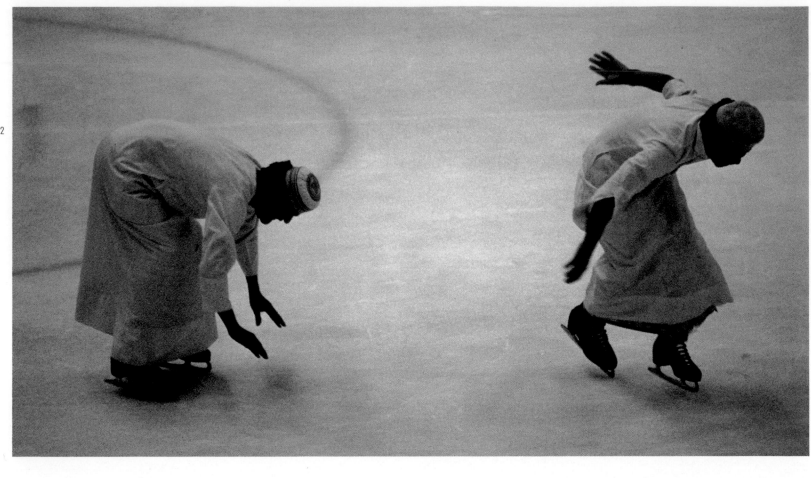

72 Photographer WALTER SCHMITZ	Photographe WALTER SCHMITZ	Fotograf WALTER SCHMITZ
Designer DIETMAR SCHULZE	Maquettiste DIETMAR SCHULTZE	Gestalter DIETMAR SCHULZE
Art Director ROLF GILLHAUSEN	Directeur Artistique ROLF GILLHAUSEN	Art Direktor ROLF GILLHAUSEN
Publishing Company GRUNER & JAHR AG & CO.	Editeur GRUNER & JAHR AG & CO.	Verleger GRUNER & JAHR AG & CO.
"Erste Schritte in die Eiszeit", (First steps into the ice age); from a feature, "Die Wüste spielt", (The desert at play), by Rolf Kunkel in "Stern".	"Erste Schritte in die Eiszeit", (Premiers pas dans l'age glaciaire); d'un article, "Die Wüste spielt", (Le désert au jeu), par Rolf Kunkel dans "Stern".	"Erste Schritte in die Eiszeit", für die Reportage "Die Wüste spielt" von Rolf Kunkel, im "Stern".

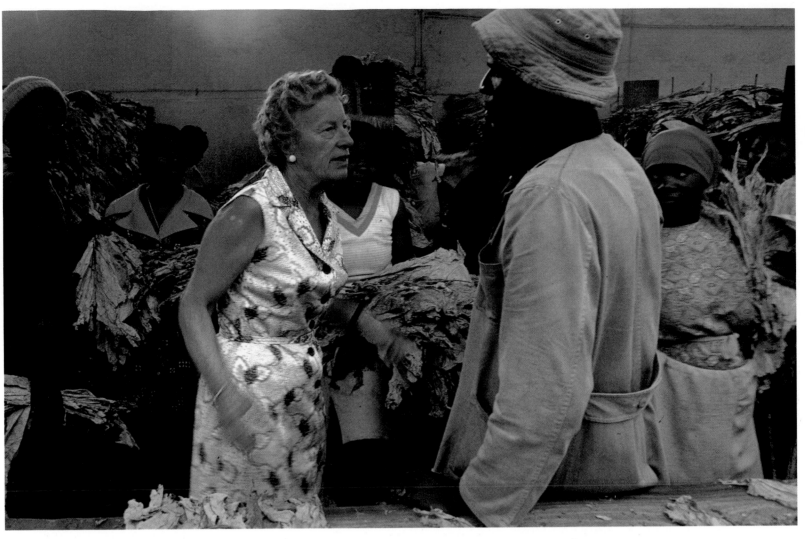

73 Photographer GEORG FISCHER

Designer PETER VOIGT

Publishing Company GRUNER & JAHR AG & CO.

Photographe GEORG FISCHER

Maquettiste PETER VOIGT

Editeur GRUNER & JAHR AG & CO.

Fotograf GEORG FISCHER

Gestalter PETER VOIGT

Verleger GRUNER & JAHR AG & CO.

"Der Frieden, der wie ein Wunder kam," (The peace that came about like a miracle); Brigitte Hoffman, a German plantation owner, photographed with tobacco farmers in Melfort, Zimbabwe, for a feature by Willy Lützenkirchen in "Geo."

"Der Frieden, der wie ein Wunder kam," (La paix qui est arrivée comme par miracle); Brigitte Hoffmann, propriétaire allemande d'une plantation, photographiée avec les cultivateurs de tabac à Melfort, Zimbabwe, pour un article de Willy Lützenkirchen dans "Geo."

"Der Frieden, der wie ein Wunder kam," Brigitte Hoffman, deutsche Plantagen-Besitzerin, fotografiert mit Tabak-Anbauern in Melfort, Zimbabwe, für eine Reportage von Willy Lützenkirchen in "Geo."

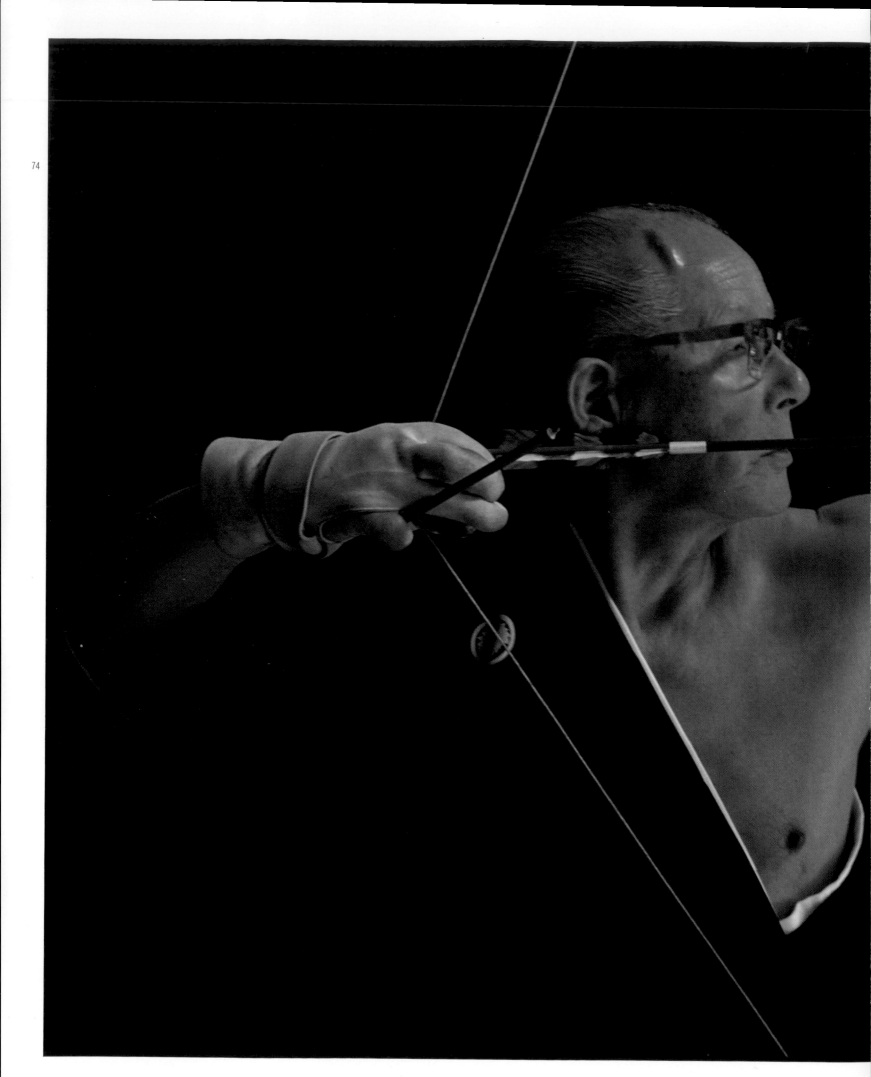

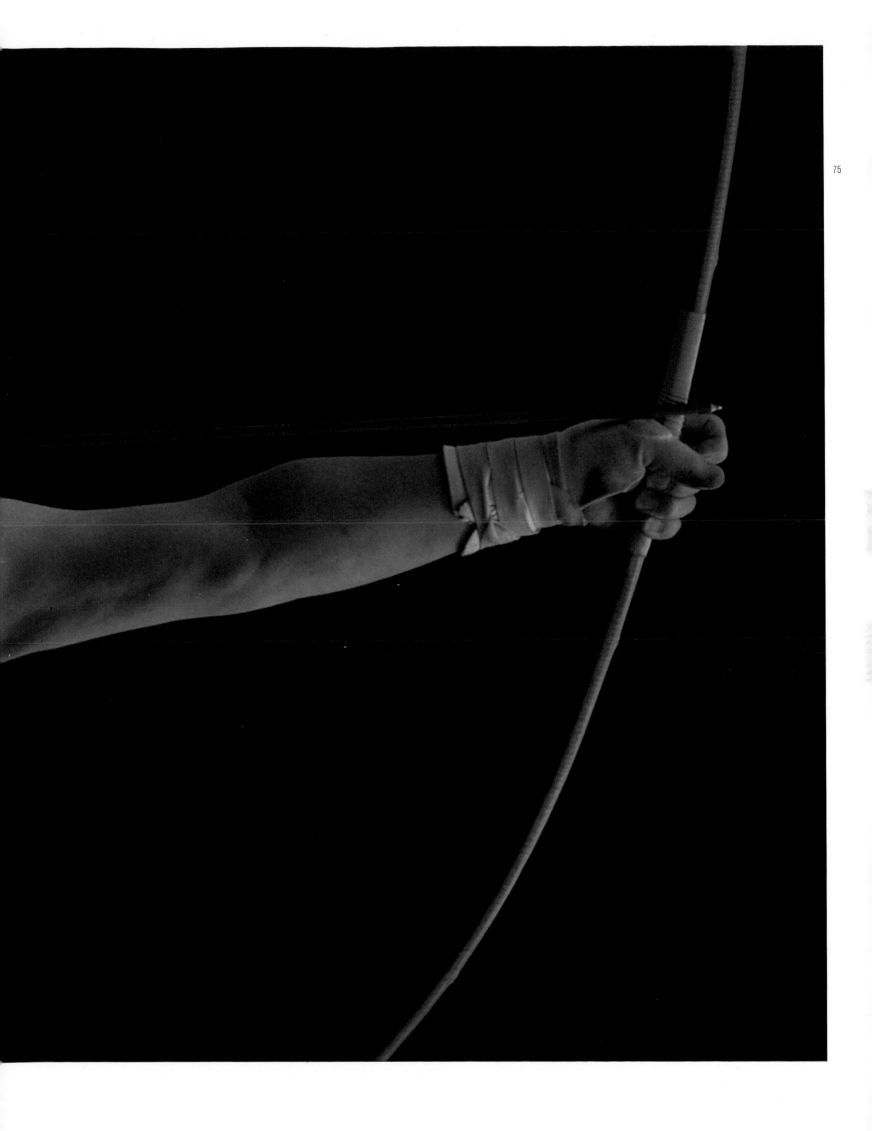

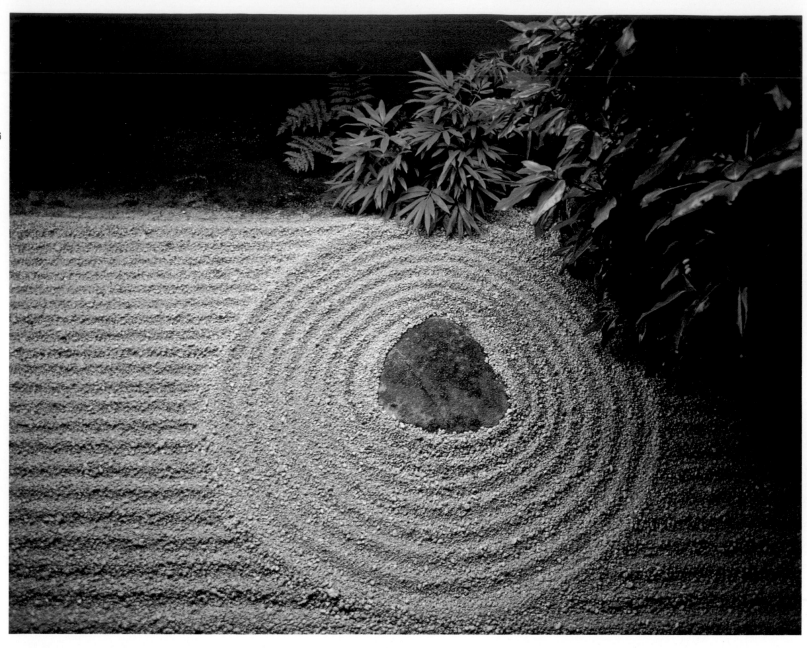

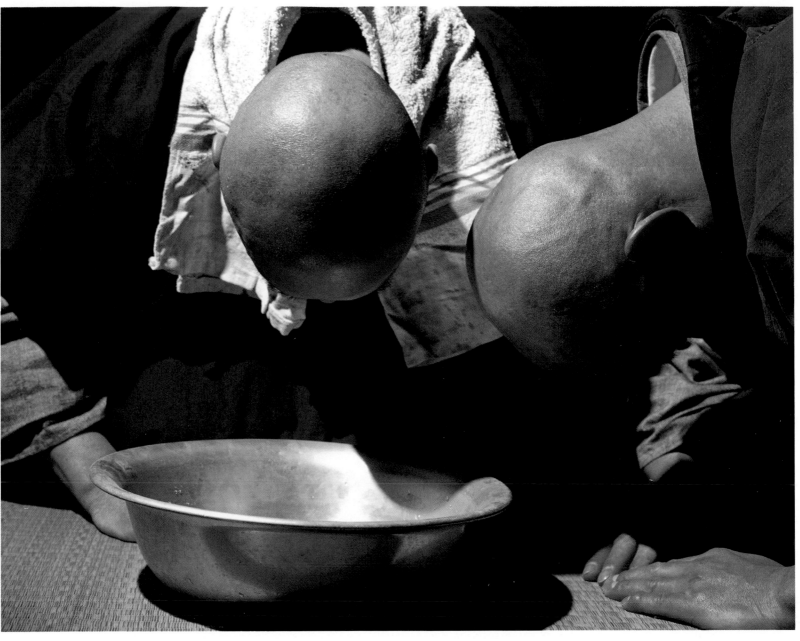

74-77 Photographer EBERHARD GRAMES | Photographe EBERHARD GRAMES | Fotograf EBERHARD GRAMES

Art Director SUSANNE WALSH | Directeur Artistique SUSANNE WALSH | Art Direktor SUSANNE WALSH

Publishing Company
KNAPP COMMUNICATIONS CORPORATION | Editeur
KNAPP COMMUNICATIONS CORPORATION | Verleger
KNAPP COMMUNICATIONS CORPORATION

Taken in Japanese monasteries for a feature by
Michael Disend, "Zen-Buddhism's Path to Serenity and
Joy", in "Geo", November 1981.
74, 75 Zen archer
76 Raked white gravel
77 Zen monks honour water before washing

Photographies prises dans des monastères japonais
pour un article de Michael Disend, "Zen-Buddhism's
Path to Serenity and Joy" (Le Chemin de la Sérénité et
de la Joie du Bouddhisme Zen); dans "Geo",
novembre 1981.
74, 75 Archer zen
76 Gravier blanc ratissé
77 Moines zen honorant l'eau avant de se laver

Aufgenommen in japanischen Klöstern für eine
Reportage von Michael Disend, "Zen-Buddhism's Path
to Serenity and Joy", (Der Weg des Zen-Buddhismus
zu Frieden und Freude); in Geo', November, 1981.
74, 75 Zen Bogenschütze
76 Geharkter weißer Kies
77 Zen Mönche ehren das Wasser vor dem Waschen

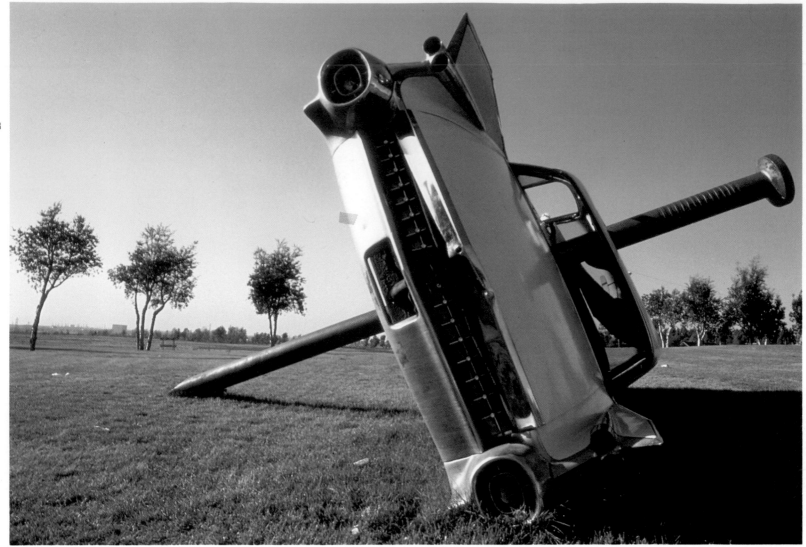

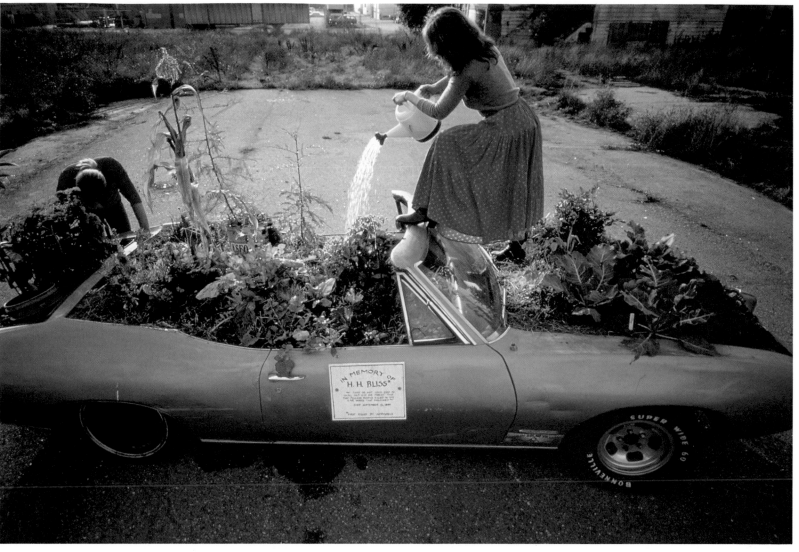

78 Photographer RENÉ BURRI	Photographe RENÉ BURRI	Fotograf RENÉ BURRI
79 Photographer BOB SENNETT	Photographe BOB SENNETT	Fotograf BOB SENNETT
Designer DIETMAR SCHULZE	Maquettiste DIETMAR SCHULZE	Gestalter DIETMAR SCHULZE
Art Director ROLF GILLHAUSEN	Directeur Artistique ROLF GILLHAUSEN	Art Direktor ROLF GILLHAUSEN
Publishing Company GRUNER & JAHR AG & CO.	Editeur GRUNER & JAHR AG & CO.	Verleger GRUNER & JAHR AG & CO.
"Das Ende der Saurier," (The demise of the dinosaurs), from a feature by Hans Werner in "Stern," May 1981. 78 "The end of an era"—A Cadillac with a two-ton nail driven through it by Californian artists. 79 Vegetables being grown in an old Pontiac in memory of Mr H.H. Bliss, the first road accident victim in the USA.	"Das Ende der Saurier," (La fin des dinosaures), d'un article par Hans Werner dans "Stern," mai 1981. 78 "La fin d'une époque"—Une Cadillac que des artistes Californiens ont transpercée d'un clou de deux tonnes. 79 Culture de légumes dans une vielle Pontiac à la mémoire de Mr H.H. Bliss, première victime d'un accident de la route aux Etats Unis.	"Das Ende der Saurier," für eine Reportage von Hans Werner im "Stern," Mai 1981. 78 "Das Ende einer Epoche"—Ein Cadillac, von kalifornischen Künstlern aufgespießt auf einen zwei Tonnen schweren Nagel. 79 Gemüsezucht in einem alten Pontiac zur Erinnerung an Mr H.H. Bliss, dem ersten Verkehrsopfer in den USA.

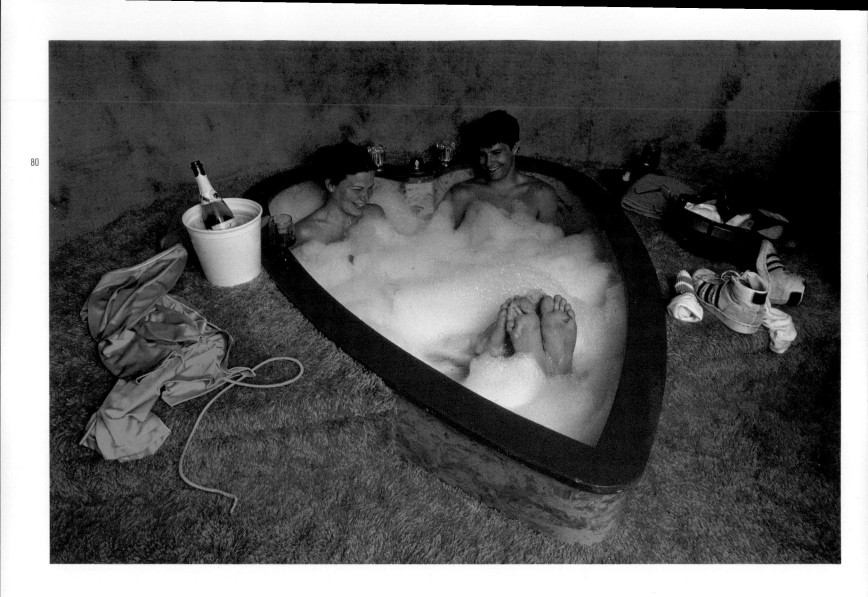

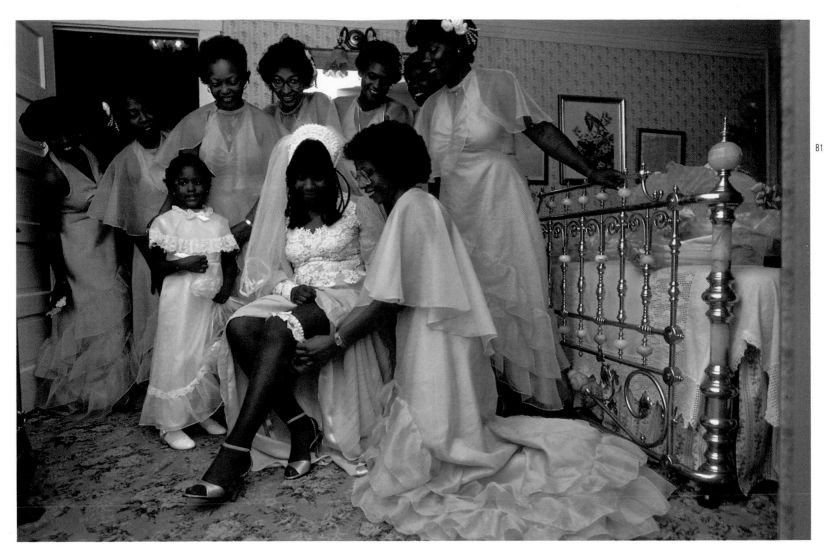

80, 81 Photographer VOLKER HINZ

Designer WALTER STRENGE

Art Director ROLF GILLHAUSEN

Publishing Company GRUNER & JAHR AG & CO.

Double-page spreads from a feature, "Hochzeit in amerikanisch," (Wedding American Style), by Emanuel Eckart in "Stern."
80 "Rosy times for ladies with heart."
81 "Coloureds like it colourful."

Photographe VOLKER HINZ

Maquettiste WALTER STRENGE

Directeur Artistique ROLF GILLHAUSEN

Editeur GRUNER & JAHR AG & CO.

Photographies sur deux pages prises d'un article "Hochzeit in amerikanisch," (Mariage à l'américaine), par Emanuel Eckart dans "Stern."
80 "Temps roses pour femmes de coeur."
81 "Les gens de couleur l'aiment coloré."

Fotograf VOLKER HINZ

Gestalter WALTER STRENGE

Art Direktor ROLF GILLHAUSEN

Verleger GRUNER & JAHR AG & CO.

Doppelseiten für die Reportage "Hochzeit in amerikanisch," von Emanuel Eckart, im "Stern."
80 "Rosa Zeiten für Herz-Damen."
81 "Die Farbigen lieben es bunt."

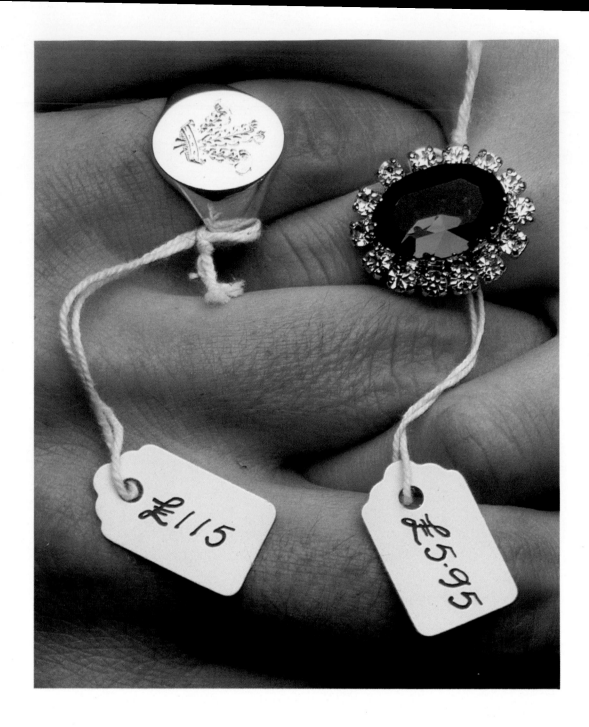

82 Photographer CLIVE ARROWSMITH Photographe CLIVE ARROWSMITH Fotograf CLIVE ARROWSMITH

Designer JOHN TENNANT Maquettiste JOHN TENNANT Gestalter JOHN TENNANT

Art Director MICHAEL RAND Directeur Artistique MICHAEL RAND Art Direktor MICHAEL RAND

Picture Editor JAMES DANZIGER Directeur de Photographie JAMES DANZIGER Bildredakteur JAMES DANZIGER

Publishing Company TIMES NEWSPAPERS LIMITED Editeur TIMES NEWSPAPERS LIMITED Verleger TIMES NEWSPAPERS LIMITED

Cover photograph for "The Sunday Times Magazine" from the issue dealing with the Royal Wedding industry; June, 1981. Photographie de couverture pour "The Sunday Times Magazine"du numéro relatif à l'industrie du Mariage Royal, juin 1981. Titel-Foto für "The Sunday Times Magazine" für die Ausgabe, in der über die Geschäfte im Zusammenhang mit der königlichen Hochzeit berichtet wurde; Juni 1981.

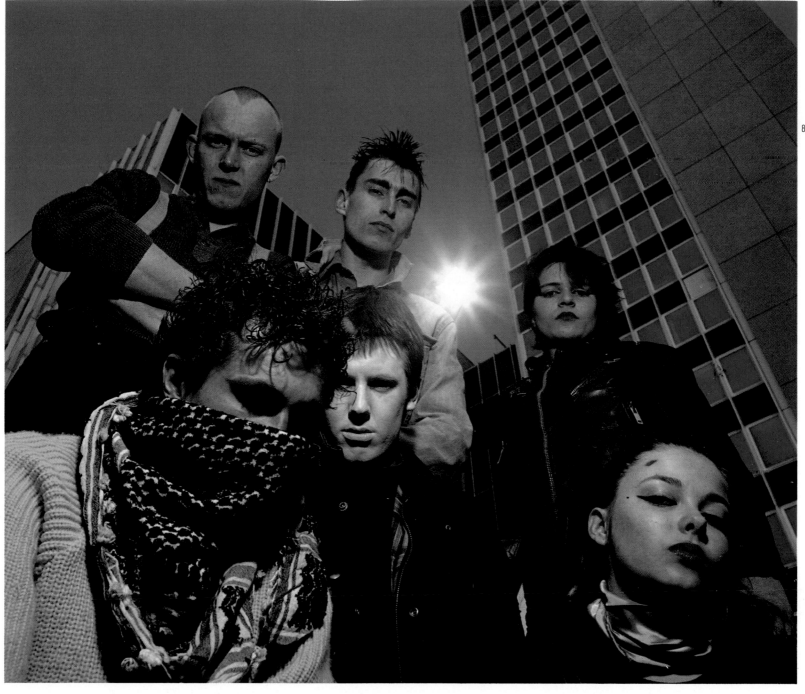

83 Photographer RED SAUNDERS	Photographe RED SAUNDERS	Fotograf RED SAUNDERS
Designer ROBERT PRIEST	Maquettiste ROBERT PRIEST	Gestalter ROBERT PRIEST
Art Director ROBERT PRIEST	Directeur Artistique ROBERT PRIEST	Art Direktor ROBERT PRIEST
Picture Editor JENNIFER CRANDALL	Directeur de Photographie JENNIFER CRANDALL	Bildredakteur JENNIFER CRANDALL
Publishing Company ESQUIRE PUBLISHING CO.	Editeur ESQUIRE PUBLISHING CO.	Verleger ESQUIRE PUBLISHING CO.
"Trashtime for Zurich," a feature by Craig Copetas concerning youth and violence in that city, published in "Esquire," July 1981.	"Trashtime for Zurich" (L'heure des Vauriens à Zurich), article de Craig Copetas relatif aux jeunes et à la violence dans cette ville, publié dans "Esquire," juillet 1981.	"Trashtime for Zurich" (Schund-Zeit für Zürich), eine Reportage von Craig Copetas über Jugendliche und Gewalttätigkeiten in der Stadt, veröffentlicht in "Esquire," Juli 1981.

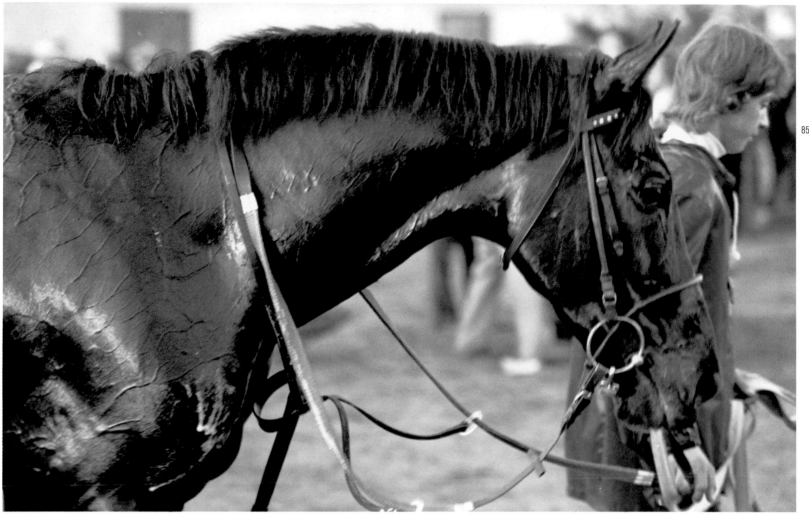

84	Photographer WALTER SCHMITZ	Photographe WALTER SCHMITZ	Fotograf WALTER SCHMITZ
85	Photographers GERD SCHAFFT/ HANS-JOACHIM ELLERBROCK	Photographes GERD SCHAFFT/ HANS-JOACHIM ELLERBROCK	Fotografen GERD SCHAFFT/ HANS-JOACHIM ELLERBROCK
	Designer JOHANNES DÖNGES	Maquettiste JOHANNES DÖNGES	Gestalter JOHANNES DÖNGES
	Publishing Company GRUNER & JAHR AG & CO.	Editeur GRUNER & JAHR AG & CO.	Verleger GRUNER & JAHR AG & CO.
	Steeplechasing at Pardubice, Czechoslovakia; double-page spreads from a feature "Tod am vierten Hindernis", (Death at the fourth fence), by Rolf Kunkel in "Geo".	Steeplechase à Pardubice, Tchécoslovaquie; photographies sur deux pages d'un article "Tod am vierten Hindernis", (Mort au quatrième obstacle), par Rolf Kunkel dans "Geo".	Hindernisrennen in Pardubice, Tschechoslowakei; Doppelseiten aus der Reportage "Tod am vierten Hindernis" von Rolf Kunkel, in "Geo".

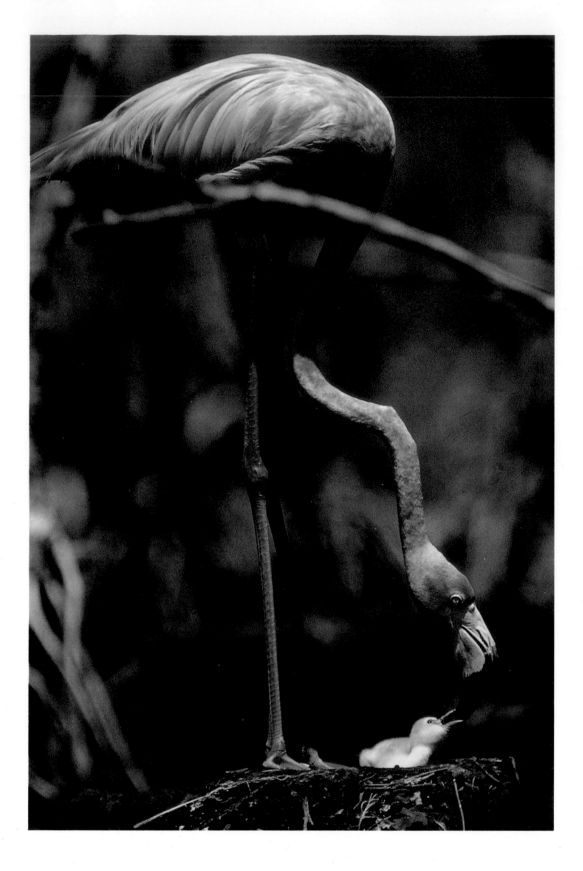

86-88 Photographer JEFF SIMON	Photographe JEFF SIMON	Fotograf JEFF SIMON
Designer MAX LENGWENUS	Maquettiste MAX LENGWENUS	Gestalter MAX LENGWENUS
Art Director ROLF GILLHAUSEN	Directeur Artistique ROLF GILLHAUSEN	Art Direktor ROLF GILLHAUSEN
Publishing Company GRUNER & JAHR AG & CO.	Editeur GRUNER & JAHR AG & CO.	Verleger GRUNER & JAHR AG & CO.
"Ein Vogel ohne Feinde," (A bird without enemies); double-page spreads from a "Stern" feature, July 1981.	"Ein Vogel ohne Feinde," (Un oiseau sans ennemis); photographie sur deux pages d'un article de "Stern," juillet 1981.	"Ein Vogel ohne Feinde," Doppelseiten für eine "Stern" Reportage, Juli 1981.

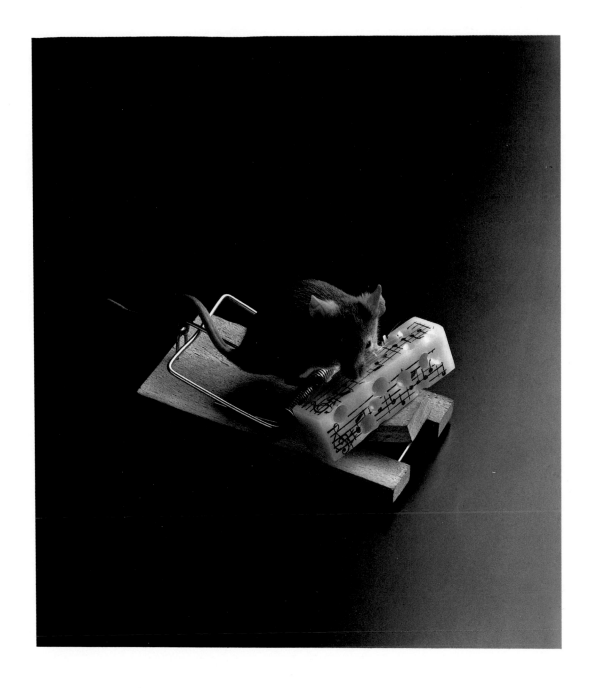

89 Photographer MAURICE SMITH

Designer YAN D. PENNORS

Art Director YAN D. PENNORS

Publishing Company
LE MONDE DE LA MUSIQUE TELERAMA

Cover photo for "Le Monde de la Musique" to illustrate
a feature by Louis Dandrel "N'ayez plus peur du
Solfège!" (No longer fear Music Theory!).

Photographe MAURICE SMITH

Maquettiste YAN D. PENNORS

Directeur Artistique YAN D. PENNORS

Editeur
LE MONDE DE LA MUSIQUE TELERAMA

Photographie de couverture pour "Le Monde de la
Musique" pour illustrer un article de Louis Dandrel;
"N'ayez plus peur du Solfège!"

Fotograf MAURICE SMITH

Gestalter YAN D. PENNORS

Art Direktor YAN D. PENNORS

Verleger
LE MONDE DE LA MUSIQUE TELERAMA

Titel-Foto für "Le Monde de la Musique" für eine
Reportage von Louis Dandrel "N'ayez plus peur du
Solfège!" (Keine Angst mehr vor Musik-Theorie!).

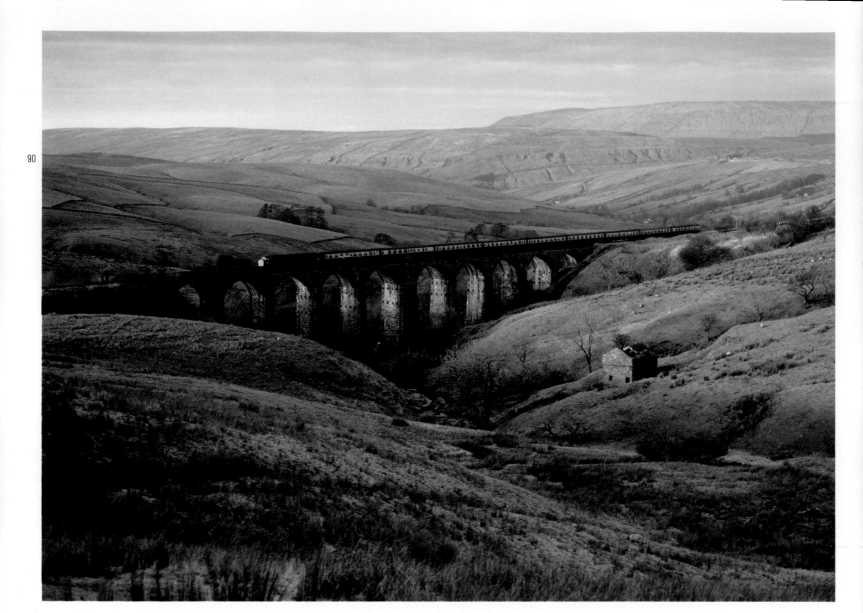

90 Photographer ALAIN LE GARSMEUR

Art Director GRAEME MURDOCH

Publishing Company THE OBSERVER MAGAZINE

Denthead Viaduct, Cumbria, photographed to illustrate the first of a series on Britain's Railways by Alexander Frater. "Part I: Settle to Carlisle, Wonder of the Northern World", used as the cover of "The Observer Magazine", February 1982.

Photographe ALAIN LE GARSMEUR

Directeur Artistique GRAEME MURDOCH

Editeur THE OBSERVER MAGAZINE

Le Viaduc de Denthead, Cumbria, photographié pour illustrer la premier article d'une série sur les Chemins Fer de Grande-Bretagne par Alexander Frater. "Part I: Settle to Carlisle, Wonder of the Northern World" (Première Partie: Installez-vous jusqu'à Carlisle, Merveille du Monde Septentrional) utilisée comme couverture de "The Observer Magazine", février 1982.

Fotograf ALAIN LE GARSMEUR

Art Direktor GRAEME MURDOCH

Verleger THE OBSERVER MAGAZINE

Denthead Viadukt, Cumbria, aufgenommen für den ersten Teil einer Serie über die Eisenbahn Großbritanniens von Alexander Frater "Part I: Settle to Carlisle, Wonder of the Northern World" (Teil I: Von Settle nach Carlisle, Wunder der nördlichen Welt), eingesetzt auf dem Titel von "The Observer Magazine", Februar 1982.

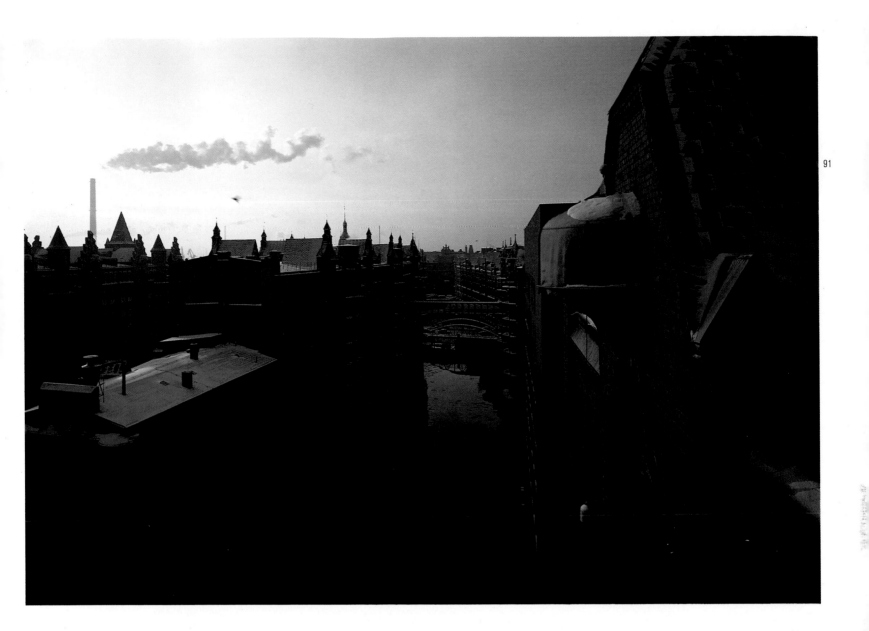

Photographer RICHARD FISCHER

Designer INGO GÖTZE

Art Director MANFRED MANKE

Publishing Company
ZEITVERLAG GERD BUCERIUS KG

Double-page spread of Hamburg for a feature by
Angelica Grimm, "Rote Stadt am Fleet", (Red city on
the waterway); "Zeitmagazin", March 1982.

Photographe RICHARD FISCHER

Maquettiste INGO GÖTZE

Directeur Artistique MANFRED MANKE

Editeur
ZEITVERLAG GERD BUCERIUS KG

Photographie sur deux pages de Hambourg pour un
article par Angelica Grimm, "Rote Stadt am Fleet",
(Ville rouge sur la voie d'eau); "Zeitmagazin",
mars 1982.

Fotograf RICHARD FISCHER

Gestalter INGO GÖTZE

Art Direktor MANFRED MANKE

Verleger
ZEITVERLAG GERD BUCERIUS KG

Doppelseitige Aufnahme von Hamburg für die
Reportage "Rote Stadt am Fleet" von Angelica Grimm;
"Zeitmagazin", März 1982.

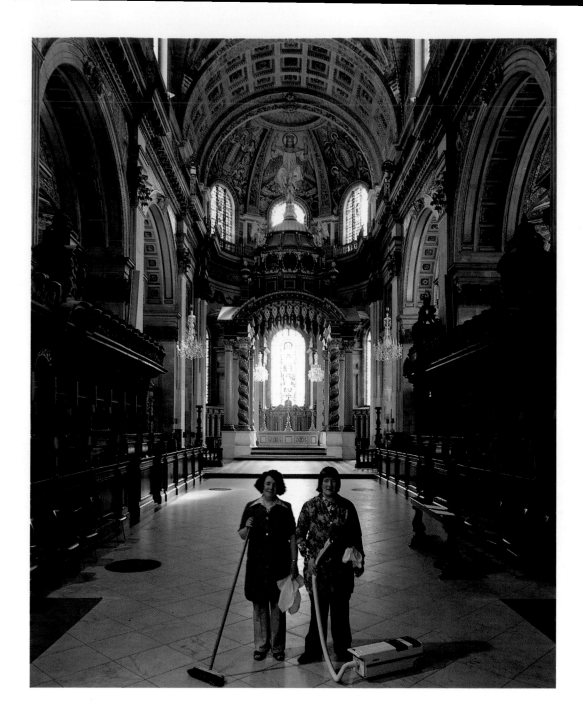

92 Photographer DENIS WAUGH

Designer BOB CIANO

Art Director BOB CIANO

Picture Editor JOHN LOENGARD

Publishing Company TIME-LIFE INC.

Cleaning ladies at St. Paul's Cathedral, London, part of a feature by Gail Ridgwell—"Prince Charles' Private World: A Rich Life in Royal Style," in "Life," July 1981. Subsequently used as the cover of "The Sunday Times Magazine," July 1981.

Photographe DENIS WAUGH

Maquettiste BOB CIANO

Directeur Artistique BOB CIANO

Directeur de Photographie JOHN LOENGARD

Editeur TIME-LIFE INC.

Femmes d'ménage à la Cathédrale St. Paul, Londres, partie d'un article par Gail Ridgwell—"Prince Charles' Private World: A Rich Life in Royal Style" (Le Monde Privé du Prince Charles: Une Vie Riche dans le Style Royal); dans "Life," juillet 1981. Utilisée par la suite comme couverture de "The Sunday Times Magazine," juillet 1981.

Fotograf DENIS WAUGH

Gestalter BOB CIANO

Art Direktor BOB CIANO

Bildredakteur JOHN LOENGARD

Verleger TIME-LIFE INC.

Putzfrauen in St. Paul's Cathedral, London, Teil einer Reportage von Gail Ridgwell—"Prince Charles' Private World: A Rich Life in Royal Style" (Prinz Charles private Welt: Wohlhabendes Leben im königlichen Stil); erschienen in "Life," Juli 1981. Ebenfalls veröffentlicht auf dem Titelblatt von "The Sunday Times Magazine," Juli 1981.

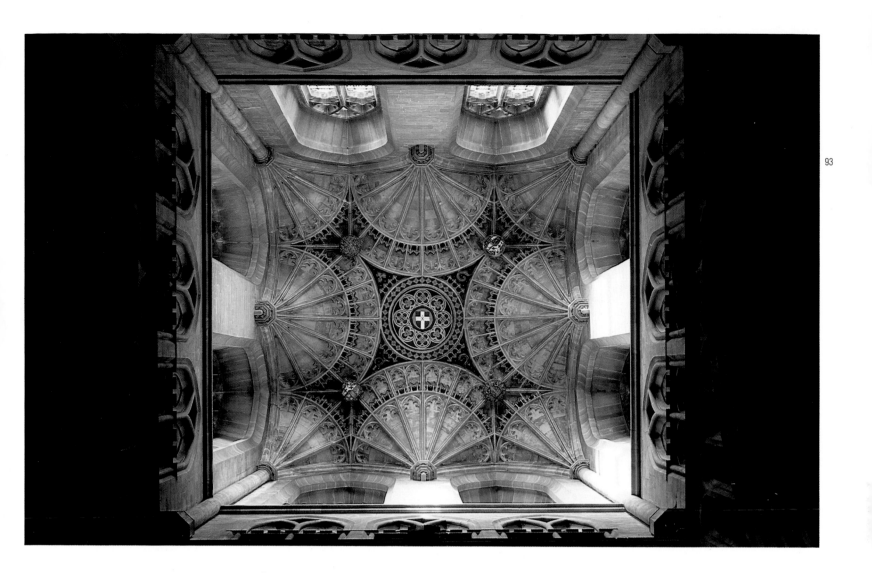

93 Photographer DENIS WAUGH	Photographe DENIS WAUGH	Fotograf DENIS WAUGH
Designer BOB CIANO	Maquettiste BOB CIANO	Gestalter BOB CIANO
Art Director BOB CIANO	Directeur Artistique BOB CIANO	Art Direktor BOB CIANO
Picture Editor JOHN LOENGARD	Directeur de Photographie JOHN LOENGARD	Bildredakteur JOHN LOENGARD
Publishing Company TIME-LIFE INC.	Editeur TIME-LIFE INC.	Verleger TIME-LIFE INC.
"Canterbury Cathedral", part of a Christmas feature in "Life", December 1981, showing the ceiling of Bell Harry Tower.	"Canterbury Cathedral" (La Cathédrale de Cantorbéry), partie d'un article de Noel dans "Life", décembre 1981, montrant le plafond de la Bell Harry Tower.	"Canterbury Cathedral", Teil einer Weihnachts-Reportage in "Life", Dezember 1981, eine Aufnahme des Gewölbes des Bell Harry Turms.

Photographer TESSA TRAEGER	Photographe TESSA TRAEGER	Fotograf TESSA TRAEGER
Designer TESSA TRAEGER	Maquettiste TESSA TRAEGER	Gestalter TESSA TRAEGER
Art Director SUSAN MANN	Directeur Artistique SUSAN MANN	Art Direktor SUSAN MANN
Publishing Company CONDÉ NAST PUBLICATIONS LIMITED	Editeur CONDÉ NAST PUBLICATIONS LIMITED	Verleger CONDÉ NAST PUBLICATIONS LIMITED
A selection of take-away food on paper plates photographed against a background painting by Terry Stratton for Arabella Boxer's food series in English "Vogue", June 1981.	Une sélection d'aliments à emporter sur assiettes de papier photographiée avec en arrière plan un tableau de Terry Stratton pour la série d'articles sur la nourriture par Arabella Boxer dans le "Vogue" anglais, juin 1981.	Eine Auswahl von Imbiß-Gerichten auf Papptellern, fotografiert vor einem Gemälde von Terry Stratton für Arabella Boxers Serie über Essen und Trinken in der englischen "Vogue" Ausgabe, Juni 1981.

94, 95 ▶

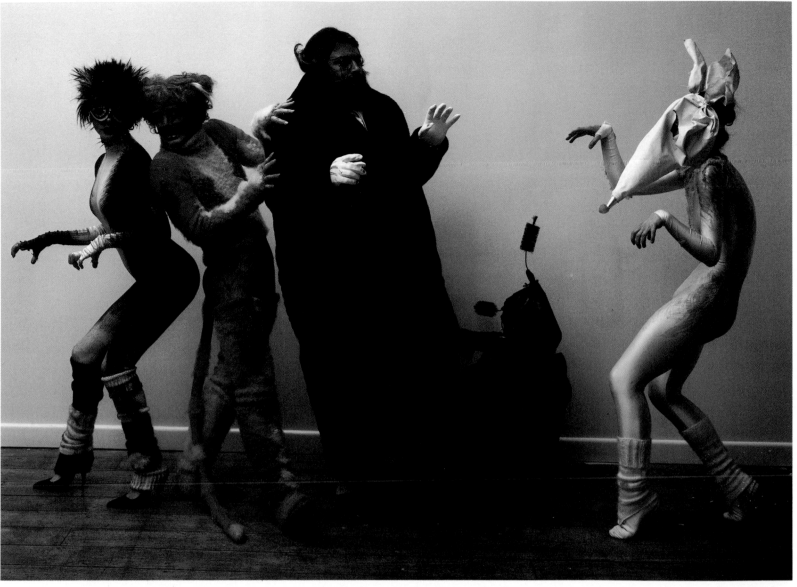

97 Photographer ROLPH GOBITS

Designer DAVID HILLMAN

Art Director DAVID HILLMAN

Publishing Company
SUNDAY EXPRESS NEWSPAPERS LIMITED

"Feline Fancy," a feature by Rachel Gould on Andrew Lloyd-Webber's musical "Cats," in "The Sunday Express Magazine," April 1981.

◀ **96** Photographer ROLPH GOBITS

Designer DAVID HILLMAN

Art Director DAVID HILLMAN

Publishing Company
SUNDAY EXPRESS NEWSPAPERS LIMITED

A photograph to illustrate Sight taken from a feature by Brian Inglis, "The Senses," published in "The Sunday Express Magazine," May 1981.

Photographe ROLPH GOBITS

Maquettiste DAVID HILLMAN

Directeur Artistique DAVID HILLMAN

Editeur
SUNDAY EXPRESS NEWSPAPERS LIMITED

"Feline Fancy" (Fantaisie féline), un article de Rachel Gould sur la comédie musicale "Cats" de Andrew Lloyd-Webber; dans "The Sunday Express Magazine," avril 1981.

Photographe ROLPH GOBITS

Maquettiste DAVID HILLMAN

Directeur Artistique DAVID HILLMAN

Editeur
SUNDAY EXPRESS NEWSPAPERS LIMITED

Une photographie pour illustrer La Vue prise d'un article par Brian Inglis, "The Senses" (Les Sens), publié dans "The Sunday Express Magazine," mai 1981.

Fotograf ROLPH GOBITS

Gestalter DAVID HILLMAN

Art Direktor DAVID HILLMAN

Verleger
SUNDAY EXPRESS NEWSPAPERS LIMITED

"Feline Fancy" (Katzen-Fantasie), eine Reportage von Rachel Gould über das Musical "Cats" von Andrew Lloyd-Webber; in "The Sunday Express Magazine," April 1981.

Fotograf ROLPH GOBITS

Gestalter DAVID HILLMAN

Art Direktor DAVID HILLMAN

Verleger
SUNDAY EXPRESS NEWSPAPERS LIMITED

Ein Foto zur Illustration des Sehvermögens für eine Reportage von Brian Inglis, "The Senses" (Die Sinnesorgane), veröffentlicht in "The Sunday Express Magazine," Mai 1981.

99 Photographer ROLPH GOBITS

Designer DAVID HILLMAN

Art Director DAVID HILLMAN

Publishing Company
SUNDAY EXPRESS NEWSPAPERS LIMITED

Kenneth Connor as Sarah the Cook in the pantomime "Robinson Crusoe", from a feature by John Walker "There is nothing like a Dame", in "The Sunday Express Magazine", December 1981.

◀ **98** Designer JOHN TENNANT

Picture Editor JAMES DANZIGER

Publishing Company TIMES NEWSPAPERS LIMITED

Joan Collins in a photo booth for a feature by James Danziger, "Me by Myself: An Experiment in Self-portrait Photography", published in "The Sunday Times Magazine", February 1981.

Photographe ROLPH GOBITS

Maquettiste DAVID HILLMAN

Directeur Artistique DAVID HILLMAN

Editeur
SUNDAY EXPRESS NEWSPAPERS LIMITED

Kenneth Connor dans le rôle de Sarah la Cuisinière dans la revue- féerie "Robinson Crusoe", tirée d'un article par John Walker "There is nothing like a Dame" (Il n'y a rien de tel qu'une 'Dame'); dans "The Sunday Express Magazine", décembre 1981.

Maquettiste JOHN TENNANT

Directeur de Photographie JAMES DANZIGER

Editeur TIMES NEWSPAPERS LIMITED

Joan Collins dans une cabine de photo pour un article de James Danziger, "Me by Myself: An Experiment in Self-portrait Photography" (Moi par moi-même: Un essai dans la photographie de l'auto-portrait), publiée dans "The Sunday Times Magazine", fevrier 1981.

Fotograf ROLPH GOBITS

Gestalter DAVID HILLMAN

Art Direktor DAVID HILLMAN

Verleger
SUNDAY EXPRESS NEWSPAPERS LIMITED

Kenneth Connor als die Köchin Sarah in der Pantomime "Robinson Crusoe", für eine Reportage von John Walker "There is nothing like a Dame" (Nichts ist vergleichbar mit einer Dame); in "The Sunday Express Magazine", Dezember 1981.

Gestalter JOHN TENNANT

Bildredakteur JAMES DANZIGER

Verleger TIMES NEWSPAPERS LIMITED

Joan Collins in einem Foto-Kiosk für eine Reportage von James Danziger, "Me by Myself: An Experiment in Self-portrait Photography" (Ich, von mir selbst: Ein Experiment in Selbstportraits), veröffentlicht in "The Sunday Times Magazine", Februar 1981.

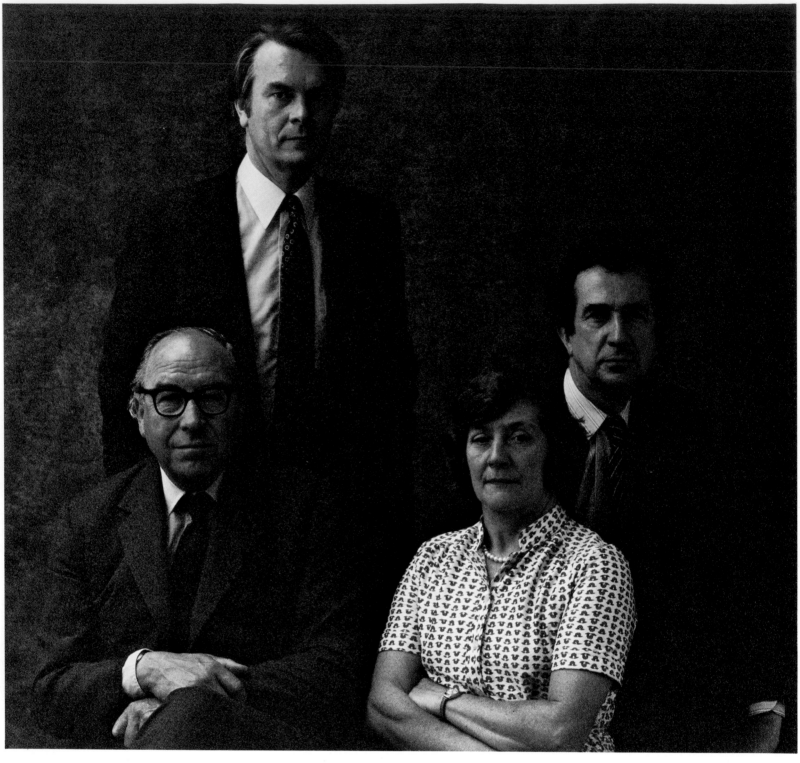

100 Photographer SNOWDON | Photographe SNOWDON | Fotograf SNOWDON

Designer JOHN TENNANT | Maquettiste JOHN TENNANT | Gestalter JOHN TENNANT

Art Director MICHAEL RAND | Directeur Artistique MICHAEL RAND | Art Direktor MICHAEL RAND

Publishing Company TIMES NEWSPAPERS LIMITED | Editeur TIMES NEWSPAPERS LIMITED | Verleger TIMES NEWSPAPERS LIMITED

"The Birth of the S.D.P.," a feature by Andrew Stephen in "The Sunday Times Magazine," September 1981. From left to right: Roy Jenkins, David Owen, Shirley Williams and Bill Rodgers. | "The Birth of the S.D.P.," (La naissance du S.D.P.), article par Andrew Stephen dans "The Sunday Times Magazine," septembre 1981. De gauche à droite: Roy Jenkins, David Owen, Shirley Williams et Bill Rodgers. | "The Birth of the S.D.P.," (Die Geburt der S.D.P.), eine Reportage von Andrew Stephen in "The Sunday Times Magazine," September 1981. Von links nach rechts: Roy Jenkins, David Owen, Shirley Williams und Bill Rodgers.

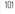

Photographer DAVID MONTGOMERY Photographe DAVID MONTGOMERY Fotograf DAVID MONTGOMERY

Designer LUCY SISMAN Maquettiste LUCY SISMAN Gestalter LUCY SISMAN

Art Director MICHAEL RAND Directeur Artistique MICHAEL RAND Art Direktor MICHAEL RAND

Publishing Company TIMES NEWSPAPERS LIMITED Editeur TIMES NEWSPAPERS LIMITED Verleger TIMES NEWSPAPERS LIMITED

Double-page spread from a feature by Jilly Cooper, "The Cruel Common Entrance," in "The Sunday Times Magazine," May 1981. Photographie sur deux pages pour un article de Jilly Cooper, "The Cruel Common Entrance" (Le cruel examen d'entrée), dans "The Sunday Times Magazine," mai 1981. Doppelseite für eine Reportage von Jilly Cooper, "The Cruel Common Entrance" (Die grausame 'Common Entrance' Aufnahmeprüfung), in "The Sunday Times Magazine," Mai 1981.

Photographer HELMUT NEWTON	Photographe HELMUT NEWTON	Fotograf HELMUT NEWTON
Designer APRIL SILVER	Maquettiste APRIL SILVER	Gestalter APRIL SILVER
Art Director ROBERT PRIEST	Directeur Artistique ROBERT PRIEST	Art Direktor ROBERT PRIEST
Picture Editor JENNIFER CRANDALL	Directeur de Photographie JENNIFER CRANDALL	Bildredakteur JENNIFER CRANDALL
Publishing Company ESQUIRE PUBLISHING CO.	Editeur ESQUIRE PUBLISHING CO.	Verleger ESQUIRE PUBLISHING CO.
"The Quotable Donald Sutherland" photographed in California for a feature by Carol Caldwell in "Esquire," March 1981.	"The Quotable Donald Sutherland" (Donald Sutherland, digne d'être cité), photographié en Californie pour un article par Carol Caldwell dans "Esquire," mars 1981.	"The Quotable Donald Sutherland" (Der zitierbare Donald Sutherland), aufgenommen in Kalifornien für eine Reportage von Carol Caldwell, in "Esquire," März 1981.

Photographer PHILIP SAYER	Photographe PHILIP SAYER	Fotograf PHILIP SAYER
Designer MUNEY RIVERS	Maquettiste MUNEY RIVERS	Gestalter MUNEY RIVERS
Art Director ROBERT PRIEST	Directeur Artistique ROBERT PRIEST	Art Direktor ROBERT PRIEST
Picture Editor JENNIFER CRANDALL	Directeur de Photographie JENNIFER CRANDALL	Bildredakteur JENNIFER CRANDALL
Publishing Company ESQUIRE PUBLISHING CO.	Editeur ESQUIRE PUBLISHING CO.	Verleger ESQUIRE PUBLISHING CO.
Philip Roth photographed at Chichester Theatre, Sussex, for a feature by Alain Finkielkraut, "The Ghosts of Roth"; in "Esquire," September 1981.	Philip Roth photographié au Théâtre de Chichester, Sussex, pour un article de Alain Finkielkraut, "The Ghosts of Roth" (Les fantômes de Roth), dans "Esquire," septembre 1981.	Philip Roth, aufgenommen im Chichester Theater, Sussex, für eine Reportage von Alain Finkielkraut, "The Ghosts of Roth" (Die Geister des Roth); in "Esquire," September 1981.

103 ▶

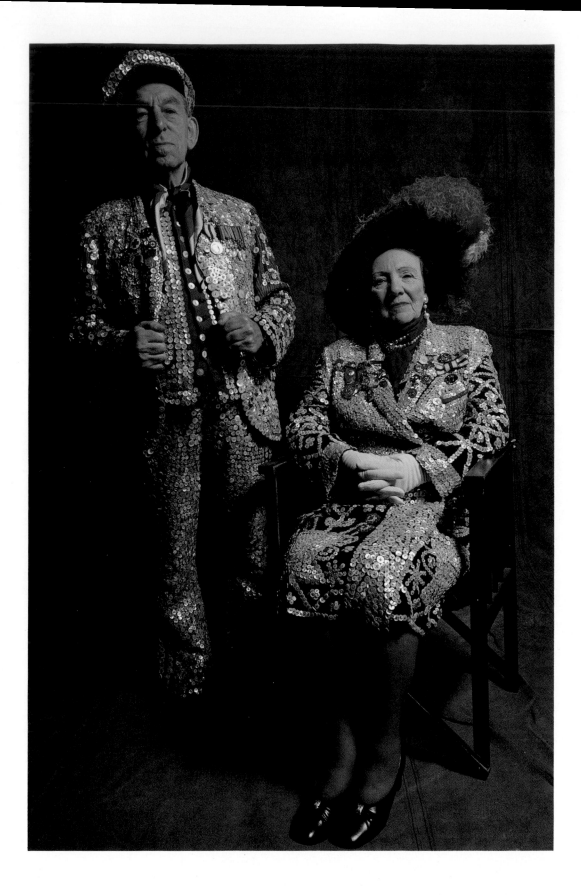

104 Photographer JOHN CLARIDGE

Art Director ADRIAN TAYLOR

Publishing Company
AMERICAN EXPRESS PUBLISHING CORPORATION

Studio shot of the Pearly King and Queen used in an
article on Londoners written by Judith Friedberg;
published in "Travel and Leisure".

Photographe JOHN CLARIDGE

Directeur Artistique ADRIAN TAYLOR

Editeur
AMERICAN EXPRESS PUBLISHING CORPORATION

Photographie de studio des Pearly King et Queen
utilisée dans un article sur les Londoniens écrit par
Judith Friedberg; publié dans "Travel and Leisure".

Fotograf JOHN CLARIDGE

Art Direktor ADRIAN TAYLOR

Verleger
AMERICAN EXPRESS PUBLISHING CORPORATION

Studio-Aufnahme des Perlenkönigs und seiner Königin,
eingesetzt in einer Reportage über Londoner von
Judith Friedberg; veröffentlicht in "Travel and Leisure".

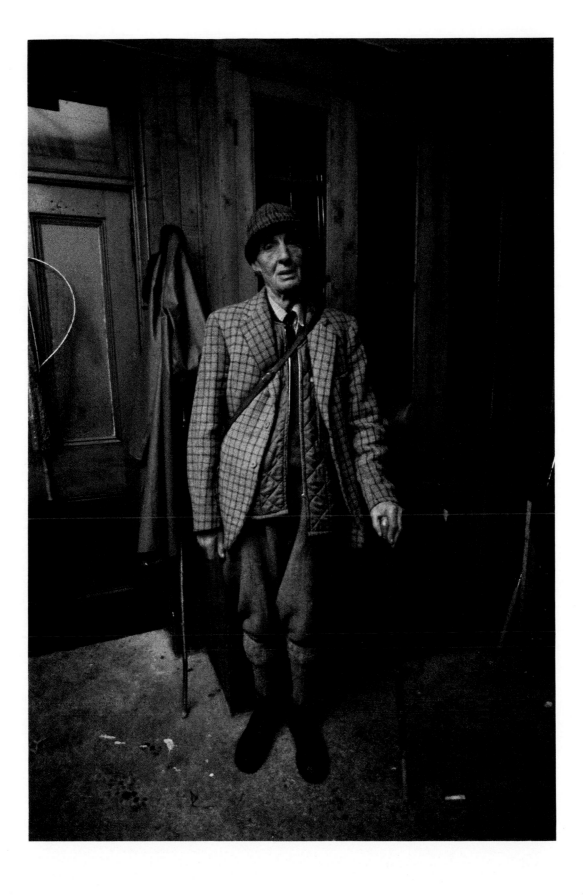

Photographer JOHN CLARIDGE

Photographe JOHN CLARIDGE

Fotograf JOHN CLARIDGE

Art Director ADRIAN TAYLOR

Directeur Artistique ADRIAN TAYLOR

Art Direktor ADRIAN TAYLOR

Publishing Company
AMERICAN EXPRESS PUBLISHING CORPORATION

Editeur
AMERICAN EXPRESS PUBLISHING CORPORATION

Verleger
AMERICAN EXPRESS PUBLISHING CORPORATION

Taken on the Isle of Mull, Scotland, to illustrate an article in "Travel and Leisure" on hotels and their environments called "Europe, Country Style" by Charlotte Curtis. Published in June 1982.

Prises sur l'Ile de Mull, Ecosse, pour illustrer un article dans "Travel and Leisure" sur les hotels et leur environnement intitulé "Europe Country Style" (Europe, style champêtre) par Charlotte Curtis. Publié en juin 1982.

Aufgenommen auf der Insel Mull, Schottland, für einen Artikel in "Travel and Leisure" über Hotels und deren Umgebung mit dem Titel "Europe, Country Style" (Europa im ländlichen Stil), von Charlotte Curtis. Veröffentlicht im Juni 1982.

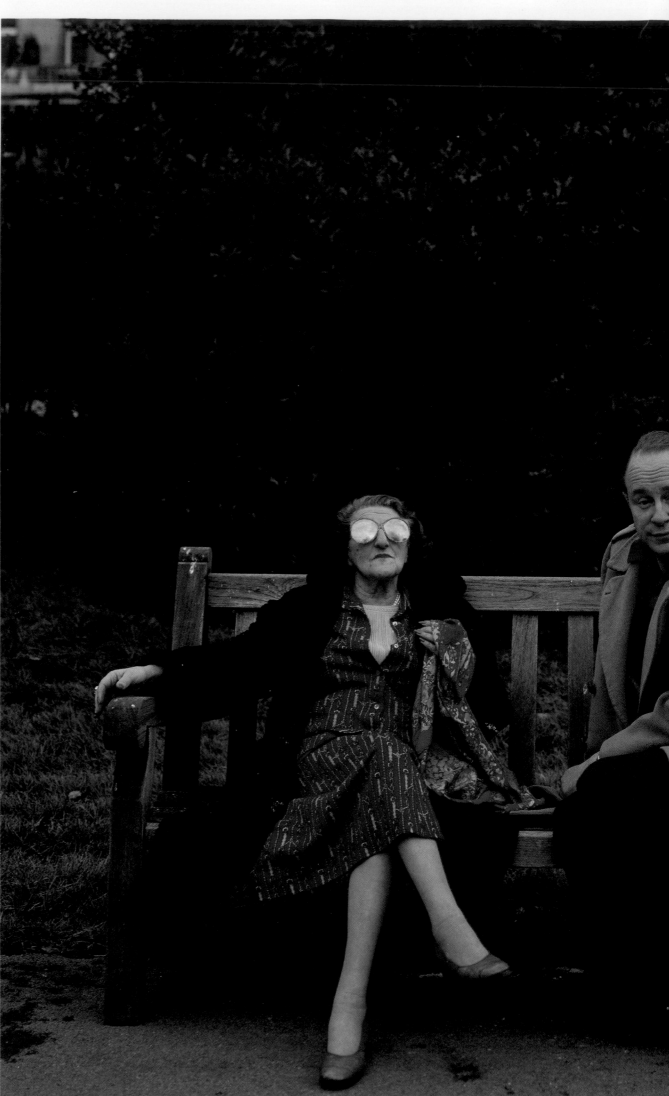

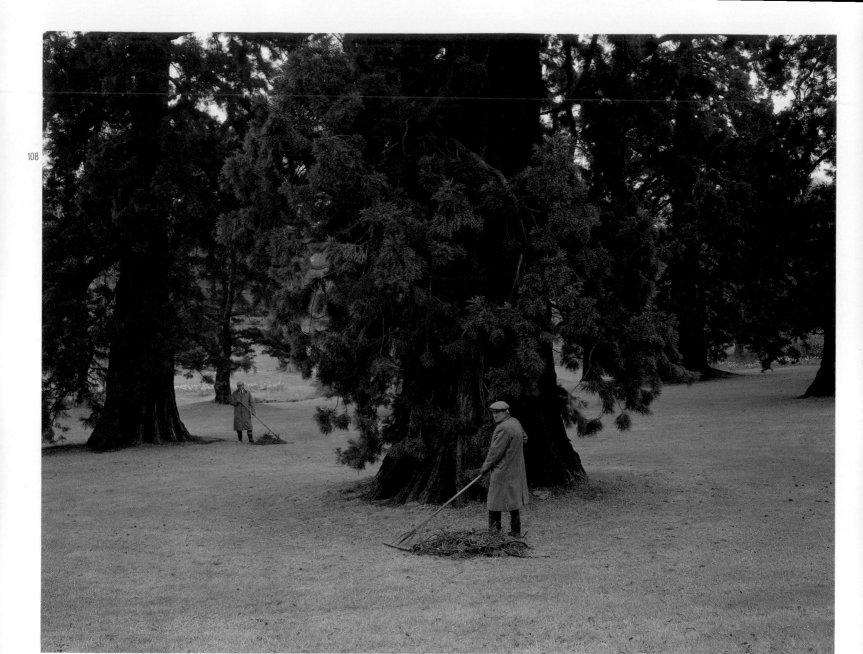

108 Photographer DENIS WAUGH	Photographe DENIS WAUGH	Fotograf DENIS WAUGH
Designer BOB CIANO	Maquettiste BOB CIANO	Gestalter BOB CIANO
Art Director BOB CIANO	Directeur Artistique BOB CIANO	Art Direktor BOB CIANO
Picture Editor JOHN LOENGARD	Directeur de Photographie JOHN LOENGARD	Bildredakteur JOHN LOENGARD
Publishing Company TIME-LIFE INC.	Editeur TIME-LIFE INC.	Verleger TIME-LIFE INC.
Gardeners at Sandringham House, Norfolk, England, part of a feature by Gail Ridgwell—"Prince Charles' Private World: A Rich Life in Royal Style"; in "Life," July 1981. Subsequently used in "The Sunday Times Magazine," July 1981.	Jardiniers à Sandringham House, Norfolk, Angleterre, partie d'un article par Gail Ridgwell "Prince Charles' Private World: A Rich Life in Royal Style" (Le Monde Privé du Prince Charles: Une Vie Riche dans le Style Royal); dans "Life," juillet 1981. Utilisé par la suite dans "The Sunday Times Magazine," juillet 1981.	Gärtner in Sandringham House, Norfolk, England, Teil einer Reportage von Gail Ridgwell – "Prince Charles' Private World: A Rich Life in Royal Style" (Prinz Charles private Welt: Wohlhabendes Leben im königlichen Stil); erschienen in "Life," Juli 1981. Ebenfalls veröffentlicht in "The Sunday Times Magazine," Juli 1981.
◀ **106, 107** Photographer DENIS WAUGH	Photographe DENIS WAUGH	Fotograf DENIS WAUGH
Art Director GRAEME MURDOCH	Directeur Artistique GRAEME MURDOCH	Art Direktor GRAEME MURDOCH
Publishing Company THE OBSERVER MAGAZINE	Editeur THE OBSERVER MAGAZINE	Verleger THE OBSERVER MAGAZINE
Taken in Regent's Park, London, for a feature by Maureen Cleave on Ned Sherrin and Caryl Brahms' play "The Mitford Girls"; in "The Observer Magazine," July 1981.	Prise dans Regent's Park, Londres, pour un article de Maureen Cleave sur "The Mitford Girls" (Les soeurs Mitford), pièce de Ned Sherrin et Caryl Brahms; dans "The Observer Magazine," juillet 1981.	Aufgenommen im Regent's Park, London, für eine Reportage von Maureen Cleave über das Theaterstück "The Mitford Girls" (Die Mitford Schwestern) von Ned Sherrin und Caryl Brahms; erschienen in "The Observer Magazine," Juli 1981.

109 Photographer DENIS WAUGH

Designer LUCY SISMAN

Picture Editor BRUCE BERNARD

Publishing Company TIMES NEWSPAPERS LIMITED

The Amadeus Quartet photographed in a Berlin hotel prior to giving a recital; for an article by Ruth Hall, "Perfect Discord", in "The Sunday Times Magazine."

Photographe DENIS WAUGH

Maquettiste LUCY SISMAN

Directeur de Photographie BRUCE BERNARD

Editeur TIMES NEWSPAPERS LIMITED

Le Amadeus Quartet photographié dans un hôtel de Berlin juste avant un récital: pour une article de Ruth Hall, "Perfect Discord" (Dissonance parfaite), dans "The Sunday Times Magazine."

Fotograf DENIS WAUGH

Gestalter LUCY SISMAN

Bildredakteur BRUCE BERNARD

Verleger TIMES NEWSPAPERS LIMITED

Aufnahme des Amadeus Quartetts in einem Berliner Hotel kurz vor einem Konzert; für eine Reportage von Ruth Hall "Perfect Discord" (Perfekte Dissonanz), in "The Sunday Times Magazine."

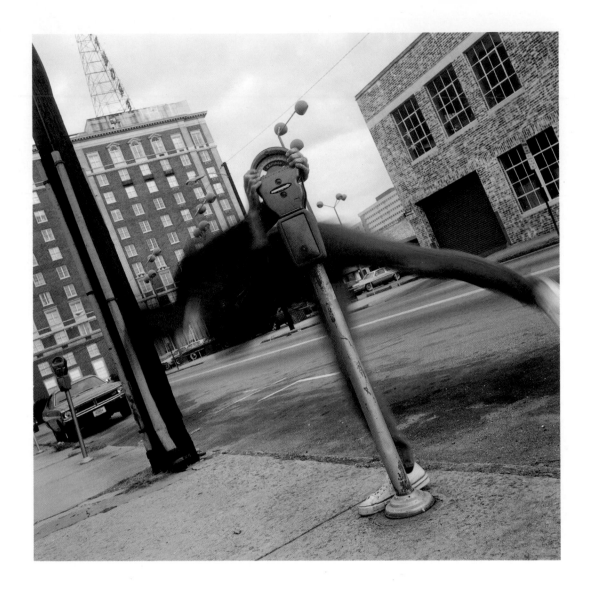

112 Photographer BRIAN GRIFFIN

Designer APRIL SILVER

Art Director ROBERT PRIEST

Picture Editor JENNIFER CRANDALL

Publishing Company ESQUIRE PUBLISHING CO.

Photographed for a feature on Dee Dee Ramone, "Didn't Wanna Be A Pinhead No More," by Frank Rose in "Esquire."

Photographe BRIAN GRIFFIN

Maquettiste APRIL SILVER

Directeur Artistique ROBERT PRIEST

Directeur de Photographie JENNIFER CRANDALL

Editeur ESQUIRE PUBLISHING CO.

Photographié pour un article sur Dee Dee Ramone, "Didn't Wanna Be A Pinhead No More," par Frank Rose dans "Esquire."

Fotograf BRIAN GRIFFIN

Gestalter APRIL SILVER

Art Direktor ROBERT PRIEST

Bildredakteur JENNIFER CRANDALL

Verleger ESQUIRE PUBLISHING CO.

Aufgenommen für eine Reportage über Dee Dee Ramone, "Didn't Wanna Be A Pinhead No More" (Wollte kein Stecknadelkopf mehr sein), von Frank Rose in "Esquire."

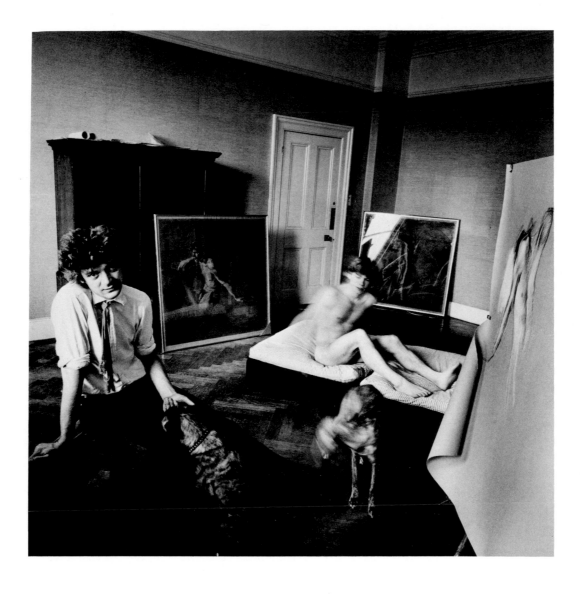

113-117 Photographer DUDLEY REED

Art Directors JAYNE GOULD/ROB BENNETT

Publishing Company
CONDÉ NAST PUBLICATIONS LIMITED

Photographs from a feature on young English portrait painters, "Painted Faces," by Jessica Berens and Bobby Butler-Sloss in "Tatler," May 1982. The artists are:
113 Matthew Carr
114 Emma Sargent and Will Topley
115 Edward Bell
116 Luciana Martinez
117 Jason Bratby

Photographe DUDLEY REED

Directeurs Artistiques JAYNE GOULD/ROB BENNETT

Editeur
CONDÉ NAST PUBLICATIONS LIMITED

Photographies tirées d'un article sur de jeunes peintres de portraits anglais, "Painted Faces" (Visages peints), par Jessica Berens et Bobby Butler-Sloss dans "Tatler," mai 1982. Les artistes sont:
113 Matthew Carr
114 Emma Sargent et Will Topley
115 Edward Bell
116 Luciana Martinez
117 Jason Bratby

Fotograf DUDLEY REED

Art Direktoren JAYNE GOULD/ROB BENNETT

Verleger
CONDÉ NAST PUBLICATIONS LIMITED

Fotos für eine Reportage über junge englische Portrait-Maler, "Painted Faces" (Gemalte Gesichter), von Jessica Berens und Bobby Butler-Sloss, in "Tatler," Mai 1982. Die Künstler sind:
113 Matthew Carr
114 Emma Sargent und Will Topley
115 Edward Bell
116 Luciana Martinez
117 Jason Bratby

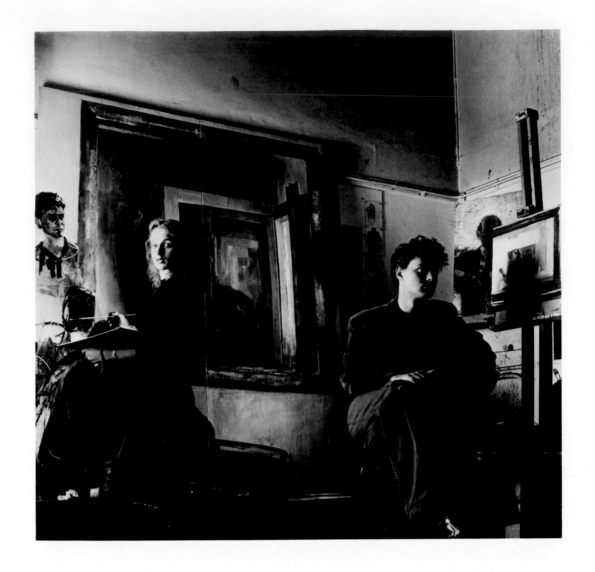

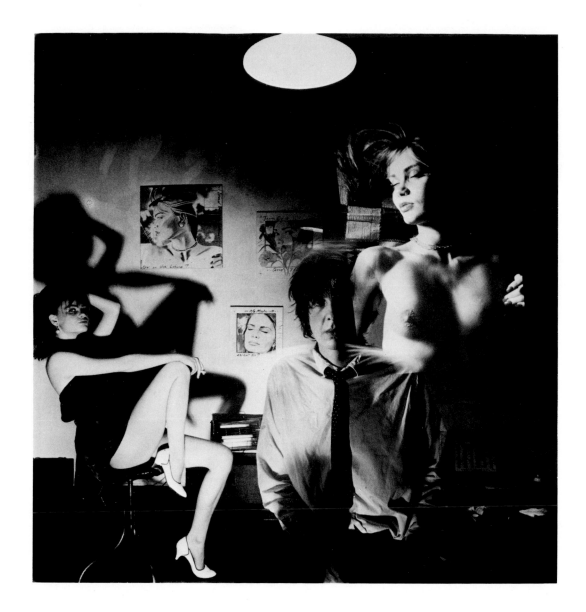

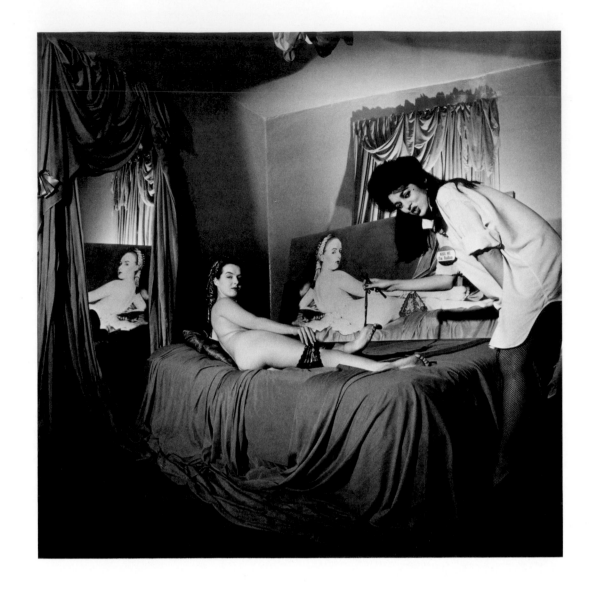

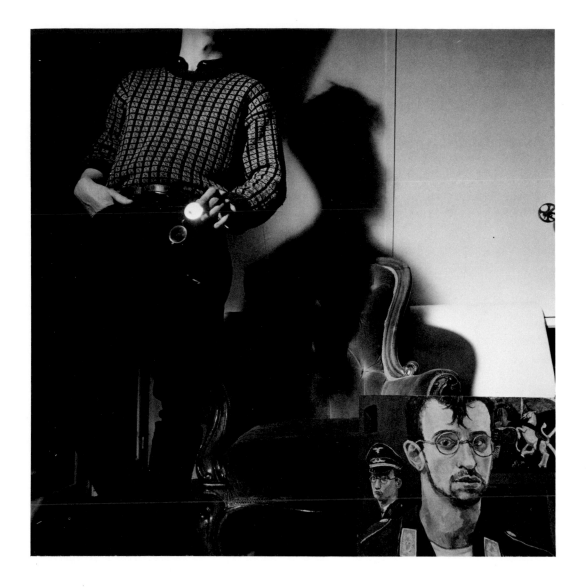

118 Photographer KONRAD R. MÜLLER

Designer GERLINDE MISSNER

Art Director MANFRED MANKE

Publishing Company
ZEITVERLAG GERD BUCERIUS KG

Photograph of Bruno Kreisky's hands for a feature by
Gerhard Roth, "Ein Tag im Leben des Bruno K," (A day
in the life of Bruno K); in "Zeitmagazin," January 1981.

Photographe KONRAD R. MÜLLER

Maquettiste GERLINDE MISSNER

Directeur Artistique MANFRED MANKE

Editeur
ZEITVERLAG GERD BUCERIUS KG

Photographie des mains de Bruno Kreisky pour un
article de Gerhard Roth, "Ein Tag im Leben des
Bruno K," (Un jour dans la vie de Bruno K); dans
"Zeitmagazin," janvier 1981.

Fotograf KONRAD R. MÜLLER

Gestalter GERLINDE MISSNER

Art Direktor MANFRED MANKE

Verleger
ZEITVERLAG GERD BUCERIUS KG

Bruno Kreiskys Hände, fotografiert für eine Reportage
von Gerhard Roth, "Ein Tag im Leben des Bruno K,"
im "Zeitmagazin," Januar 1981.

Photographer PHILIP STARLING

Art Director ALAN TANNENBAUM

Publishing Company SOHO WEEKLY NEWS INC.

Photographed at an air display on the U.S. Airbase at
Greenham in Berkshire, and published in
"SoHo News," New York.

Photographe PHILIP STARLING

Directeur Artistique ALAN TANNENBAUM

Editeur SOHO WEEKLY NEWS INC.

Photographie prise à une fête aéronautique à la base
aérienne américaine, à Greenham, dans le Berkshire, et
pubilée dans "SoHo News," New York.

Fotograf PHILIP STARLING

Art Direktor ALAN TANNENBAUM

Verleger SOHO WEEKLY NEWS INC.

Aufgenommen bei einer Flugdemonstration auf dem
U.S. Stützpunkt Greenham, in Berkshire, und
veröffentlicht in "SoHo News," New York.

119 ▶

Photographer HELMUT NEWTON

Designer PAUL WAGNER

Art Director JOCELYN KARGÈRE

Publishing Company
LES ÉDITIONS CONDÉ NAST S.A.

Fashion shot for French "Vogue," October 1981.

Photographe HELMUT NEWTON

Maquettiste PAUL WAGNER

Directeur Artistique JOCELYN KARGÈRE

Editeur
LES ÉDITIONS CONDÉ NAST S.A.

Photographie de mode pour le "Vogue" français,
octobre 1981.

Fotograf HELMUT NEWTON

Gestalter PAUL WAGNER

Art Direktor JOCELYN KARGÈRE

Verleger
LES ÉDITIONS CONDÉ NAST S.A.

Mode-Foto für die französische "Vogue" Ausgabe,
Oktober 1981.

120, 121 ▶

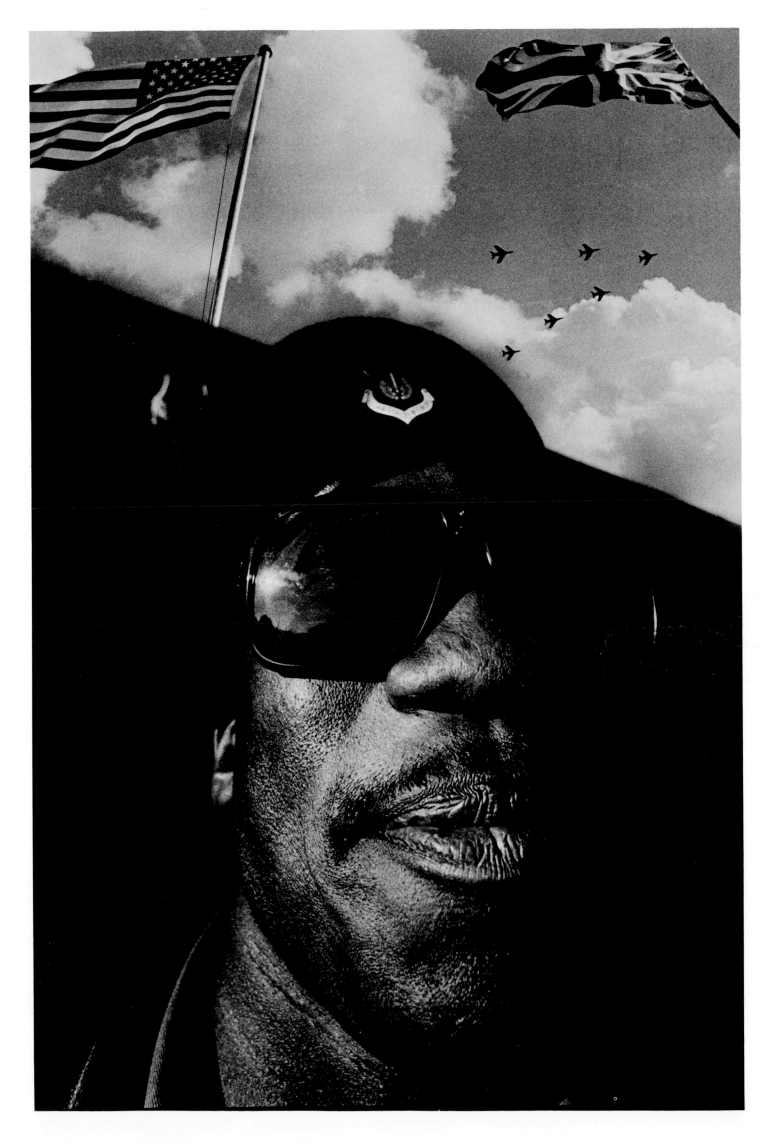

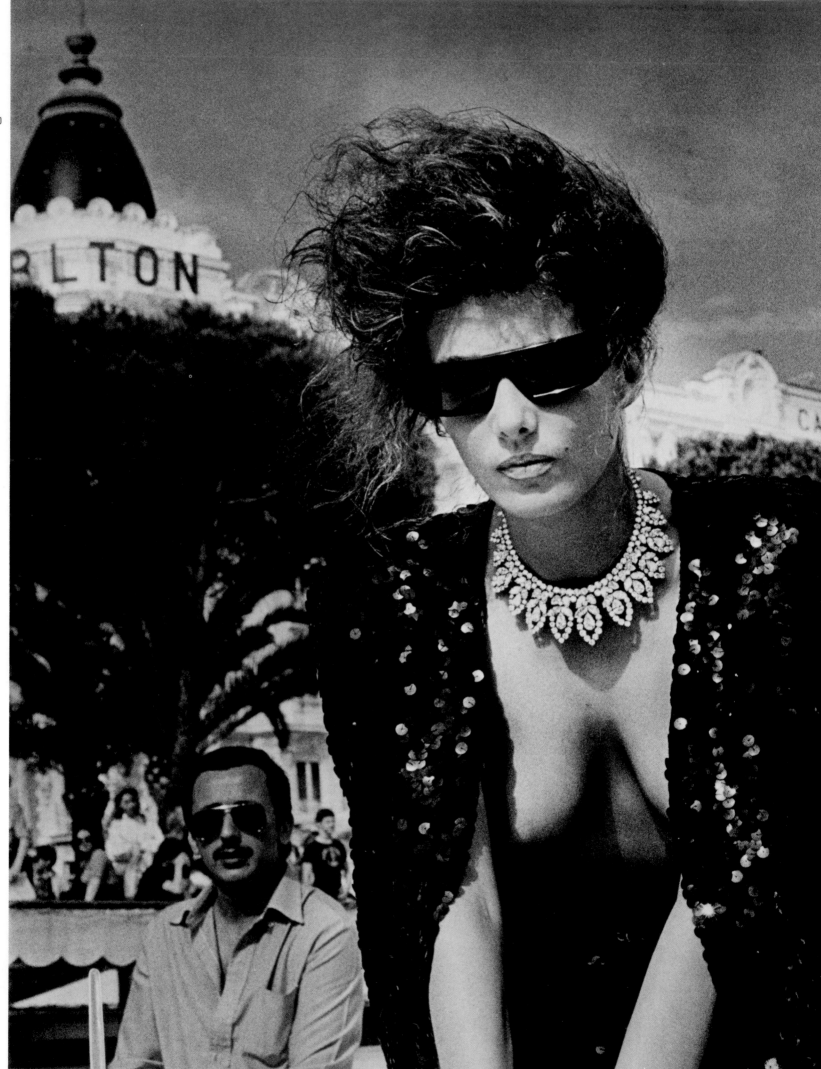

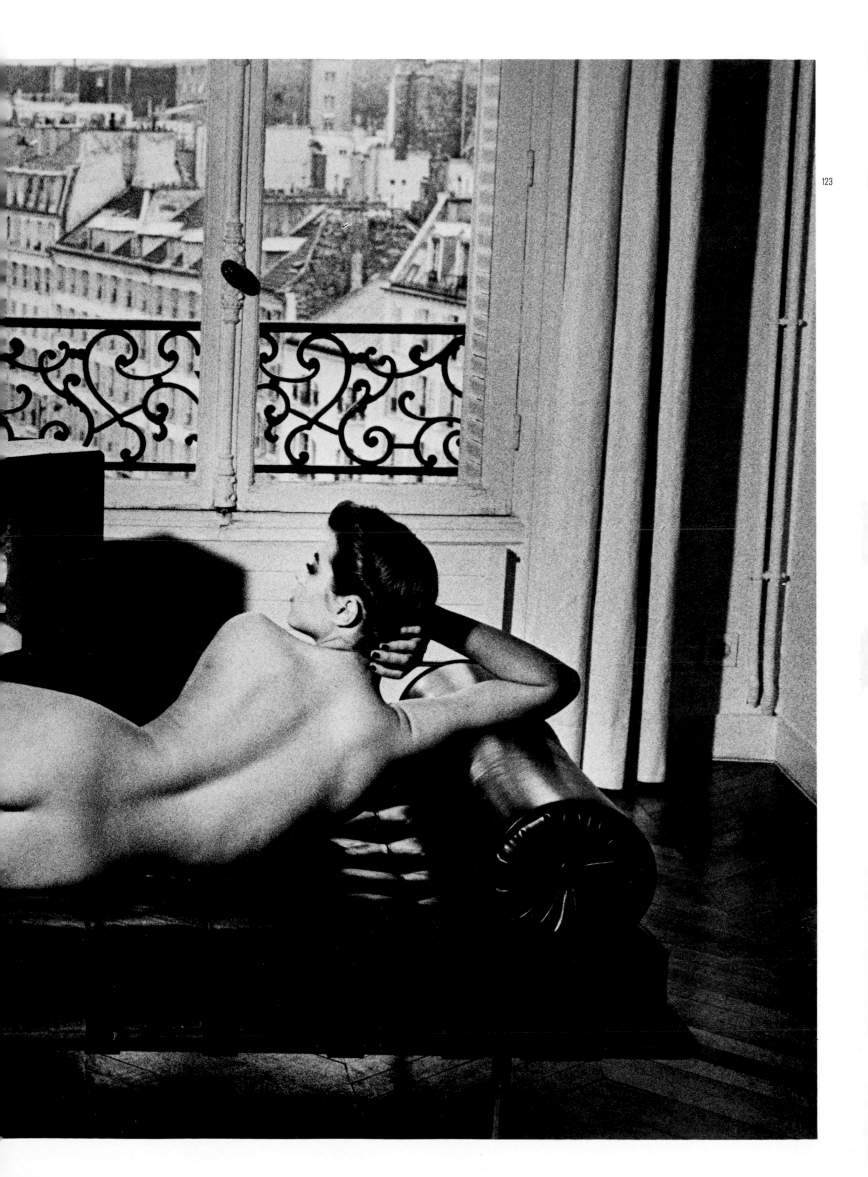

124

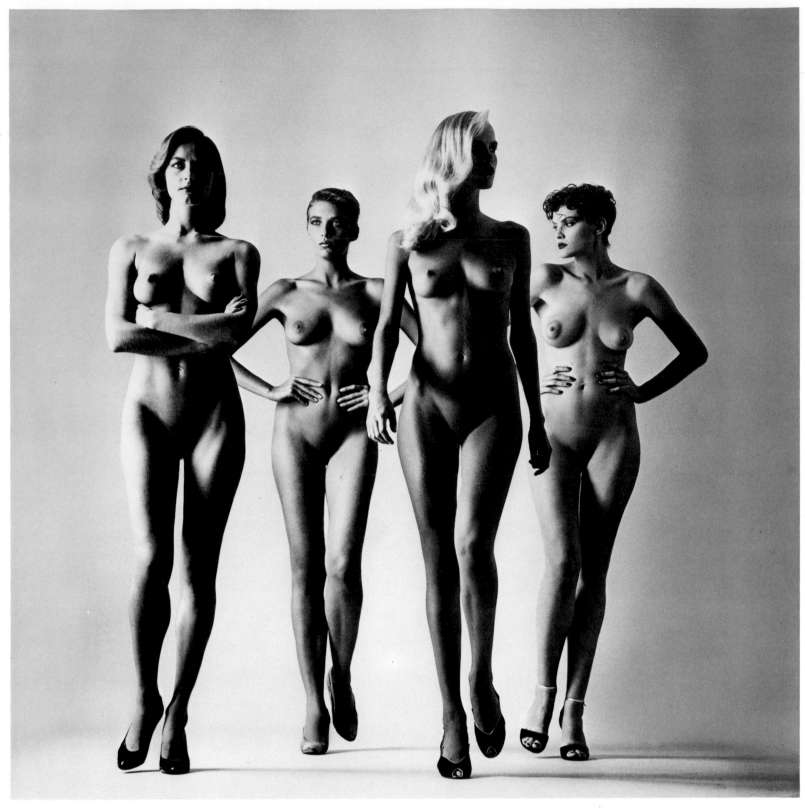

◀ **122, 123** Photographer HELMUT NEWTON

Designer PAUL WAGNER

Art Director JOCELYN KARGÈRE

Publishing Company
LES ÉDITIONS CONDÉ NAST S.A.

Photographed for a feature on video by Diane de Braux
in French "Vogue," December 1981.

Photographe HELMUT NEWTON

Maquettiste PAUL WAGNER

Directeur Artistique JOCELYN KARGÈRE

Editeur
LES ÉDITIONS CONDÉ NAST S.A.

Photographie pour un article sur video par Diane de
Braux dans le "Vogue" français, décembre 1981.

Fotograf HELMUT NEWTON

Gestalter PAUL WAGNER

Art Direktor JOCELYN KARGÈRE

Verleger
LES ÉDITIONS CONDÉ NAST S.A.

Aufgenommen für eine Reportage über Video von
Diane de Braux in der französischen "Vogue" Ausgabe,
Dezember 1981.

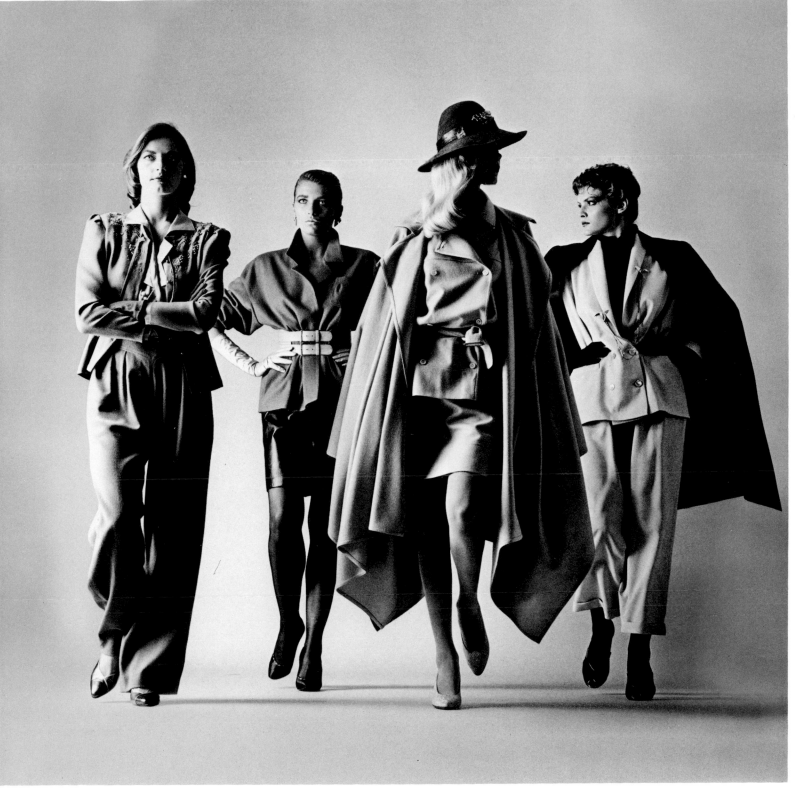

124-127	Photographer HELMUT NEWTON	Photographe HELMUT NEWTON	Fotograf HELMUT NEWTON
	Designer PAUL WAGNER	Maquettiste PAUL WAGNER	Gestalter PAUL WAGNER
	Art Director JOCELYN KARGÈRE	Directeur Artistique JOCELYN KARGÈRE	Art Direktor JOCELYN KARGÈRE
	Publishing Company LES ÉDITIONS CONDÉ NAST S.A.	Editeur LES ÉDITIONS CONDÉ NAST S.A.	Verleger LES ÉDITIONS CONDÉ NAST S.A.
	Fashion shots for French "Vogue," published in November 1981.	Photographies de mode pour le "Vogue" français, publiées en novembre 1981.	Mode-Fotos für die französische "Vogue" Ausgabe, veröffentlicht im November 1981.

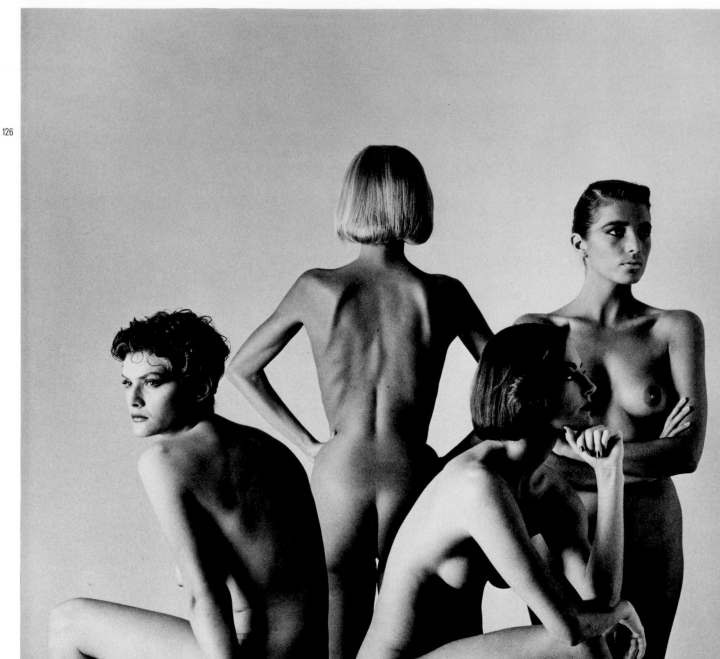

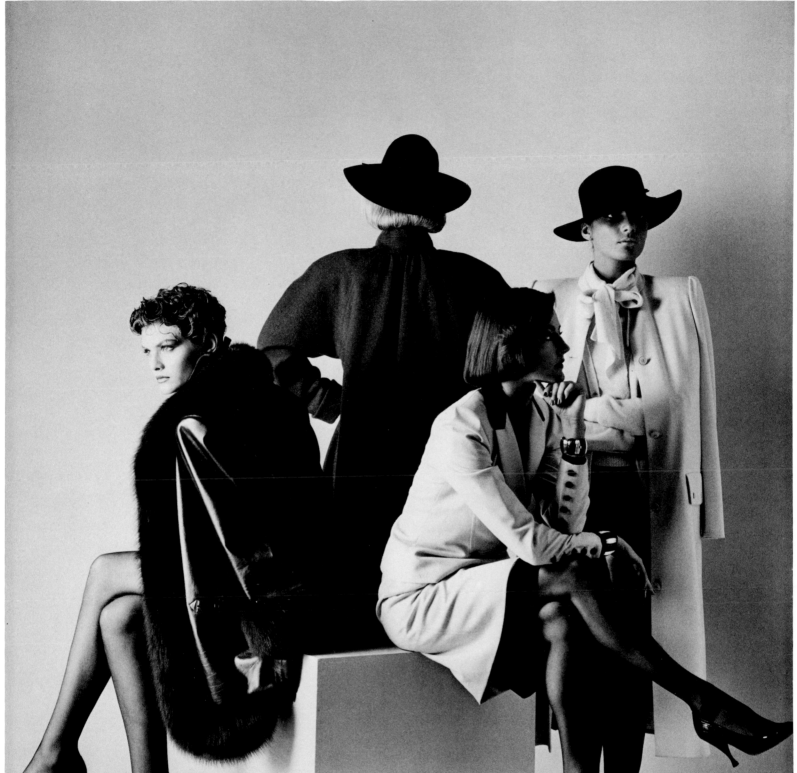

128 Photographer PHILIP STARLING

Art Director ALAN TANNENBAUM

Publishing Company SOHO WEEKLY NEWS INC.

Photographed in the Kings Road, London, and published in "SoHo News", New York.

Photographe PHILIP STARLING

Directeur Artistique ALAN TANNENBAUM

Editeur SOHO WEEKLY NEWS INC.

Photographie prise dans la Kings Road, Londres, et publiées dans "SoHo News", New York.

Fotograf PHILIP STARLING

Art Direktor ALAN TANNENBAUM

Verleger SOHO WEEKLY NEWS INC.

Aufgenommen in der Kings Road, London, und veröffentlicht in "SoHo News", New York.

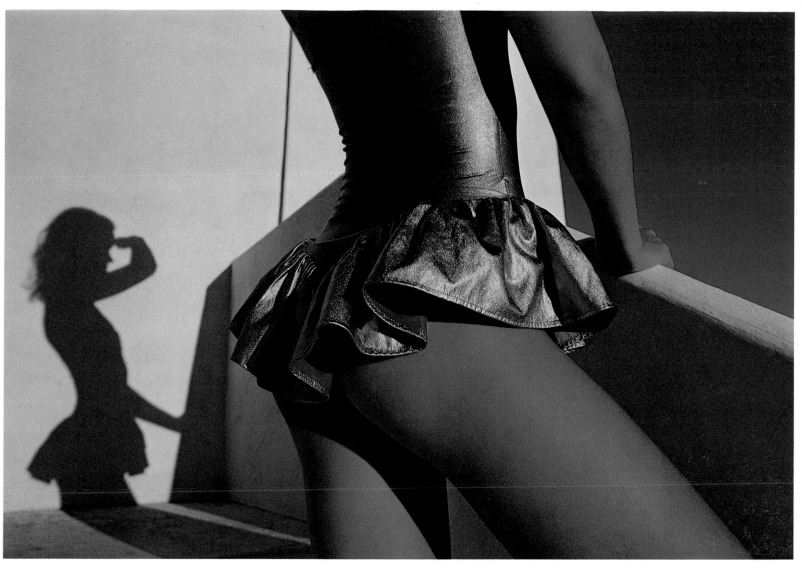

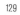

129 Photographer WOLFGANG BEHNKEN	Photographe WOLFGANG BEHNKEN	Fotograf WOLFGANG BEHNKEN
Art Director WOLFGANG BEHNKEN	Directeur Artistique WOLFGANG BEHNKEN	Art Direktor WOLFGANG BEHNKEN
Publishing Company GRUNER & JAHR AG & CO.	Editeur GRUNER & JAHR AG & CO.	Verleger GRUNER & JAHR AG & CO.
Photographed on Formentera, Spain, for a holiday fashion feature in "Stern."	Photographie prise sur Formentera, Espagne, pour un article de mode de vacances dans "Stern."	Aufgenommen auf Formentera, Spanien, für eine Reportage über Ferienmode im "Stern."

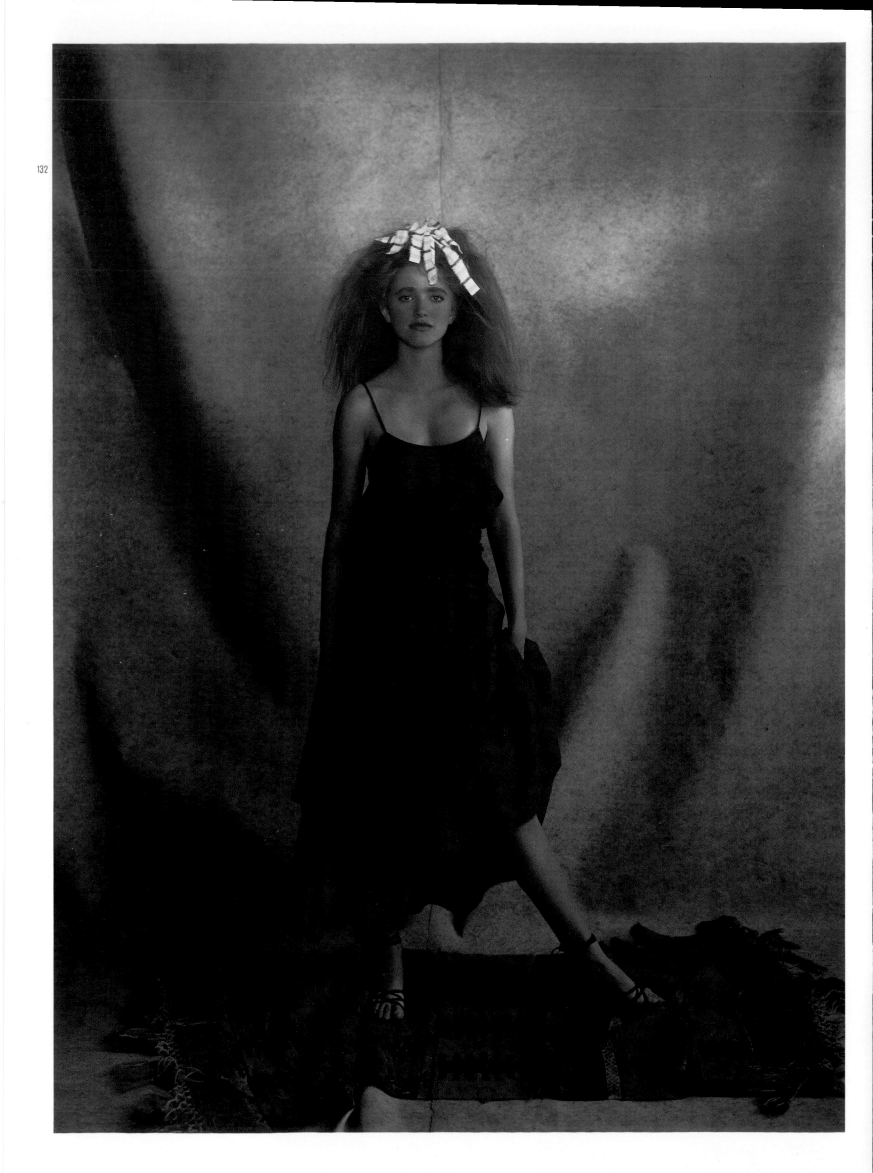

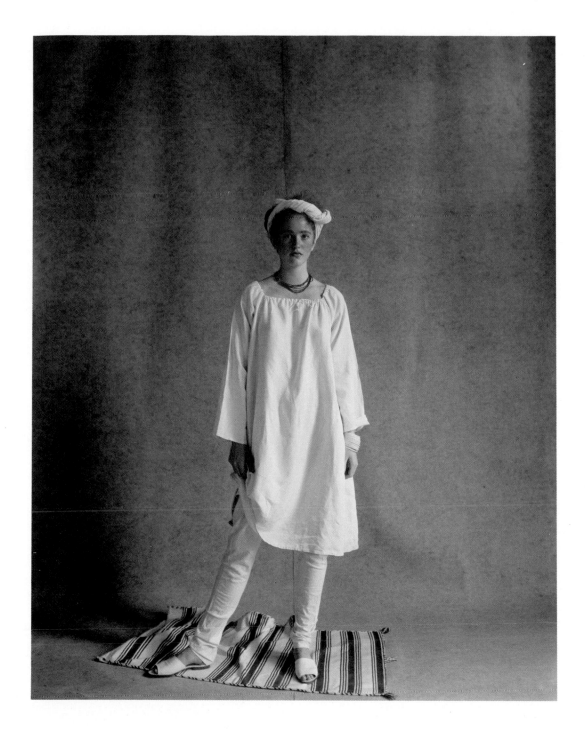

132-139 Photographer BARRY LATEGAN | Photographe BARRY LATEGAN | Fotograf BARRY LATEGAN

Designer SUSAN MANN | Maquettiste SUSAN MANN | Gestalter SUSAN MANN

Art Director SUSAN MANN | Directeur Artistique SUSAN MANN | Art Direktor SUSAN MANN

Publishing Company
CONDÉ NAST PUBLICATIONS LIMITED© | Editeur
CONDÉ NAST PUBLICATIONS LIMITED© | Verleger
CONDÉ NAST PUBLICATIONS LIMITED©

A series of photographs for a fashion feature in English "Vogue," July 1981. | Série de photographies pour un article de mode dans le "Vogue" anglais, juillet 1981. | Eine Serie von Fotos für eine Mode-Reportage in der englischen "Vogue" Ausgabe, Juli 1981.

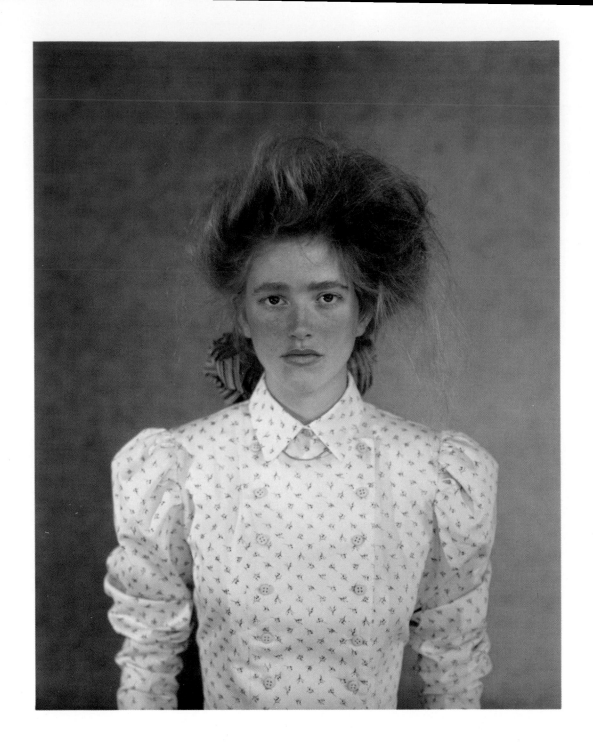

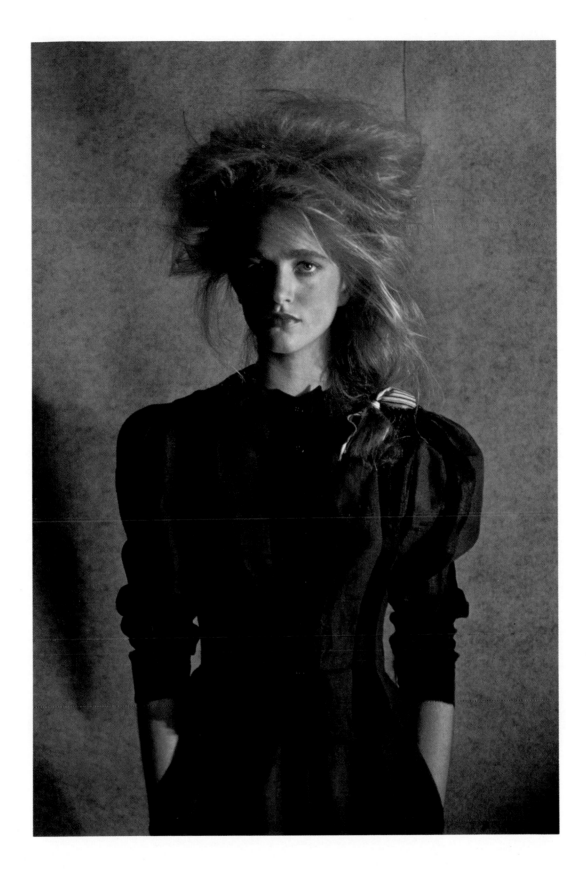

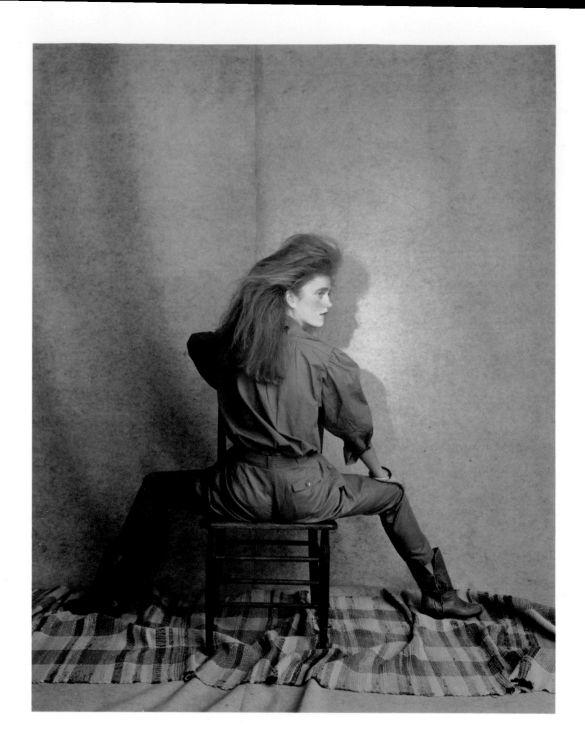

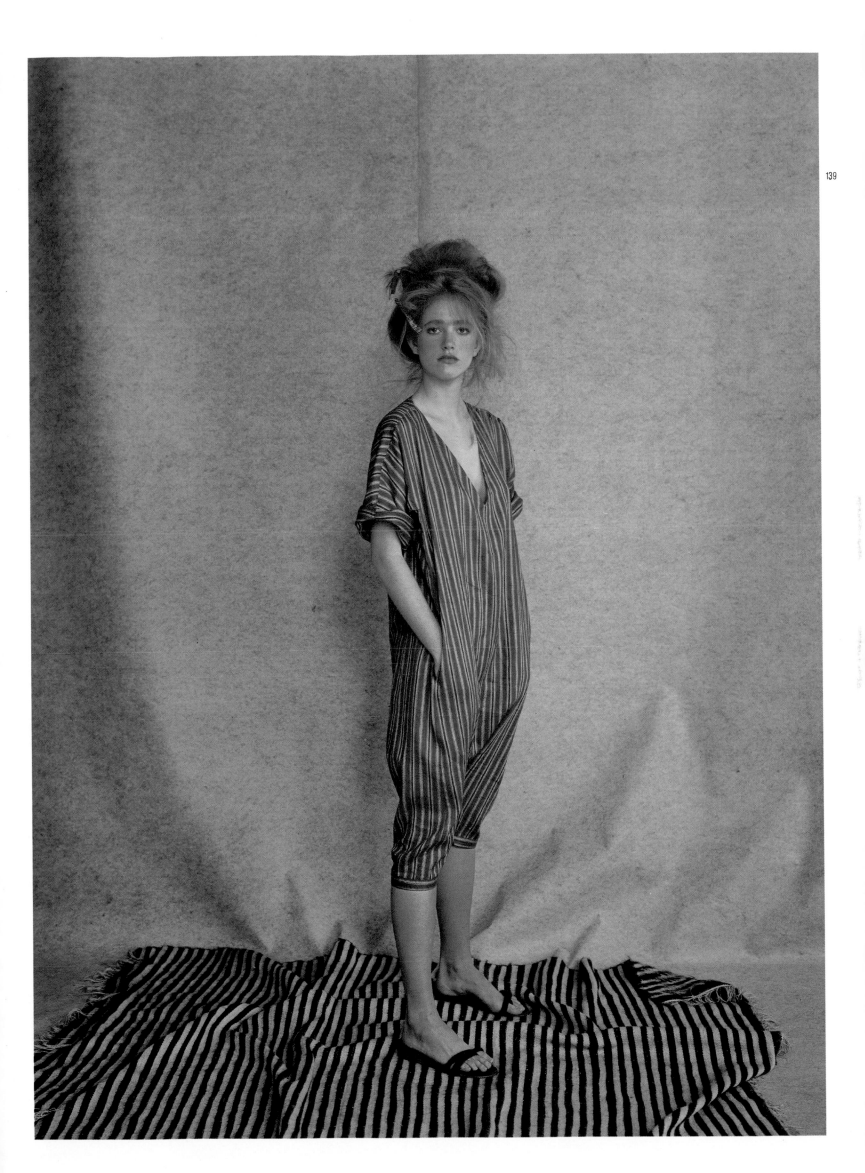

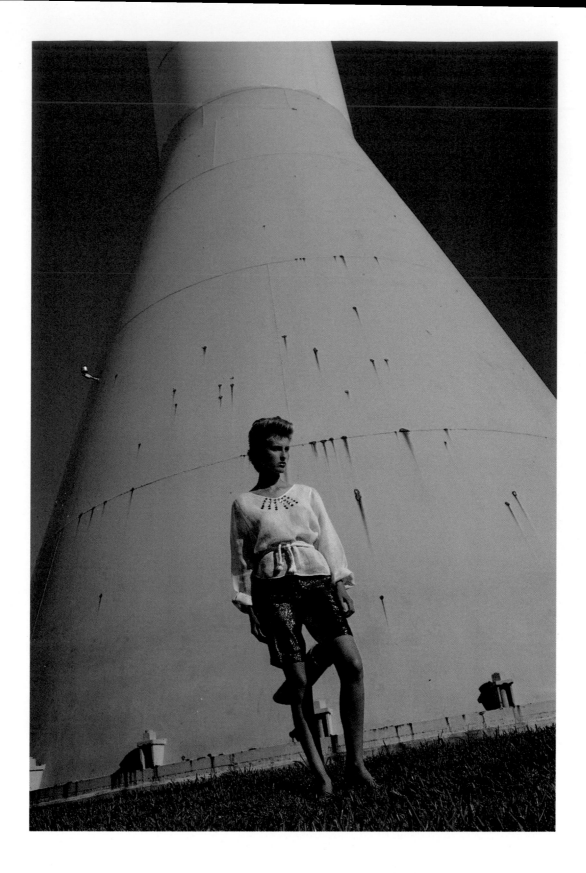

140 Photographer STEVE HIETT	Photographe STEVE HIETT	Fotograf STEVE HIETT
Designer STEVE HIETT	Maquettiste STEVE HIETT	Gestalter STEVE HIETT
Art Director JOCELYN KARGÈRE	Directeur Artistique JOCELYN KARGÈRE	Art Direktor JOCELYN KARGÈRE
Publishing Company LES ÉDITIONS CONDÉ NAST S.A.	Editeur LES ÉDITIONS CONDÉ NAST S.A.	Verleger LES ÉDITIONS CONDÉ NAST S.A.
Fashion shot taken in Hollywood, Florida, for French "Vogue."	Photographie de mode prise à Hollywood, Floride, pour le "Vogue" français.	Mode-Foto, aufgenommen in Hollywood, Florida, für die französische "Vogue" Ausgabe.

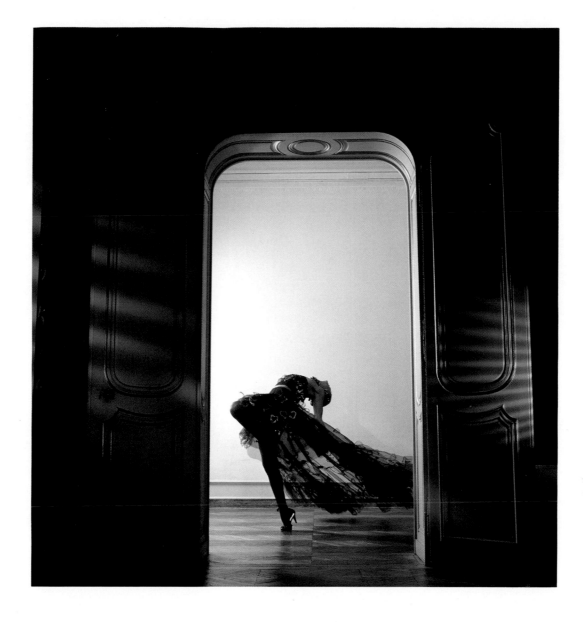

141 Photographer JOE GAFFNEY

Publishing Company EDIZIONI SYDS

Taken for a feature on the Paris couture collections, "Il Nero e il Bianco", (The black and the white), published in "Harpers Bazaar Italia".

Photographe JOE GAFFNEY

Editeur EDIZIONI SYDS

Photographie pour un article sur les collections de Paris, "Il Nero e il Bianco", (Le Noir et le Blanc), publiée dans "Harpers Bazaar Italia".

Fotograf JOE GAFFNEY

Verleger EDIZIONI SYDS

Aufgenommen für eine Reportage über die Couture-Kollektionen in Paris, "Il Nero e il Bianco", (Schwarz und Weiß), veröffentlicht in "Harpers Bazaar Italia".

Photographer THOMAS PAULUS

Designer MAX LENGWENUS

Art Director WOLFGANG BEHNKEN

Publishing Company GRUNER & JAHR AG & CO.

Double-page spread for a feature by Barbara Larcher, "Nackt bis auf die Haut", (Naked to the skin); "Stern", June 1981.

Photographe THOMAS PAULUS

Maquettiste MAX LENGWENUS

Directeur Artistique WOLFGANG BEHNKEN

Editeur GRUNER & JAHR AG & CO.

Photographies sur deux pages pour un article de Barbara Larcher, "Nackt bis auf die Haut", (Nu jusqu'à la peau); "Stern", juin 1981.

Fotograf THOMAS PAULUS

Gestalter MAX LENGWENUS

Art Direktor WOLFGANG BEHNKEN

Verleger GRUNER & JAHR AG & CO.

Doppelseite für eine Reportage von Barbara Larcher "Nackt bis auf die Haut"; im "Stern", Juni 1981.

142, 143 ▶

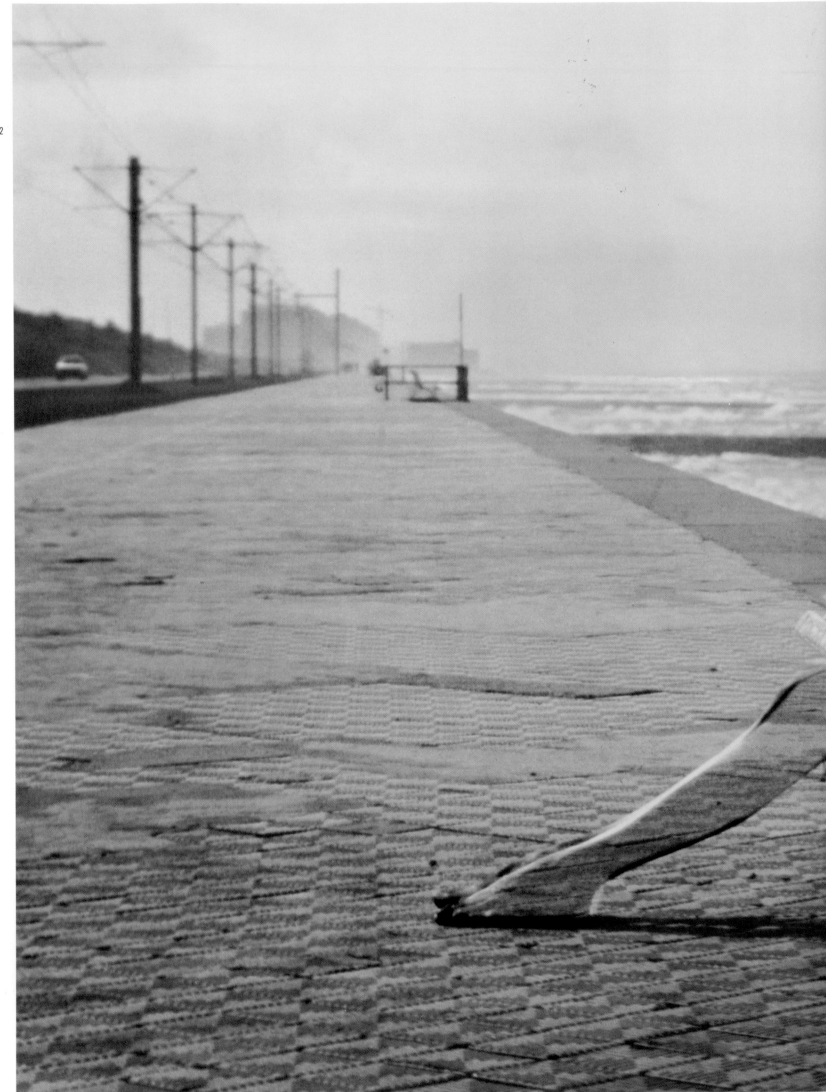

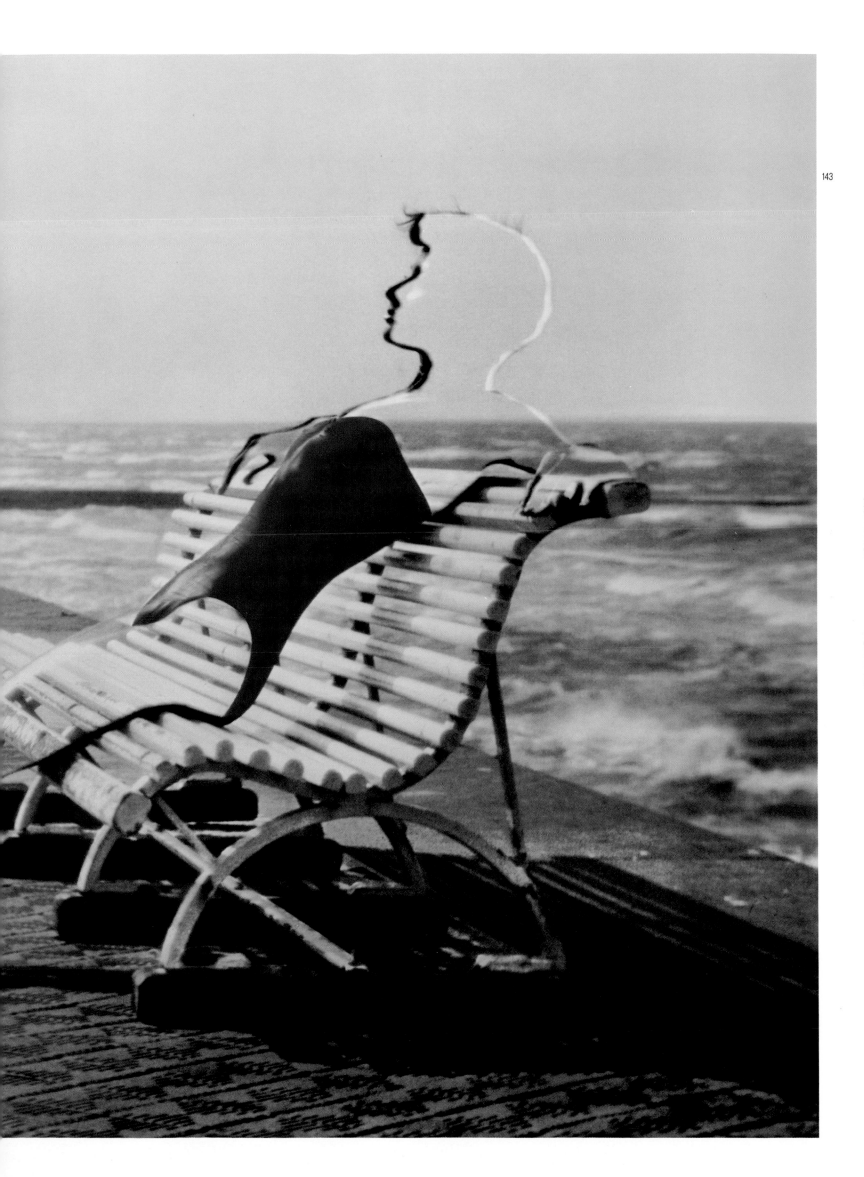

144 Photographer STEVE HIETT

Photographe STEVE HIETT

Fotograf STEVE HIETT

Art Director MARINA FAUSTI

Directeur Artistique MARINA FAUSTI

Art Direktor MARINA FAUSTI

Publishing Company
ARNOLDO MONDADORI EDITORE

Editeur
ARNOLDO MONDADORI EDITORE

Verleger
ARNOLDO MONDADORI EDITORE

Fashion shot taken at Miami Beach, Florida, for "Linea Italiana."

Photographie de mode prise à Miami Beach, Floride, pour "Linea Italiana."

Mode-Foto, aufgenommen in Miami Beach, Florida, für "Linea Italiana."

145 Photographer STEVE HIETT

Art Director ANGELICA BLECHSCHMIDT

Publishing Company CONDÉ NAST VERLAG GMBH

Photographed in Nice and used in an editorial
promotional feature on Ford cars in German "Vogue."

Photographe STEVE HIETT

Directeur Artistique ANGELICA BLECHSCHMIDT

Editeur CONDÉ NAST VERLAG GMBH

Photographié à Nice et utilisé dans un article de
presse promotionnel sur les voitures Ford dans le
"Vogue" allemand.

Fotograf STEVE HIETT

Art Direktor ANGELICA BLECHSCHMIDT

Verleger CONDÉ NAST VERLAG GMBH

Aufgenommen in Nizza und eingesetzt in einer
Redaktions-Promotion für Ford Autos in der deutschen
"Vogue" Ausgabe.

E U R O P E A N

P H O T O G R A P H Y

B O O K S

This section includes work commissioned for book jackets, paperback covers, and all types of photographically illustrated books.

LIVRES Photographies pour des jaquettes de livres reliés, des couvertures de livres de poche, et toutes sortes de livres illustrés, romans ou autres.

BÜCHER Fotografie für Schutzumschläge, Paperback-Umschläge und Bücher aller Art, Romane und Sachbücher.

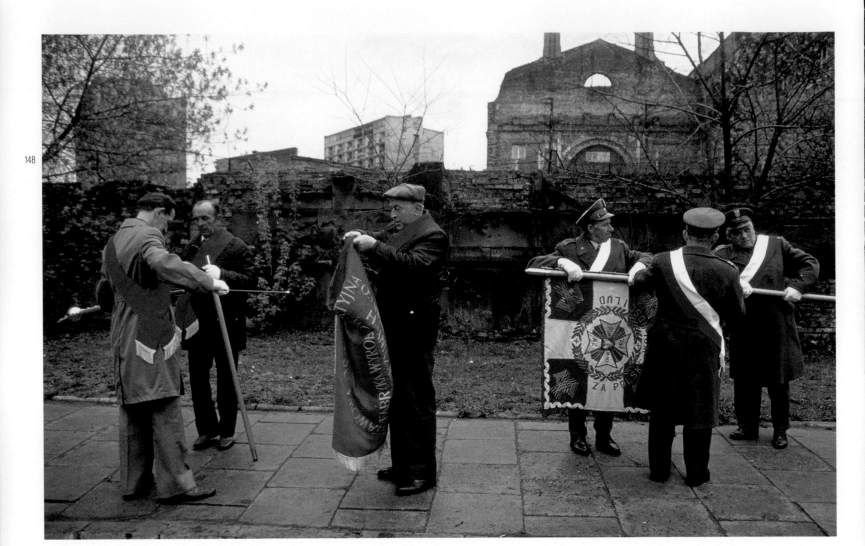

148-154 Photographer BRUNO BARBEY

Designer HARTMUT BRÜCKNER

Editor MAX SCHELER

Publishing Company
HOFFMANN UND CAMPE VERLAG

Writer KARL DEDECIUS

Photographs from "Polen—Ein Merian-Buch".
(Poland—A Merian Book).
148 Veterans after the May Day parades.
149 After work, dancing lessons at one of the old
mansions in Kracow.
150, 151 People queueing for bread near Kielce.
152 Easter pilgrimage at Kalwaria Zebrzydowska.
153 Belief in God and the church: in Czstochowa
people queue for confession.
154 In the country, the tradition of naive wall paintings
was only revived recently.

Photographe BRUNO BARBEY

Maquettiste HARTMUT BRÜCKNER

Editeur MAX SCHELER

Editeur
HOFFMANN UND CAMPE VERLAG

Auteur KARL DEDECIUS

Photographies de "Polen—Ein Merian-Buch".
(La Pologne—Un Livre Merian).
148 Les vétérans après les défilés du 1er mai.
149 Après le travail, leçons de danse dans un des
vieux hôtels de Cracovie.
150, 151 Queue pour le pain près de Kielce.
152 Pèlerinage de Pâques a Kalwaria Zebrzydowska.
153 Croyance en Dieu et en l'église: à Czestochowa
on fait la queue pour aller à confesse.
154 A la campagne la tradition des peintures murales
naïves n'a été renouvelée que récemment.

Fotograf BRUNO BARBEY

Gestalter HARTMUT BRÜCKNER

Redakteur MAX SCHELER

Verleger
HOFFMANN UND CAMPE VERLAG

Autor KARL DEDECIUS

Fotos aus "Polen—Ein Merian-Buch".
148 Veteranen nach den Feierlichkeiten zum 1. Mai.
149 Nach Feierabend, Tanzstunde in einem der
prächtigen Häuser in Krakau.
150, 151 Schlangestehen für Brot in der Nähe von
Kielce.
152 Österliche Pilgerfahrt in Kalwaria Zebrzydowska.
153 Vertrauen in Gott und die Kirche: in Czstochowa
stehen Menschen schlange zur Beichte.
154 Auf dem Lande wurde die traditionelle
Wandmalerei erst kürzlich wiederbelebt.

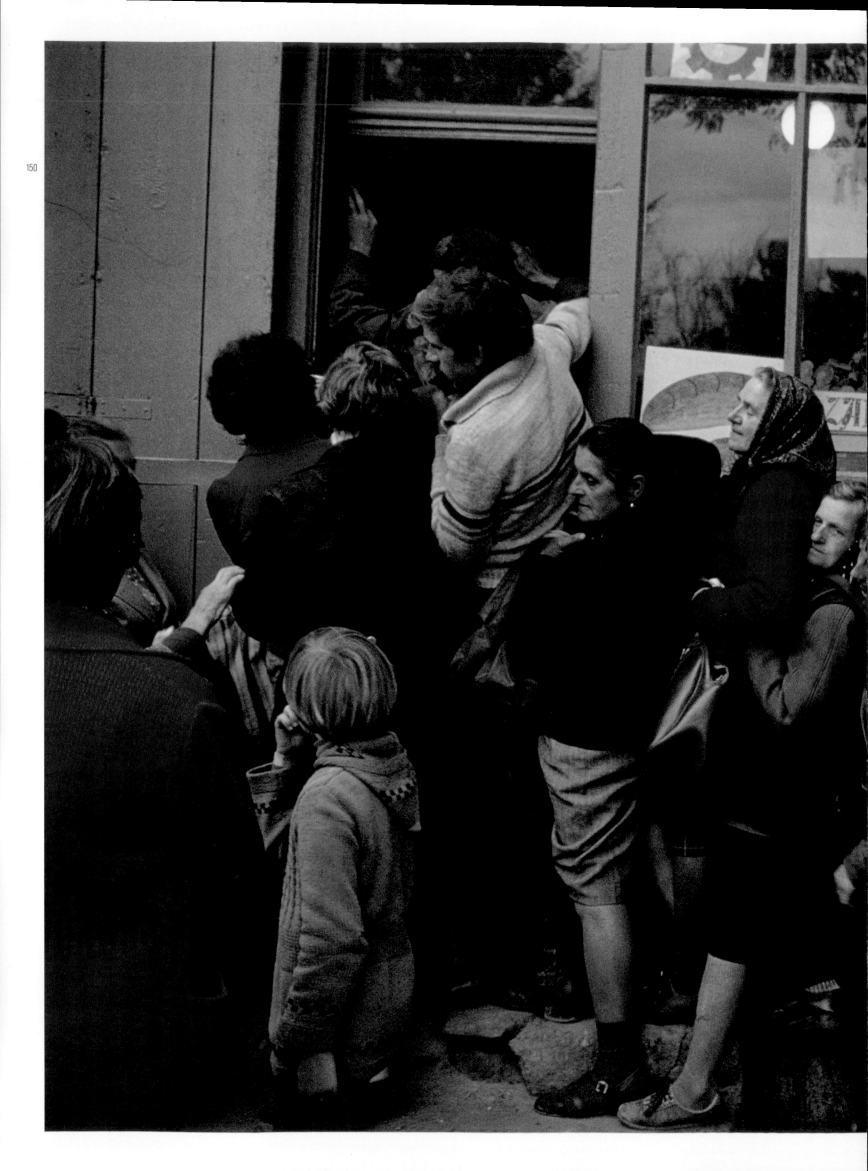

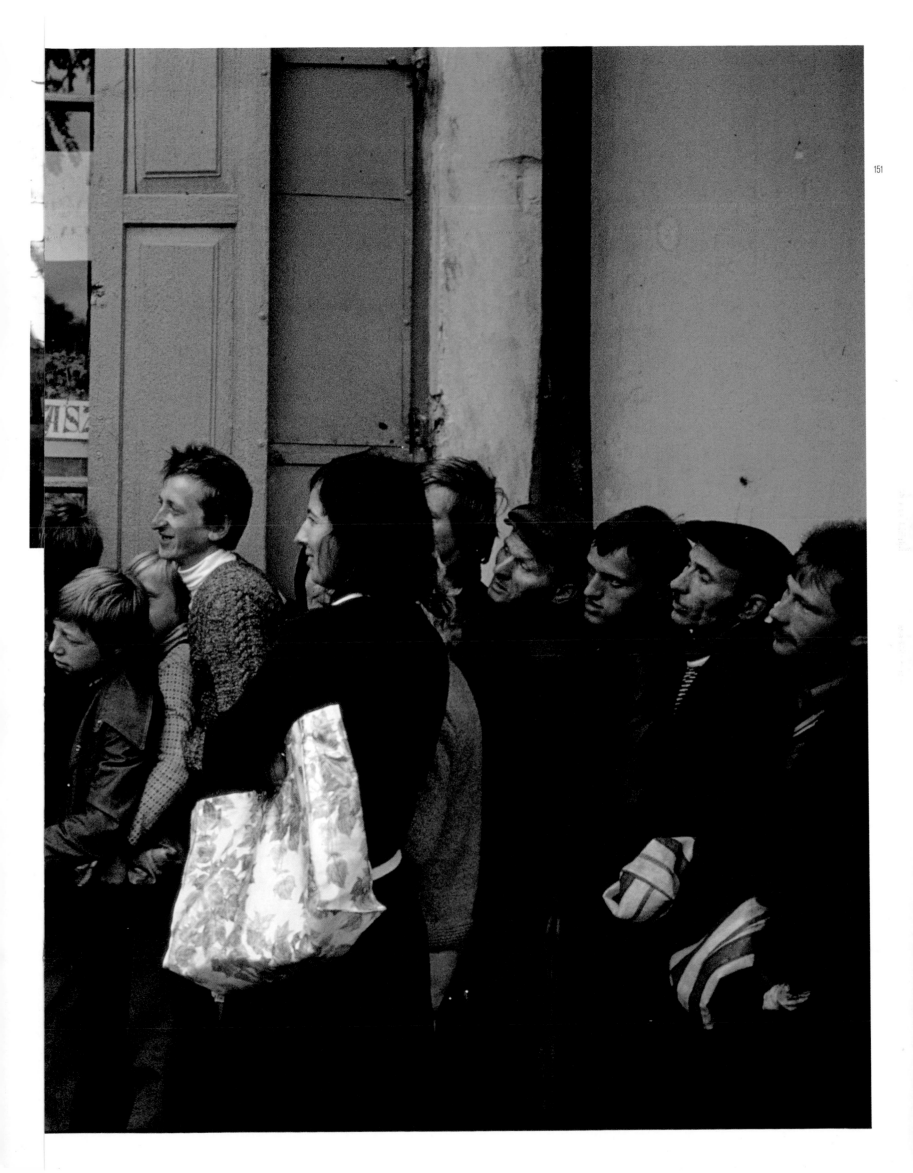

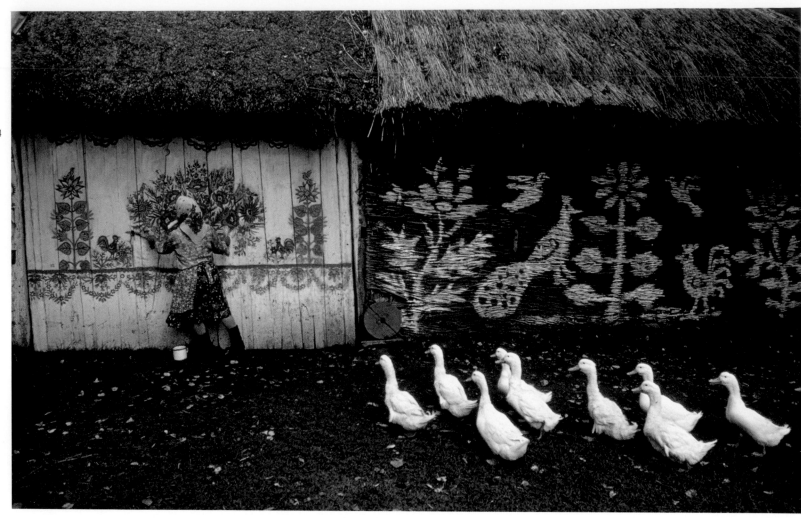

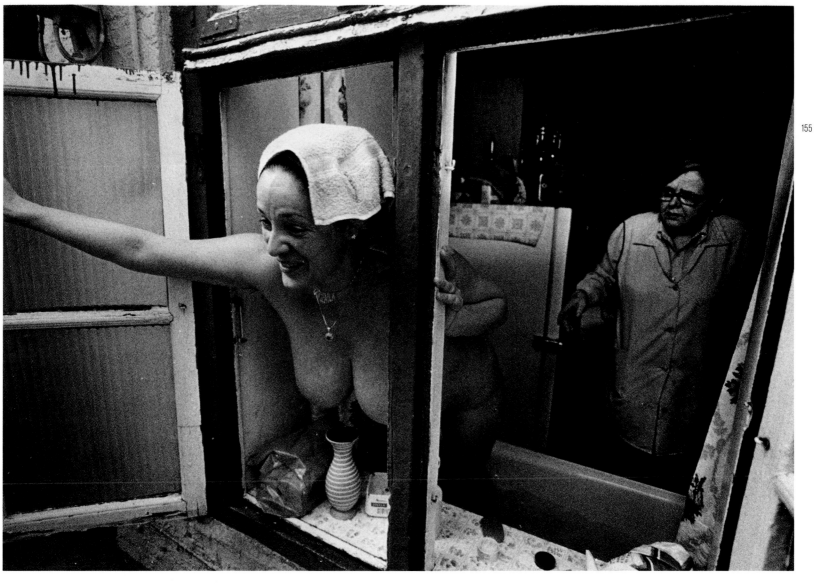

155 Photographer ANDREJ REISER

Designer HARTMUT BRÜCKNER

Publishing Company EICHBORN VERLAG

Writer FEE ZSCHOCKE

Photograph from Andrej Reiser's book "Domenica und die Herbertstrasse" which illustrates the life of a Hamburg prostitute.

Photographe ANDREJ REISER

Maquettiste HARTMUT BRÜCKNER

Editeur EICHBORN VERLAG

Auteur FEE ZSCHOCKE

Photographie du livre d'Andrej Reiser "Domenica und die Herbertstrasse" qui illustre la vie d'une prostituée de Hambourg.

Fotograf ANDREJ REISER

Gestalter HARTMUT BRÜCKNER

Verleger EICHBORN VERLAG

Autor FEE ZSCHOCKE

Foto aus dem Buch "Domenica und die Herbertstrasse" von Andrej Reiser, über das Leben einer Prostituierten in Hamburg.

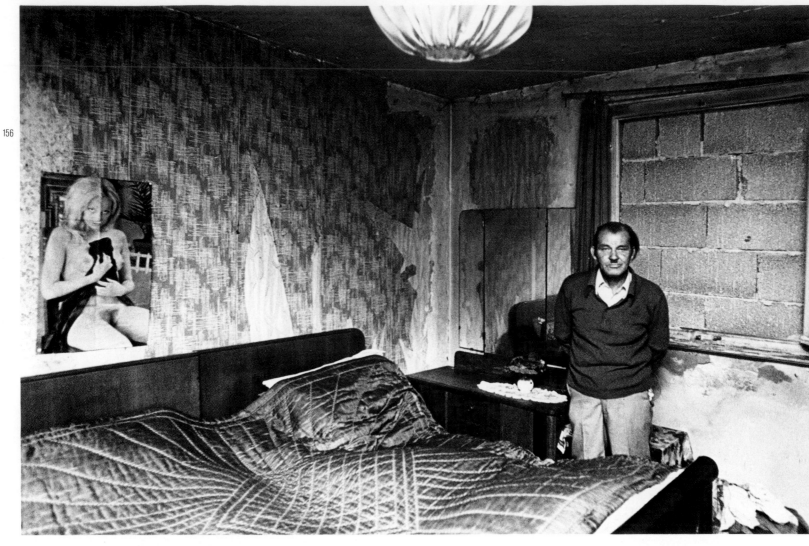

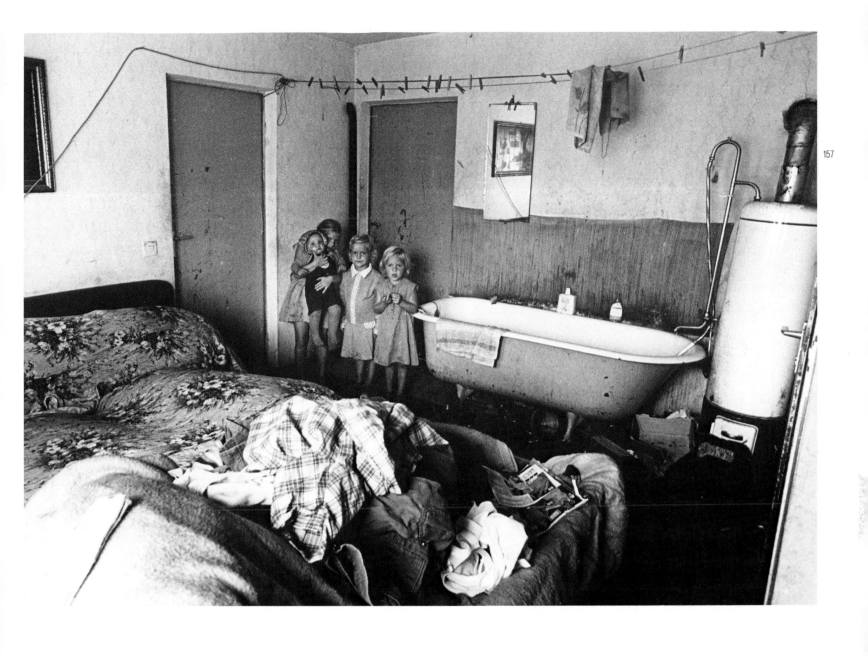

156, 157 Photographer RENATE VON FORSTER

Designer PETER APPELT

Publishing Company GRUBE UND RICHTER

Writer JÜRGEN ROTH

Photographs from the book "Wie soll man hier leben?",
(How can anyone live here?), about the housing
shortage in an affluent society.

Photographe RENATE VON FORSTER

Maquettiste PETER APPELT

Editeur GRUBE UND RICHTER

Auteur JÜRGEN ROTH

Photographies du livre "Wie soll man hier leben?"
(Comment peut-on vivre ici?), concernant la crise du
logement dans la société d'abondance.

Fotograf RENATE VON FORSTER

Gestalter PETER APPELT

Verleger GRUBE UND RICHTER

Autor JÜRGEN ROTH

Fotos aus dem Buch "Wie soll man hier leben?", über
die Wohnungsnot in einer Wohlstandsgesellschaft.

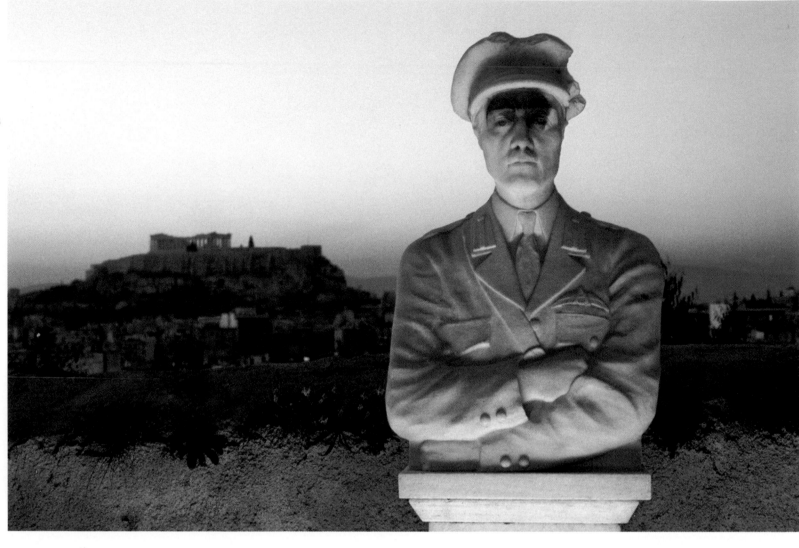

158, 159

Photographer MICHAEL RUETZ	Photographe MICHAEL RUETZ	Fotograf MICHAEL RUETZ
Designers MICHAEL RUETZ/KLAUS DETJEN	Maquettistes MICHAEL RUETZ/KLAUS DETJEN	Gestalter MICHAEL RUETZ/KLAUS DETJEN
Publishing Company CARL HANSER VERLAG	Editeur CARL HANSER VERLAG	Verleger CARL HANSER VERLAG
Photographs from the book "Nekropolis", (Necropolis), which shows curious and touching memorial sites. 158 Monument in a cemetery in Athens. 159 Two gravesites in a Dutch cemetery, linked across the wall of their religious divide.	Photographies du livre "Nekropolis" (Nécropole), qui montrent des sites commémoratifs curieux et émouvants. 158 Monument dans un cimetière d'Athènes. 159 Deux tombes dans un cimetière hollandais, reliées par le mur de leur partage religieux.	Fotos aus dem Buch "Nekropolis", über kuriose und rührende Gedenkstätten. 158 Grabmal in einem Friedhof in Athen. 159 Zwei Grabstätten in einem Friedhof in Holland, verbunden trotz der Mauer ihrer verschiedenen Glauben.

ADVERTISING & POSTERS

This section includes work commissioned for posters, prints and advertisements for consumer magazines.

PUBLICITÉ ET AFFICHES Cette section comprend des travaux commandés pour des affiches, des illustrations et de la publicité pour les magazines de consommateurs.

WERBUNG UND PLAKATE Dieser Abschnitt umfaßt Auftragsarbeiten für Plakate, Drucksachen und Anzeigen für Verbraucherzeitschriften.

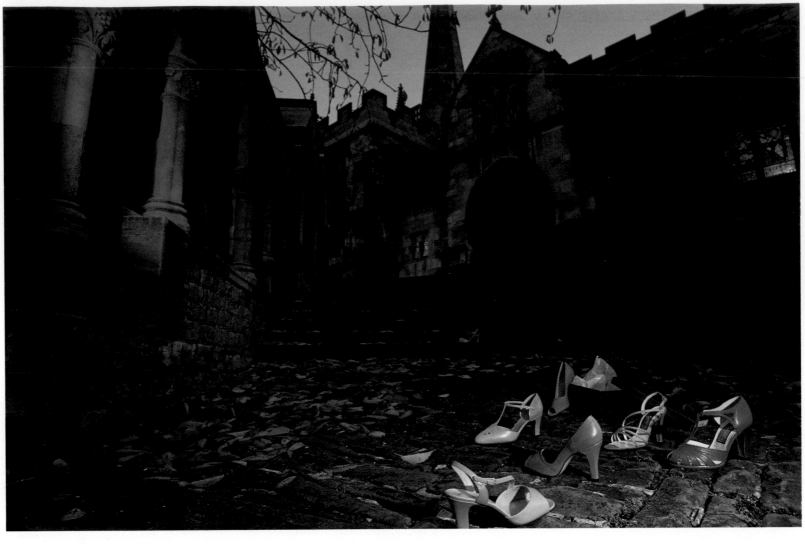

162 Photographer JOHN CLARIDGE

Art Director ALAN WALDIE

Advertising Agency COLLETT DICKENSON
PEARCE & PARTNERS LIMITED

Copywriter MIKE COZENS

Client CLARKS SHOES LIMITED

Advertisement for Clarks Shoes with the copyline
"Paris, Rome or Somerset?" which appeared in
selected British magazines.

Photographe JOHN CLARIDGE

Directeur Artistique ALAN WALDIE

Agence de Publicité COLLETT DICKENSON
PEARCE & PARTNERS LIMITED

Rédacteur MIKE COZENS

Client CLARKS SHOES LIMITED

Publicité pour les chaussures Clarks, avec la légende
"Paris, Rome ou le Somerset?" qui a paru dans divers
magazines britanniques.

Fotograf JOHN CLARIDGE

Art Direktor ALAN WALDIE

Werbeagentur COLLETT DICKENSON
PEARCE & PARTNERS LIMITED

Texter MIKE COZENS

Auftraggeber CLARKS SHOES LIMITED

Anzeige für Clarks Schuhe mit dem Text "Paris, Rom
oder Somerset?",erschienen in verschiedenen
englischen Zeitschriften.

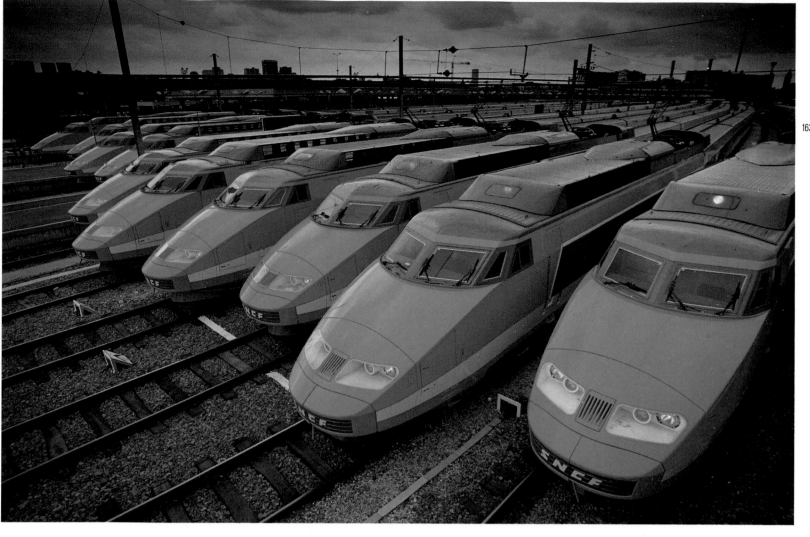

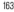

163 Photographer JOHN CLARIDGE	Photographe JOHN CLARIDGE	Fotograf JOHN CLARIDGE
Art Director JOHN SCOTT	Directeur Artistique JOHN SCOTT	Art Direktor JOHN SCOTT
Advertising Agency HAVAS CONSEIL	Agence de Publicité HAVAS CONSEIL	Werbeagentur HAVAS CONSEIL
Copywriter JEAN LOUIS BLANC	Rédacteur JEAN LOUIS BLANC	Texter JEAN LOUIS BLANC
Client S.N.C.F.	Client S.N.C.F.	Auftraggeber S.N.C.F.
Advertisement which appeared in French consumer magazines for the T.G.V. train.	Publicité qui a paru dans des magazines de consommateurs français pour le train T.G.V.	Anzeige für den T.G.V. Zug, erschienen in französischen Verbraucherzeitschriften.

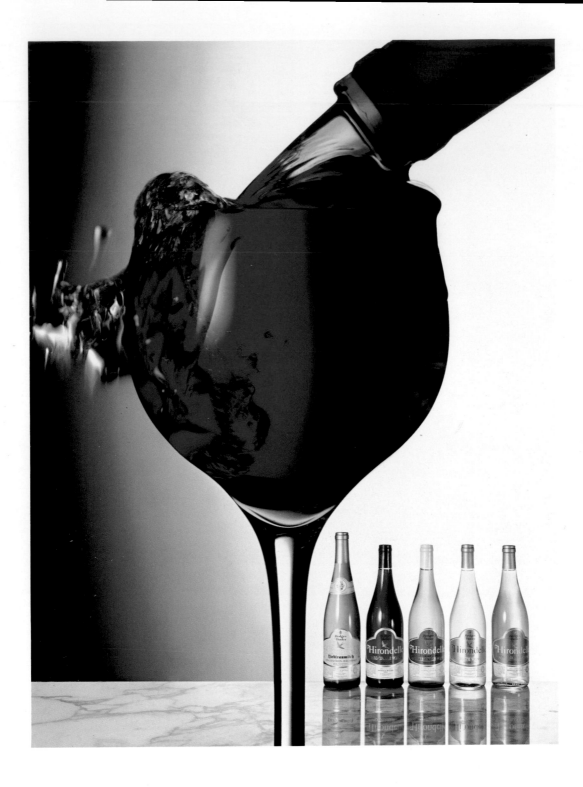

Photographer GARY BRYAN

Art Director ERIC SPIRES

Advertising Agency LINTAS LIMITED

Client HEDGES AND BUTLER LIMITED

Advertisement for Hirondelle wine which appeared in British trade magazines.

Photographer KNUT BRY

Designer CERRUTI 1881, PARIS

Client CERRUTI 1881, FRANCE

Photograph taken in the evening light at Deauville, France, and published as an advertisement for Cerruti in "L'Uomo Vogue" and "Mondo Uomo", Condé Nast Publications, Italy.

Photographe GARY BRYAN

Directeur Artistique ERIC SPIRES

Agence de Publicité LINTAS LIMITED

Client HEDGES AND BUTLER LIMITED

Publicité pour le vin Hirondelle qui a paru dans des magazines professionnels britanniques.

Photographe KNUT BRY

Maquettiste CERRUTI 1881, PARIS

Client CERRUTI 1881, FRANCE

Photographie prise à la lumière du soir à Deauville, France, et publiée comme réclame pour Cerruti dans "L'Uomo Vogue" et "Mondo Uomo", Condé Nast Publications, Italie.

Fotograf GARY BRYAN

Art Direktor ERIC SPIRES

Werbeagentur LINTAS LIMITED

Auftraggeber HEDGES AND BUTLER LIMITED

Anzeige für Hirondelle Wein, erschienen in englischen Fachzeitschriften.

Fotograf KNUT BRY

Gestalter CERRUTI 1881, PARIS

Auftraggeber CERRUTI 1881, FRANCE

Foto, aufgenommen im Abendlicht in Deauville, Frankreich, und veröffentlicht als Anzeige für Cerruti in "L'Uomo Vogue" und "Mondo Uomo", Condé Nast Publications, Italien.

165▶

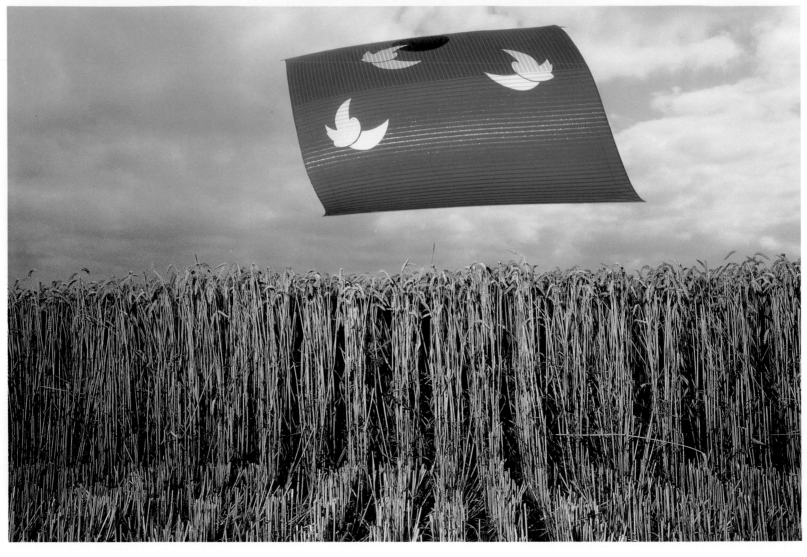

166 Photographer ALEXIS STROUKOFF

Designer PAUL WAGNER

Art Director JOCELYN KARGÈRE

Client ROCHAS

Advertisement for Rochas scarves which appeared in French "Vogue", November, 1981.

Photographe ALEXIS STROUKOFF

Maquettiste PAUL WAGNER

Directeur Artistique JOCELYN KARGÈRE

Client ROCHAS

Publicité pour les écharpes Rochas qui a paru dans le "Vogue" français, en novembre 1981.

Fotograf ALEXIS STROUKOFF

Gestalter PAUL WAGNER

Art Direktor JOCELYN KARGÈRE

Auftraggeber ROCHAS

Anzeige für Rochas Tücher, erschienen in der französischen "Vogue", November 1981.

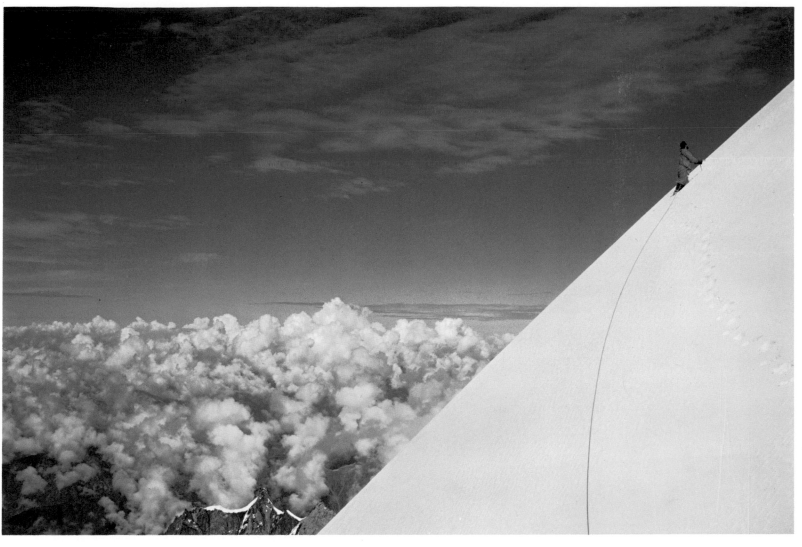

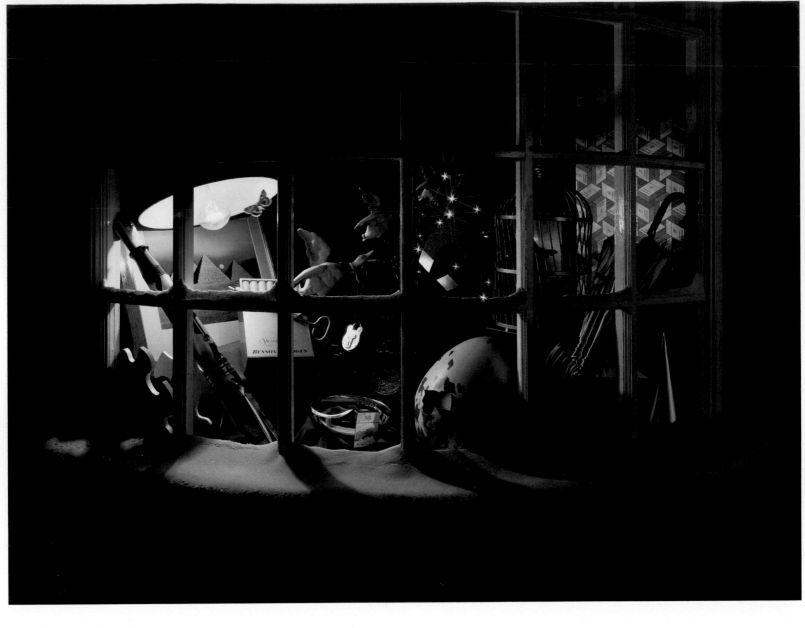

Photographer GRAHAM FORD | Photographe GRAHAM FORD | Fotograf GRAHAM FORD

Art Director JOHN MERRIMAN | Directeur Artistique JOHN MERRIMAN | Art Direktor JOHN MERRIMAN

Advertising Agency COLLETT DICKENSON
PEARCE & PARTNERS LIMITED | Agence de Publicité COLLETT DICKENSON
PEARCE & PARTNERS LIMITED | Werbeagentur COLLETT DICKENSON
PEARCE & PARTNERS LIMITED

Copywriter PAUL WEINBERGER | Rédacteur PAUL WEINBERGER | Texter PAUL WEINBERGER

Client GALLAHER LIMITED | Client GALLAHER LIMITED | Auftraggeber GALLAHER LIMITED

Advertisement for Benson & Hedges cigarettes which appeared in British magazines and newspapers. | Publicité pour les cigarettes Benson & Hedges qui a paru dans des magazines et journaux britanniques. | Anzeige für Benson & Hedges Zigaretten, erschienen in englischen Zeitschriften und Zeitungen.

169 Photographer ROLPH GOBITS	Photographe ROLPH GOBITS	Fotograf ROLPH GOBITS
Art Director BRIAN STEWART	Directeur Artistique BRIAN STEWART	Art Direktor BRIAN STEWART
Advertising Agency KMP PARTNERSHIP LIMITED	Agence de Publicité KMP PARTNERSHIP LIMITED	Werbeagentur KMP PARTNERSHIP LIMITED
Copywriter RICHARD COOK	Rédacteur RICHARD COOK	Texter RICHARD COOK
Client GLOW-WORM LIMITED	Client GLOW-WORM LIMITED	Auftraggeber GLOW-WORM LIMITED
Advertisement for heating systems aimed at local councils, with the copyline "Here's an easy cut to make. Spend less on keeping them warm," which appeared in British trade papers.	Publicité sur les systèmes de chauffage à l'adresse des conseils municipaux, avec la légende "Here's an easy cut to make. Spend less on keeping them warm" (Voici une coupure facile. Dépensez moins pour leur tenir chaud), qui a paru dans les journaux professionnels britanniques.	Anzeige für Heizungsinstallationen, gezielt auf Lokalbehörden, mit dem Titel "Here's an easy cut to make. Spend less on keeping them warm" (Eine einfache Sparmaßnahme. Weniger Aufwand zur Wärmebereitung), erschienen in englischen Fachzeitschriften.

Photographer PER WIKLUND	Photographe PER WIKLUND	Fotograf PER WIKLUND
Designer PER WIKLUND	Maquettiste PER WIKLUND	Gestalter PER WIKLUND
Client AXEL V. BERGSTRÖM A.B.	Client AXEL V. BERGSTRÖM A.B.	Auftraggeber AXEL V. BERGSTRÖM A.B.
Advertisement for Nikon cameras with the copyline "Today is the first day in the rest of your life," which appeared in specialist magazines.	Publicité pour les appareils de photo Nikon avec la légende "Today is the first day in the rest of your life" (Aujourd'hui vous commencez pour toute la vie), qui a paru dans des magazines spécialisés.	Anzeige für Nikon Kameras mit dem Text "Today is the first day in the rest of your life" (Heute ist der erste Tag im Rest Ihres Lebens), erschienen in Fachzeitschriften.

170, 171 ▶

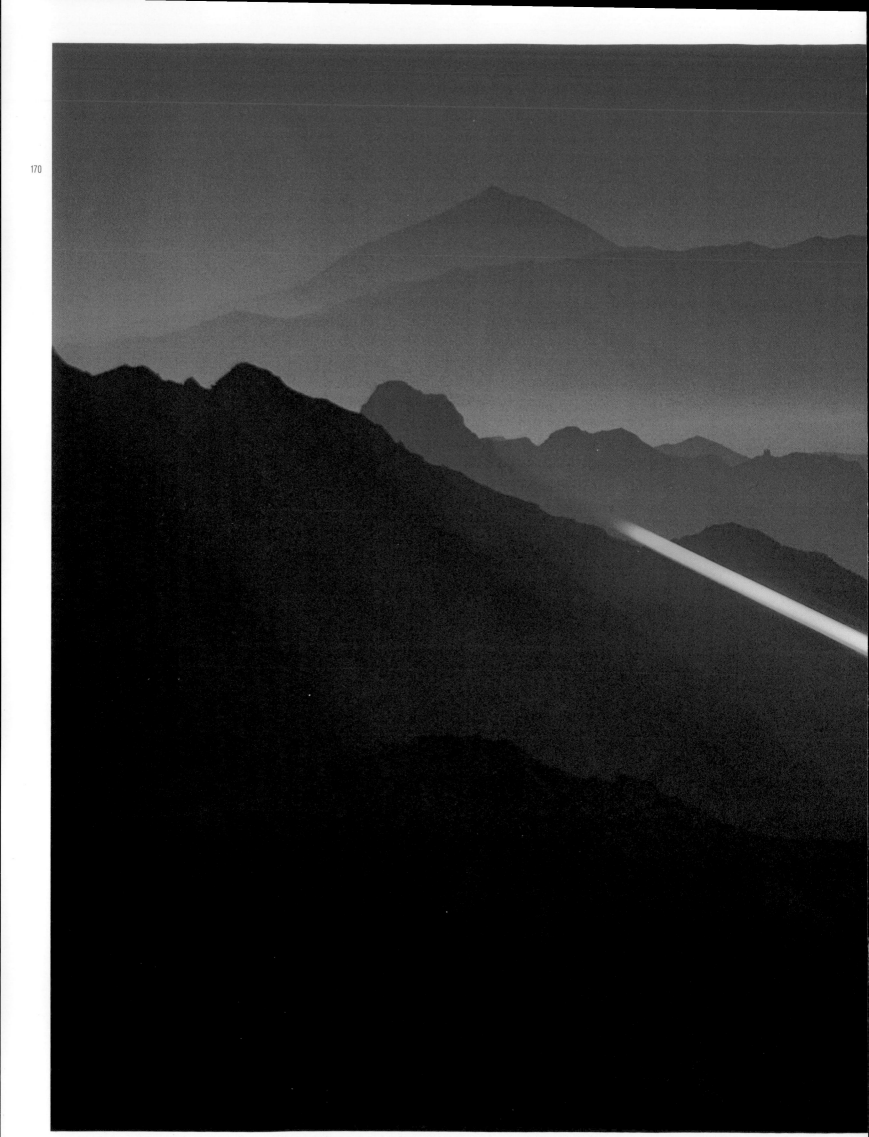

Photographer STAK

Art Director MIKE PRESTON

Advertising Agency J. WALTER THOMPSON

Copywriter RICHARD SLOGGETT

Client THE NATIONAL WESTMINSTER BANK LIMITED

Advertisement promoting special facilities available to farmers with the copyline "A lot of bank managers think that's all there is to farming," which was published in "Farmers' Weekly."

Photographe STAK

Directeur Artistique MIKE PRESTON

Agence de Publicité J. WALTER THOMPSON

Rédacteur RICHARD SLOGGETT

Client THE NATIONAL WESTMINSTER BANK LIMITED

Publicité annonçant des facilités spéciales accordées aux fermiers avec la légende "A lot of bank managers think that's all there is to farming" (Bien des directeurs de banques pensent que l'exploitation agricole ce n'est rien d'autre), qui a paru dans "Farmers' Weekly."

Fotograf STAK

Art Direktor MIKE PRESTON

Werbeagentur J. WALTER THOMPSON

Texter RICHARD SLOGGETT

Auftraggeber THE NATIONAL WESTMINSTER BANK LIMITED

Anzeige zur Promotion von Sondereinrichtungen für Bauern mit dem Titel "A lot of bank managers think that's all there is to farming" (Viele Bankdirektoren glauben daß die Landwirtschaft so einfach ist), erschienen in "Farmers' Weekly."

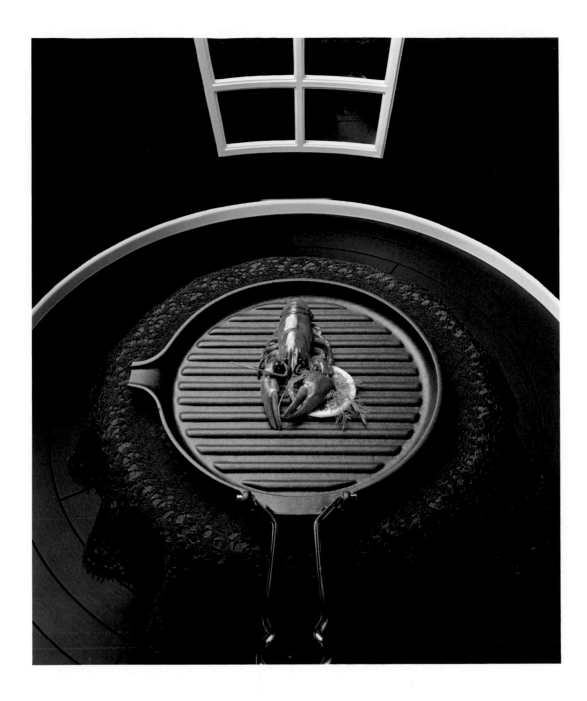

173 Photographer ADRIAN FLOWERS

Photographe ADRIAN FLOWERS

Fotograf ADRIAN FLOWERS

Art Directors
PAUL LEEVES/GLENN CLARK

Directeurs Artistiques
PAUL LEEVES/GLENN CLARK

Art Direktoren
PAUL LEEVES/GLENN CLARK

Advertising Agency AALDERS AND MARCHANT

Agence de Publicité AALDERS AND MARCHANT

Werbeagentur AALDERS AND MARCHANT

Copywriter ALAN TILBY

Rédacteur ALAN TILBY

Texter ALAN TILBY

Client LE CREUSET

Client LE CREUSET

Auftraggeber LE CREUSET

Advertisement with the copyline "Ecrevisse on lemon, herbs and Le Creuset," which appeared in British magazines.

Publicité avec la légende "Ecrevisse on lemon, herbs and Le Creuset" (Ecrevisse sur citron, herbes aromatiques et Le Creuset), qui a paru dans des magazines britanniques.

Anzeige mit dem Text "Ecrevisse on lemon, herbs and le Creuset" (Ecrevisse auf Zitrone, Kräutern und Le Creuset), erschienen in englischen Zeitschriften.

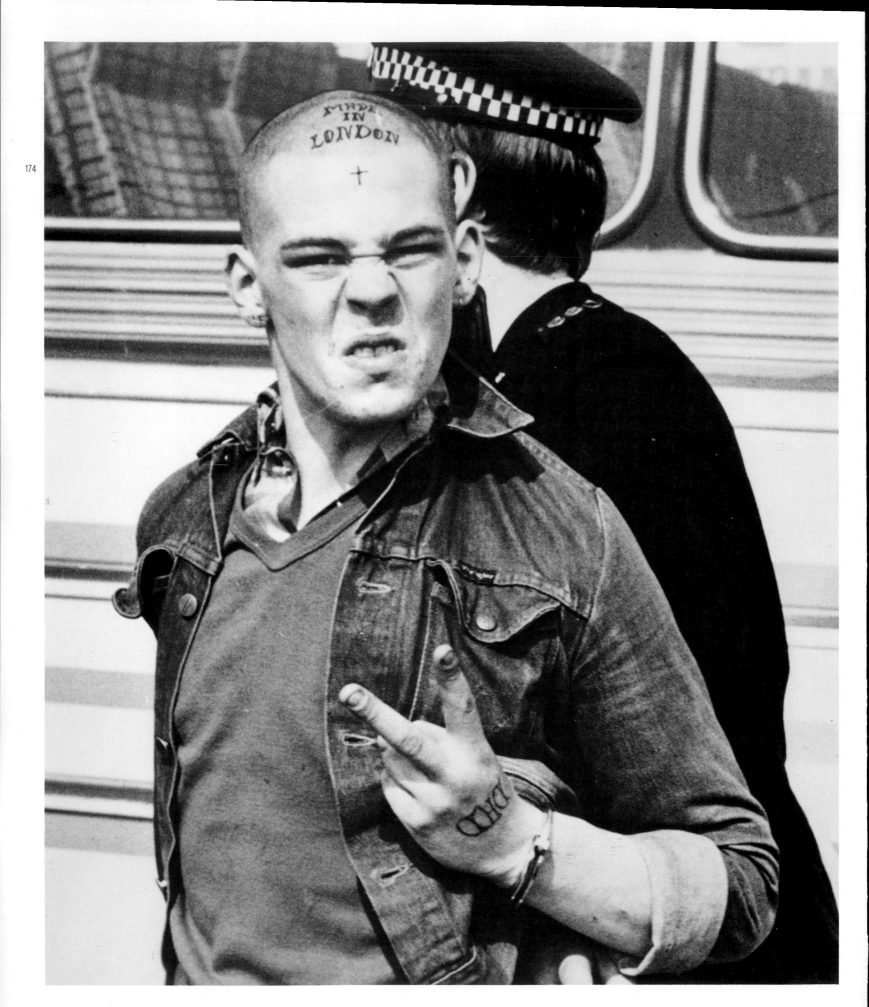

175 Photographer TERENCE DONOVAN	Photographe TERENCE DONOVAN	Fotograf TERENCE DONOVAN
Art Director PAUL ARDEN	Directeur Artistique PAUL ARDEN	Art Direktor PAUL ARDEN
Advertising Agency SAATCHI & SAATCHI	Agence de Publicité SAATCHI & SAATCHI	Werbeagentur SAATCHI & SAATCHI
Copywriter SIMON DICKETTS	Rédacteur SIMON DICKETTS	Texter SIMON DICKETTS
Client INTERNATIONAL GOLD CORPORATION	Client INTERNATIONAL GOLD CORPORATION	Auftraggeber INTERNATIONAL GOLD CORPORATION
Advertisement with the copyline "You'll never forget who gave you gold", published in British "Vogue".	Publicité avec la légende "You'll never forget who gave you gold" (Vous n'oublierez jamais qui vous a donné de l'or), publiée dans "Vogue" britannique.	Anzeige mit dem Text "You'll never forget who gave you gold" (Sie werden niemals vergessen, wer Ihnen Gold geschenkt hat) erschienen in der englischen "Vogue".
◀**174** Photographer JOHN DOWNING	Photographe JOHN DOWNING	Fotograf JOHN DOWNING
Designer GERARD STAMP	Maquettiste GERARD STAMP	Gestalter GERARD STAMP
Art Director GERARD STAMP	Directeur Artistique GERARD STAMP	Art Direktor GERARD STAMP
Advertising Agency BOASE MASSIMI POLLITT UNIVAS PARTNERSHIP LIMITED	Agence de Publicité BOASE MASSIMI POLLITT UNIVAS PARTNERSHIP LIMITED	Werbeagentur BOASE MASSIMI POLLITT UNIVAS PARTNERSHIP LIMITED
Copywriter PATRICK COLLISTER	Rédacteur PATRICK COLLISTER	Texter PATRICK COLLISTER
Client EXPRESS NEWSPAPERS LIMITED	Client EXPRESS NEWSPAPERS LIMITED	Auftraggeber EXPRESS NEWSPAPERS LIMITED
Editorial photograph taken in Brighton on a Bank Holiday Monday and subsequently used as an advertisement for "The Daily Express" which appeared in British trade magazines with the copyline "Smile, you just won an award".	Photographie de presse prise à Brighton un lundi de Bank Holiday et utilisée par la suite comme publicité pour "The Daily Express" qui a paru dans des magazines professionnels britanniques avec la légende "Smile, you just won an award" (Souriez, vous venez de gagner une récompense).	Redaktions-Foto, aufgenommen in Brighton an einem Bankfeiertags-Montag, und später in englischen Fachzeitschriften eingesetzt als Anzeige für "The Daily Express" mit dem Titel "Smile, you just won an award" (Bitte lächeln, Sie haben soeben einen Preis gewonnen).

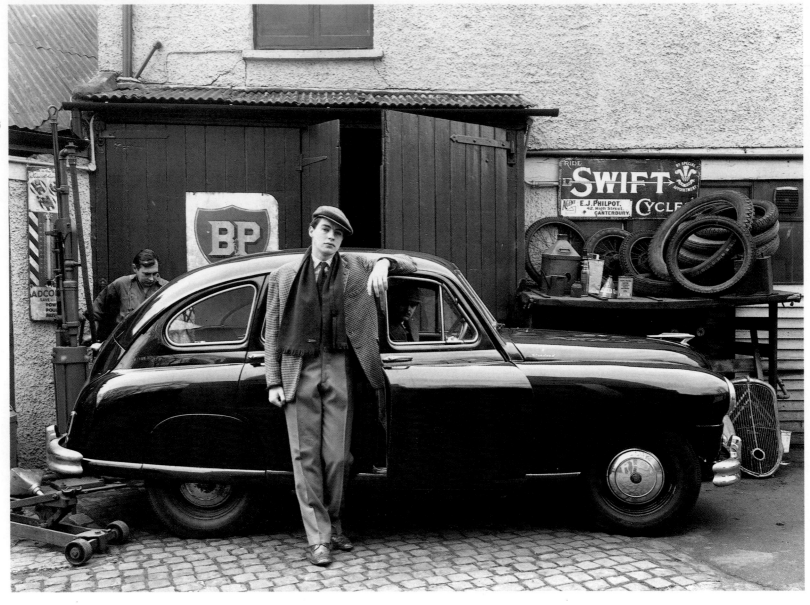

176 Photographer BOB MILLER

Designer RON BROWN

Art Director RON BROWN

Advertising Agency
ABBOTT MEAD VICKERS/SMS LIMITED

Copywriter DAVID ABBOTT

Client SUN ALLIANCE INSURANCE GROUP

Photographe BOB MILLER

Maquettiste RON BROWN

Directeur Artistique RON BROWN

Agence de Publicité
ABBOTT MEAD VICKERS/SMS LIMITED

Rédacteur DAVID ABBOTT

Client SUN ALLIANCE INSURANCE GROUP

Fotograf BOB MILLER

Gestalter RON BROWN

Art Direktor RON BROWN

Werbeagentur
ABBOTT MEAD VICKERS/SMS LIMITED

Texter DAVID ABBOTT

Auftraggeber SUN ALLIANCE INSURANCE GROUP

One of four photographs which appeared in an advertisement aimed at the over-50's with the copyline "If you learned to drive in cars like these, we can probably save you money on motor insurance," published in British newspapers and magazines.

Une des quatre photographies qui ont paru dans une publicité qui s'addressait aux personnes de plus de 50 ans avec la légende "If you learned to drive in cars like these, we can probably save you money on motor insurance," (Si vous avez appris à conduire dans ce genre de voitures, nous pouvons sans doute vous faire faire des économies sur votre assurance automobile), publiée dans des journaux et magazines britanniques.

Eins von vier Fotos, erschienen in einer Anzeige gezielt auf die über-50er Generation, mit dem Text "If you learned to drive in cars like these, we can probably save you money on motor insurance" (Wenn Sie in Autos wie diesen fahren gelernt haben können wir Ihren wahrscheinlich Versicherungsgeld sparen), veröffentlicht in englischen Zeitungen und Zeitschriften.

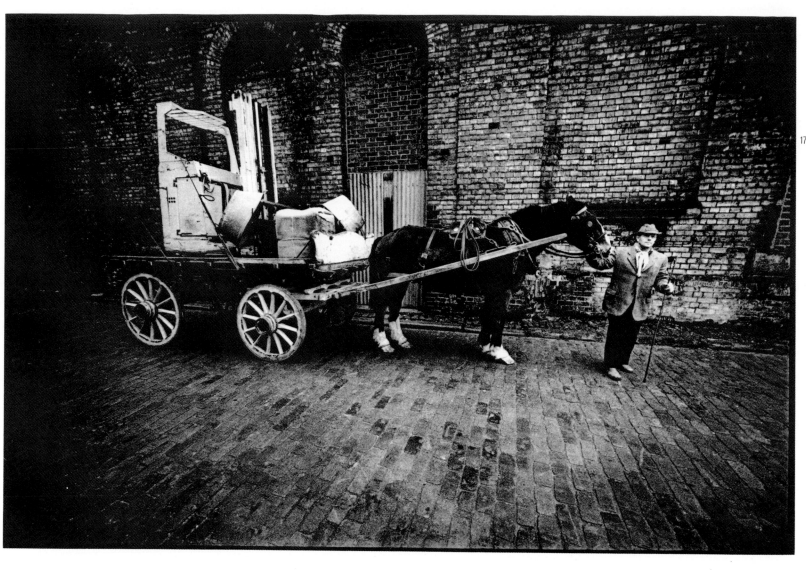

177 Photographer JOHN CLARIDGE

Art Director ALLESSIO FERLIZZA

Advertising Agency
BASTABLE ADVERTISING AND MARKETING LIMITED

Copywriter IAN MAYES

Client ATLET LIMITED

Photograph of a rag-and-bone man in the East End of
London which appeared in British specialist
magazines as an advertisement for Atlet trucks.

Photographe JOHN CLARIDGE

Directeur Artistique ALLESSIO FERLIZZA

Agence de Publicité
BASTABLE ADVERTISING AND MARKETING LIMITED

Rédacteur IAN MAYES

Client ATLET LIMITED

Photographie d'un chiffonnier de l'East End de
Londres qui a paru dans des magazines spécialisés
britanniques comme publicité pour les camions Atlet.

Fotograf JOHN CLARIDGE

Art Direktor ALLESSIO FERLIZZA

Werbeagentur
BASTABLE ADVERTISING AND MARKETING LIMITED

Texter IAN MAYES

Auftraggeber ATLET LIMITED

Foto eines Lumpensammlers in der East End von
London, erschienen in englischen Fachzeitschriften als
Anzeige für Atlet Lastkraftwagen.

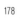

178 Photographer GRAHAM FORD	Photographe GRAHAM FORD	Fotograf GRAHAM FORD
Art Director DIGBY ATKINSON	Directeur Artistique DIGBY ATKINSON	Art Direktor DIGBY ATKINSON
Advertising Agency SAATCHI & SAATCHI	Agence de Publicité SAATCHI & SAATCHI	Werbeagentur SAATCHI & SAATCHI
Copywriters DIGBY ATKINSON/PETER WALLACH	Rédacteurs DIGBY ATKINSON/PETER WALLACH	Texter DIGBY ATKINSON/PETER WALLACH
Client SMITH AND NEPHEW ASSOCIATED COMPANIES LIMITED	Client SMITH AND NEPHEW ASSOCIATED COMPANIES LIMITED	Auftraggeber SMITH AND NEPHEW ASSOCIATED COMPANIES LIMITED
Advertisement with the copyline "Atrixo lotion makes your hands feel better," which appeared in British magazines and newspapers.	Publicité avec la légende "Atrixo lotion makes your hands feel better" (La lotion Atrixo vous adoucit les mains), qui a paru dans des magazines et journaux britanniques.	Anzeige mit dem Text "Atrixo lotion makes your hands feel better" (Mit Atrixo Lotion fühlen sich Ihre Hande wohler), erschien in englischen Zeitschriften und Zeitungen.

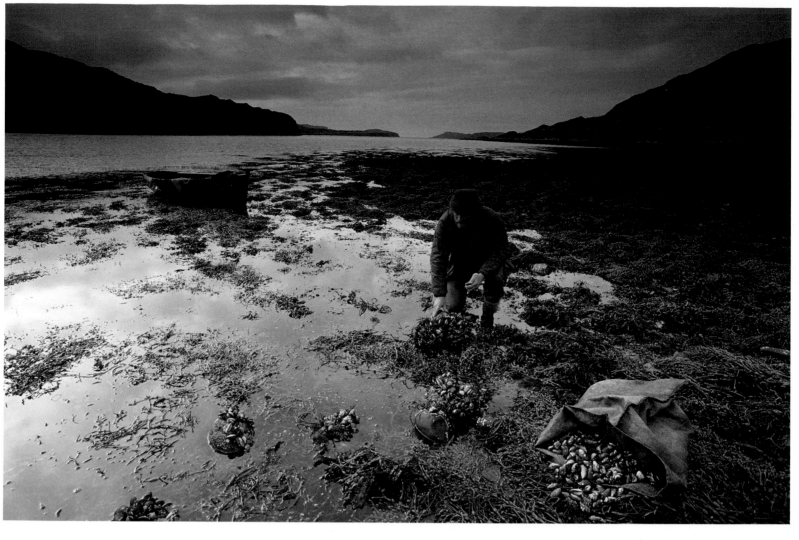

179 Photographer JOHN CLARIDGE

Art Director GARY HORNER

Advertising Agency OGILVY & MATHER LIMITED

Copywriter INDRA SINHA

Client SHELL U.K. LIMITED

Advertisement with the copyline "This, believe it or not, is how Shell goes recruiting its marine ecologists," which appeared in selected British newspapers and magazines.

Photographe JOHN CLARIDGE

Directeur Artistique GARY HORNER

Agence de Publicité OGILVY & MATHER LIMITED

Rédacteur INDRA SINHA

Client SHELL U.K. LIMITED

Publicité avec la légende "This, believe it or not, is how Shell goes recruiting its marine ecologists" (Voilà, figurez-vous, comment Shell s'y prend pour recruter ses ècologistes marins), qui a paru dans divers magazines et journaux britanniques.

Fotograf JOHN CLARIDGE

Art Direktor GARY HORNER

Werbeagentur OGILVY & MATHER LIMITED

Texter INDRA SINHA

Auftraggeber SHELL U.K. LIMITED

Anzeige mit dem Text "This, believe it or not, is how Shell goes recruiting its marine ecologists" (So, ob Sie's glauben oder nicht, wirbt Shell Marine-Ökologen an), erschienen in verschiedenen englischen Zeitungen und Zeitschriften.

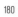

180 Photographer BRUCE BROWN

Designer BERNARD FIÉVÉ

Art Director CHRISTIAN REUILLY

Advertising Agency OGILVY & MATHER, PARIS

Copywriter JEAN MICHEL BOISSIER

Client MERCEDES BENZ FRANCE

Advertisement for Mercedes Benz cars taken in
Saintes Maries de la Mer, France, which appeared in
the French press.

Photographe BRUCE BROWN

Maquettiste BERNARD FIÉVÉ

Directeur Artistique CHRISTIAN REUILLY

Agence de Publicité OGILVY & MATHER, PARIS

Rédacteur JEAN MICHEL BOISSIER

Client MERCEDES BENZ FRANCE

Publicité pour les voitures Mercedez Benz prise aux
Saintes Maries de la Mer, France, qui a paru dans la
presse française.

Fotograf BRUCE BROWN

Gestalter BERNARD FIÉVÉ

Art Direktor CHRISTIAN REUILLY

Werbeagentur OGILVY & MATHER, PARIS

Texter JEAN MICHEL BOISSIER

Auftraggeber MERCEDES BENZ FRANCE

Anzeige für Mercedes Benz Autos, aufgenommen in
Saintes Maries de la Mer, Frankreich, erschienen in
der französischen Presse.

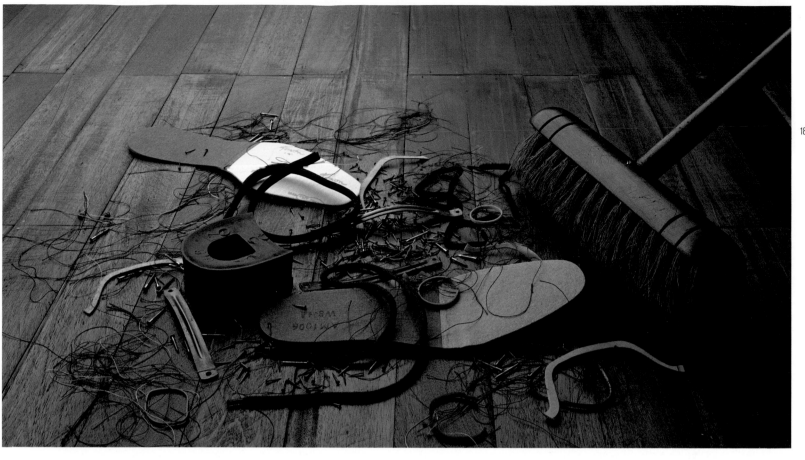

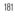

181 Photographer STAK	Photographe STAK	Fotograf STAK
Art Director NIGEL ROSE	Directeur Artistique NIGEL ROSE	Art Direktor NIGEL ROSE
Advertising Agency COLLETT DICKENSON PEARCE & PARTNERS LIMITED	Agence de Publicité COLLETT DICKENSON PEARCE & PARTNERS LIMITED	Werbeagentur COLLETT DICKENSON PEARCE & PARTNERS LIMITED
Copywriter TONY BRIGNULL	Rédacteur TONY BRIGNULL	Texter TONY BRIGNULL
Client CLARKS SHOES LIMITED	Client CLARKS SHOES LIMITED	Auftraggeber CLARKS SHOES LIMITED
Advertisement for Clarks Shoes with the copyline "We found everything that makes a shoe hurt and threw it away," which appeared in numerous British magazines.	Publicité pour les chaussures Clarks avec la légende "We found everything that makes a shoe hurt and threw it away" (Nous avons trouvé tout ce qui pouvait faire mal dans une chaussure et l'avons jeté), qui a paru dans de nombreux magazines britanniques.	Anzeige für Clarks Schuhe mit dem Titel "We found everything that makes a shoe hurt and threw it away" (Wir haben all das ausfindig gemacht, was Füßen druckt, und es rausgeworfen), erschienen in zahlreichen englischen Zeitschriften.

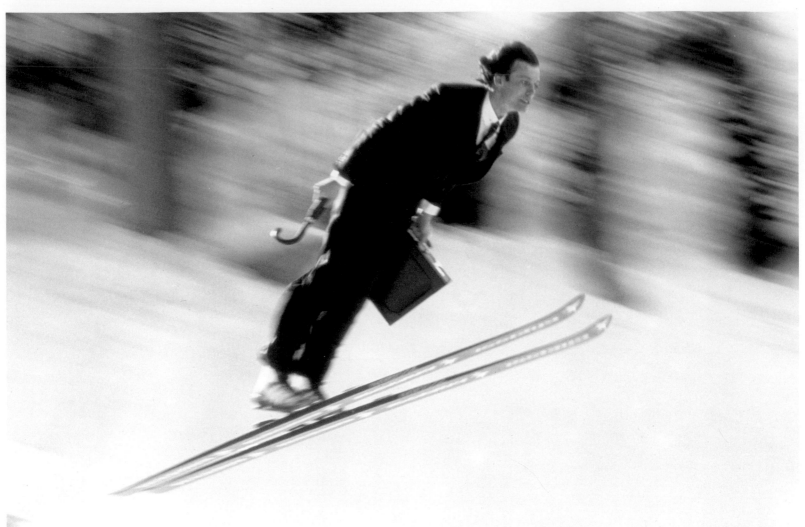

182 Photographer MANFRED VOGELSÄNGER

Art Director FRANCESCO CARROZZINI

Client CLUB MÉDITERRANÉE, GERMANY

Advertisement for Club Méditerranée which appeared
in German newspapers and magazines.

Photographe MANFRED VOGELSÄNGER

Directeur Artistique FRANCESCO CARROZZINI

Client CLUB MÉDITERRANÉE, GERMANY

Publicité pour le Club Méditerranée qui a paru dans
des journaux et magazines allemands.

Fotograf MANFRED VOGELSÄNGER

Art Direktor FRANCESCO CARROZZINI

Auftraggeber CLUB MÉDITERRANÉE, GERMANY

Anzeige für den Club Méditerranée, erschienen in
deutschen Zeitungen und Zeitschriften.

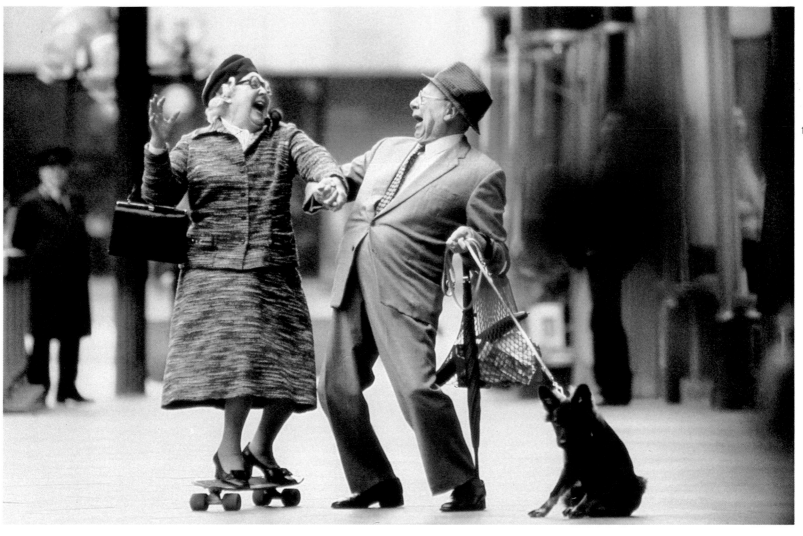

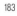

183 Photographer MANFRED VOGELSÄNGER	Photographe MANFRED VOGELSÄNGER	Fotograf MANFRED VOGELSÄNGER
Art Director ODA LINDIG	Directeur Artistique ODA LINDIG	Art Direktor ODA LINDIG
Advertising Agency JESKE UND KLEMENS	Agence de Publicité JESKE UND KLEMENS	Werbeagentur JESKE UND KLEMENS
Client KLINGE	Client KLINGE	Auftraggeber KLINGE
Advertisement for a pharmaceutical company which appeared in German magazines.	Publicité pour une compagnie pharmaceutique qui a paru dans des magazines allemands.	Anzeige für ein pharmazeutisches Unternehmen, erschienen in deutschen Zeitschriften.

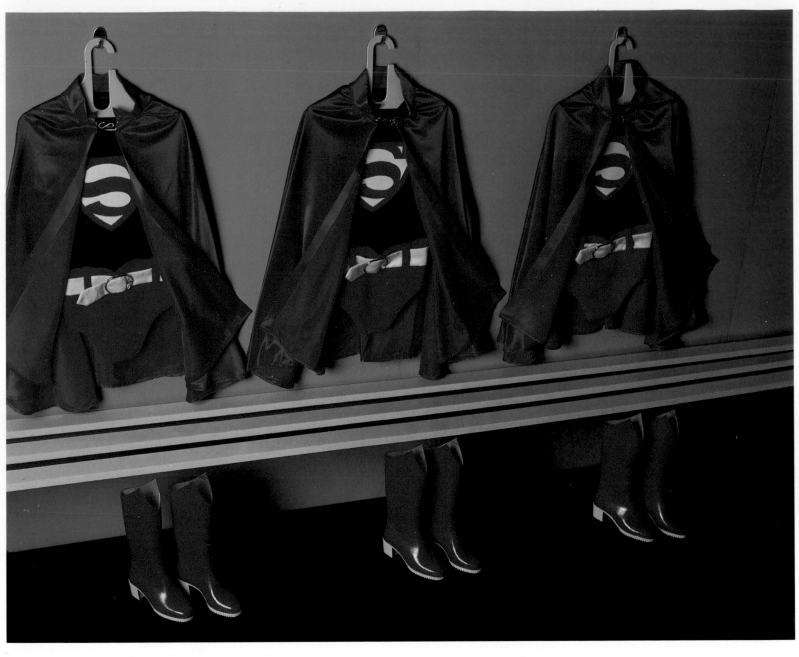

184 Photographer PETER SMITH

Art Director CHRISTOPHER PERKIS

Advertising Agency T. RICHARD JOHNSON
LIMITED ADVERTISING

Copywriter CHRISTOPHER PERKIS

Client DYNAMO AND MOTOR REPAIRS
LIMITED

Advertisement which appeared as a double-page
spread in British industrial magazines with the
copyline "The speed of our repairs is almost
legendary."

Photographe PETER SMITH

Directeur Artistique CHRISTOPHER PERKIS

Agence de Publicité T. RICHARD JOHNSON
LIMITED ADVERTISING

Rédacteur CHRISTOPHER PERKIS

Client DYNAMO AND MOTOR REPAIRS
LIMITED

Publicité qui a paru en double page dans des
magazines professionnels britanniques avec la légende
"The speed of our repairs is almost legendary" (La
vitesse de nos réparations est presque légendaire).

Fotograf PETER SMITH

Art Direktor CHRISTOPHER PERKIS

Werbeagentur T. RICHARD JOHNSON
LIMITED ADVERTISING

Texter CHRISTOPHER PERKIS

Auftraggeber DYNAMO AND MOTOR REPAIRS
LIMITED

Anzeige, erschienen als Doppelseite in englischen
Fachzeitschriften, mit dem Titel "The speed of our
repairs is almost legendary" (Reparaturen werden bei
uns mit sagenhafter Schnelligkeit durchgeführt).

Photographer KEN GRIFFITHS

Photographe KEN GRIFFITHS

Fotograf KEN GRIFFITHS

Art Director IAN POTTER

Directeur Artistique IAN POTTER

Art Direktor IAN POTTER

Advertising Agency FCO UNIVAS LIMITED

Agence de Publicité FCO UNIVAS LIMITED

Werbeagentur FCO UNIVAS LIMITED

Client BLUE RIBBON SPORTS

Client BLUE RIBBON SPORTS

Auftraggeber BLUE RIBBON SPORTS

Photograph of Canal St. Martin, Paris, used on an in-store poster for Nike sports shoes.

Photographie du Canal St. Martin, Paris, utilisée sur une affichette de magasin pour les chaussures de sport Nike.

Foto des St. Martin Kanals, Paris, für Geschäfte, die Nike Sportschuhe verkaufen.

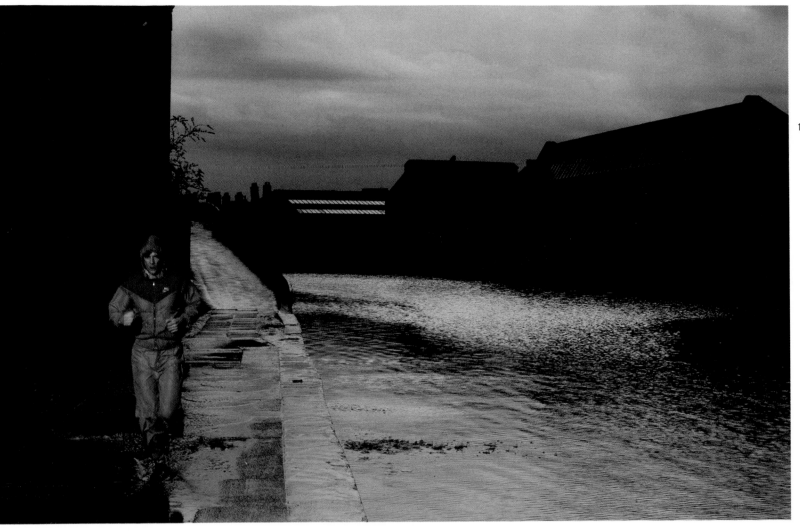

187 Photographer KEN GRIFFITHS	Photographe KEN GRIFFITHS	Fotograf KEN GRIFFITHS
Art Director IAN POTTER	Directeur Artistique IAN POTTER	Art Direktor IAN POTTER
Advertising Agency FCO UNIVAS LIMITED	Agence de Publicité FCO UNIVAS LIMITED	Werbeagentur FCO UNIVAS LIMITED
Client BLUE RIBBON SPORTS	Client BLUE RIBBON SPORTS	Auftraggeber BLUE RIBBON SPORTS
Photograph of Camden Lock, London, used on an in-store poster for Nike sports shoes.	Photographie de Camden Lock, Londres, utilisée sur une affichette de magasin pour les chaussures de sport Nike.	Foto von Camden Lock, London, für Geschäfte, die Nike Sportschuhe verkaufen.
◀**186** Photographer SHAUN SKELLY	Photographe SHAUN SKELLY	Fotograf SHAUN SKELLY
Designer ROGER GOULD,	Maquettiste ROGER GOULD,	Gestalter ROGER GOULD,
Picture Editor RAY BLUMIRE	Directeur de Photographie RAY BLUMIRE	Bildredakteur RAY BLUMIRE
Client THE DAILY TELEGRAPH LIMITED	Client THE DAILY TELEGRAPH LIMITED	Auftraggeber THE DAILY TELEGRAPH LIMITED
Portrait of Arthur Rubinstein used as a promotional poster to publicise a cover story and lead feature by Lee Langley in the "Telegraph Sunday Magazine."	Portrait d'Arthur Rubinstein utilisée comme poster publicitaire pour annoncer un article de première page et éditorial par Lee Langley dans le "Telegraph Sunday Magazine."	Portrait von Arthur Rubinstein, eingesetzt als Promotions-Poster für einen Hauptartikel von Lee Langley im "Telegraph Sunday Magazine."

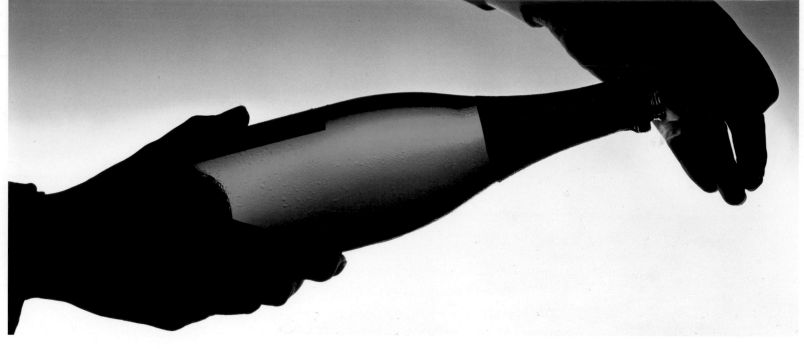

188 Photographer STAK	Photographe STAK	Fotograf STAK
Art Director JOHN SCOTT	Directeur Artistique JOHN SCOTT	Art Direktor JOHN SCOTT
Advertising Agency DOYLE DANE BERNBACH	Agence de Publicité DOYLE DANE BERNBACH	Werbeagentur DOYLE DANE BERNBACH
Client NICOLAS VINS	Client NICOLAS VINS	Auftraggeber NICOLAS VINS
Poster used on bus sides throughout France.	Affiche utilisée sur le côté des autobus partout en France.	Ein Poster, das auf den Seitenfassaden von vielen Bussen in Frankreich eingesetzt wurde.

189 Photographer BARRY MEEKUMS	Photographe BARRY MEEKUMS	Fotograf BARRY MEEKUMS
Art Director RICHARD HAYDEN	Directeur Artistique RICHARD HAYDEN	Art Direktor RICHARD HAYDEN
Advertising Agency SJIP/BBDO	Agence de Publicité SJIP/BBDO	Werbeagentur SJIP/BBDO
Copywriter BARRY WHITEHEAD	Rédacteur BARRY WHITEHEAD	Texter BARRY WHITEHEAD
Client ALLIED BREWERIES LIMITED	Client ALLIED BREWERIES LIMITED	Auftraggeber ALLIED BREWERIES LIMITED
Shot of a pub in Upton-on-Severn, Worcestershire, used as a 48 sheet poster for Ansells Bitter with the headline "The Ploughman's Lunch."	Vue d'un "pub" à Upton-on-Severn, Worcestershire, utilisée comme poster de 48 feuilles pour la bière Ansells avec la légende "The Ploughman's Lunch" (Déjeuner du laboureur).	Aufnahme eines Pubs in Upton-on-Severn, Worcestershire, für ein 48 Bogen Plakat für Ansells Bitter mit dem Titel "The Ploughman's Lunch."

D E S I G N

This section includes work commissioned for calendars, diaries, direct mail announcements, greetings cards, promotional mailings, record sleeves, stationery, technical and industrial catalogues.

DESIGN Cette section comprend des travaux commandés pour des calendriers, des agendas, des lettres circulaires, des cartes de voeux, des emballages, des livrets de promotion par poste, des pochettes de disques, de la papeterie, des catalogues techniques et industriels.

DESIGN Dieser Abschnitt umfaßt Arbeiten für Kalender, Agenden, Werbesendungen, Grußkarten, Verpackungsartikel, Prospekte, Schallplattenhüllen, Briefköpfe, technische und Industriekataloge.

192-197 Photographer BARRY LATEGAN

Designer JEREMY PEMBERTON

Advertising Agency
THE YELLOWHAMMER COMPANY LIMITED

Client
OLYMPUS OPTICAL CO. (UK) LIMITED

Series of photographs taken from a limited edition
portfolio entitled "Trees," published in February 1982.
192: Wilshire Boulevard, Los Angeles
193: Santa Monica Freeway, Los Angeles
194: Potenure, Piacenza, Italy
195: Randburg, South Africa
196, 197: Carmine and Varick, New York

Photographe BARRY LATEGAN

Maquettiste JEREMY PEMBERTON

Agence de Publicité
THE YELLOWHAMMER COMPANY LIMITED

Client
OLYMPUS OPTICAL CO. (UK) LIMITED

Série de photographies empruntées à une édition
limitée portfolio intitulée "Trees" (Arbres), publiée en
Février 1982.
192: Wilshire Boulevard, Los Angeles
193: Santa Monica Freeway, Los Angeles
194: Potenure, Piacenza, Italie
195: Randburg, Afrique du Sud
196, 197: Carmine et Varick, New York

Fotograf BARRY LATEGAN

Gestalter JEREMY PEMBERTON

Werbeagentur
THE YELLOWHAMMER COMPANY LIMITED

Auftraggeber
OLYMPUS OPTICAL CO. (UK) LIMITED

Foto-Serie aus einer numerierten Ausgabe mit dem
Titel "Trees" (Bäume), veröffentlicht im Februar 1982.
192: Wilshire Boulevard, Los Angeles
193: Santa Monica Freeway, Los Angeles
194: Potenure, Piacenza, Italien
195: Randburg, Südafrika
196, 197: Carmine und Varick, New York

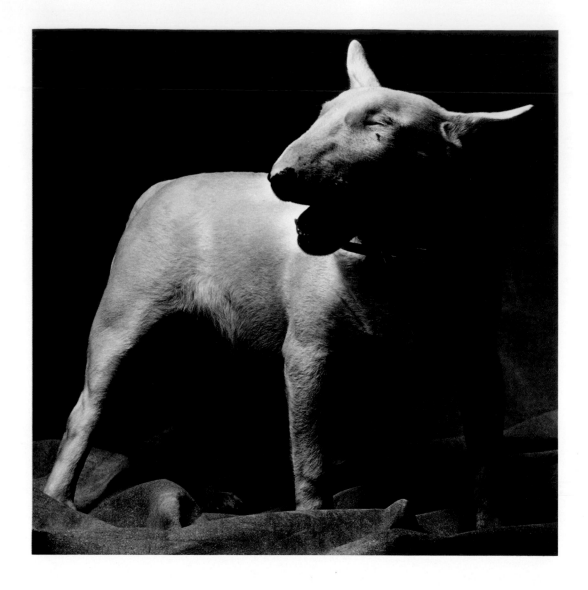

Photographer GRAHAM HUGHES

Designer GRAHAM HUGHES

Photographer's English Bull Terrier used on a self-promotional poster.

Photographe GRAHAM HUGHES

Maquettiste GRAHAM HUGHES

Bull Terrier anglais du photographe utilisé sur une affiche autopromotionnelle.

Fotograf GRAHAM HUGHES

Gestalter GRAHAM HUGHES

Der englische Bullterrier des Fotografen, für ein Plakat zur Eigenwerbung.

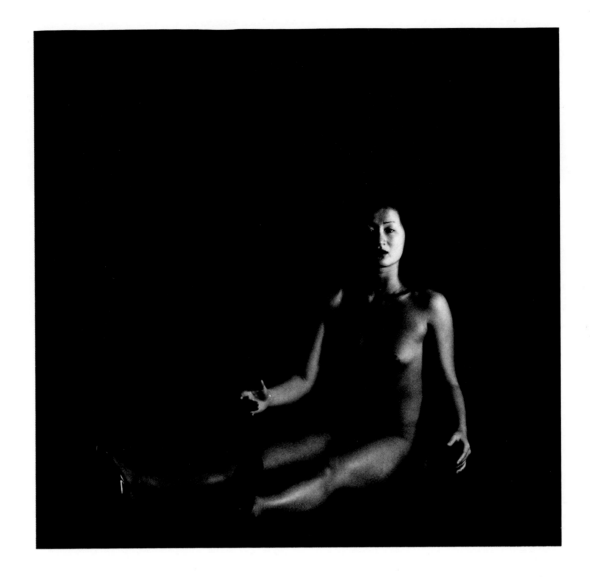

Photographer ALFRED SCHULZE RIEPING

One of a series of photographs entitled "Echt und
wahr" (Authentic and True) for use on a self-
promotional poster.

Photographe ALFRED SCHULZE RIEPING

Photographie d'une série intitulée "Echt und wahr"
(Authentiques et Véritables) pour utilisation dans une
affiche autopromotionnelle.

Fotograf ALFRED SCHULZE RIEPING

Foto innerhalb einer Serie mit dem Titel "Echt und
wahr," für ein Plakat zur Eigenwerbung.

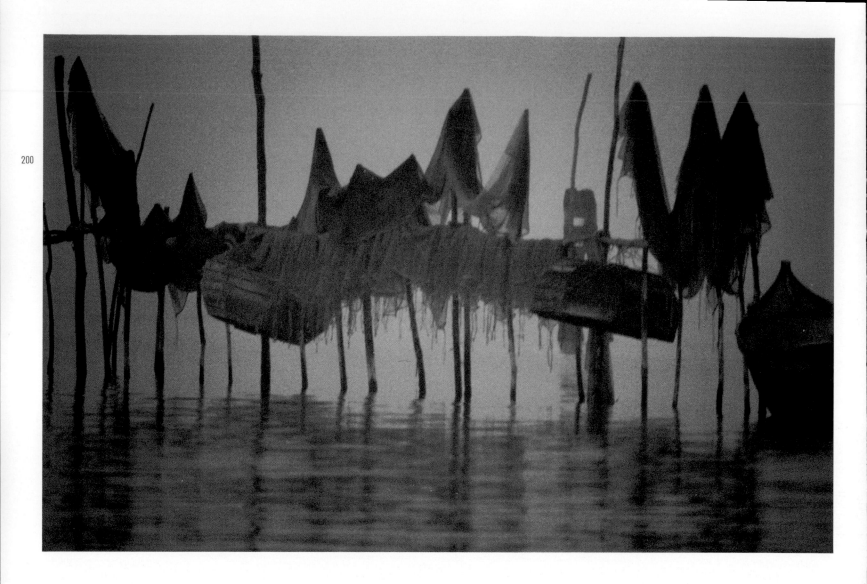

200, 201 Photographer JOHN CLARIDGE | Photographe JOHN CLARIDGE | Fotograf JOHN CLARIDGE

Art Director GWYN DAVIES | Directeur Artistique GWYN DAVIES | Art Direktor GWYN DAVIES

Advertising Agency McCANN ERICKSON LIMITED | Agence de Publicité McCANN ERICKSON LIMITED | Werbeagentur McCANN ERICKSON LIMITED

Client KODAK LIMITED | Client KODAK LIMITED | Auftraggeber KODAK LIMITED

Photographs of Venice taken from a series published by Kodak as a calendar. | Photographies de Venise prise d'une série publiée comme calendrier par Kodak. | Fotos von Venedig, aus einer Serie für einen Kodak Kalender.

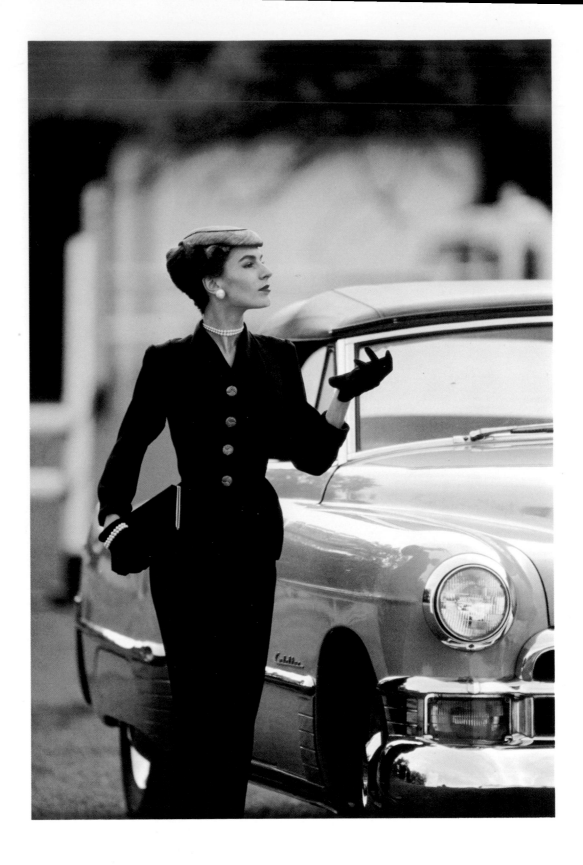

Photographer STEFAN LIEWEHR

Designer STEFAN LIEWEHR

Photograph taken in Lower Austria of model with
Cadillac Coupé used as a self-promotional poster in
March 1981.

Photographe STEFAN LIEWEHR

Maquettiste STEFAN LIEWEHR

Photographie prise en Basse Autriche d'un modèle
de Coupé Cadillac utilisée comme affiche
autopromotionnelle en mars 1981.

Fotograf STEFAN LIEWEHR

Gestalter STEFAN LIEWEHR

Foto, aufgenommen in Nieder-Österreich, von einem
Modell mit einem Cadillac Coupé, für ein Plakat zur
Eigenwerbung, veröffentlicht im März 1981.

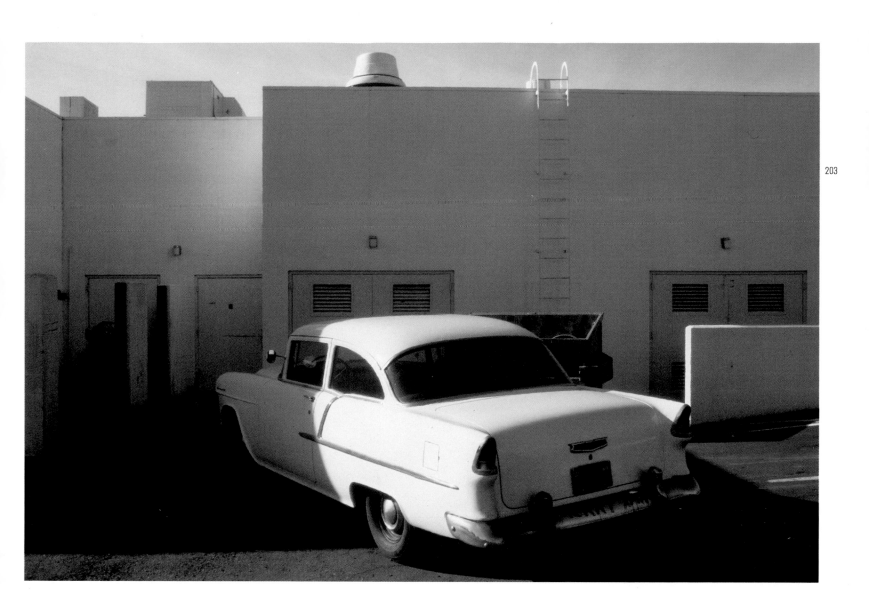

203 Photographer STEFAN LIEWEHR	Photographe STEFAN LIEWEHR	Fotograf STEFAN LIEWEHR
Designer STEFAN LIEWEHR	Maquettiste STEFAN LIEWEHR	Gestalter STEFAN LIEWEHR
Photograph taken in Las Vegas on the morning after Christmas and used as a self-promotional poster in January 1981.	Photographie prise à Las Vegas le matin après Noel et utilisée dans une affiche autopromotionnelle en janvier 1981.	Foto, aufgenommen in Las Vegas am Morgen nach dem Weihnachtsfest, für ein Plakat zur Eigenwerbung, veröffentlicht im Januar 1981.

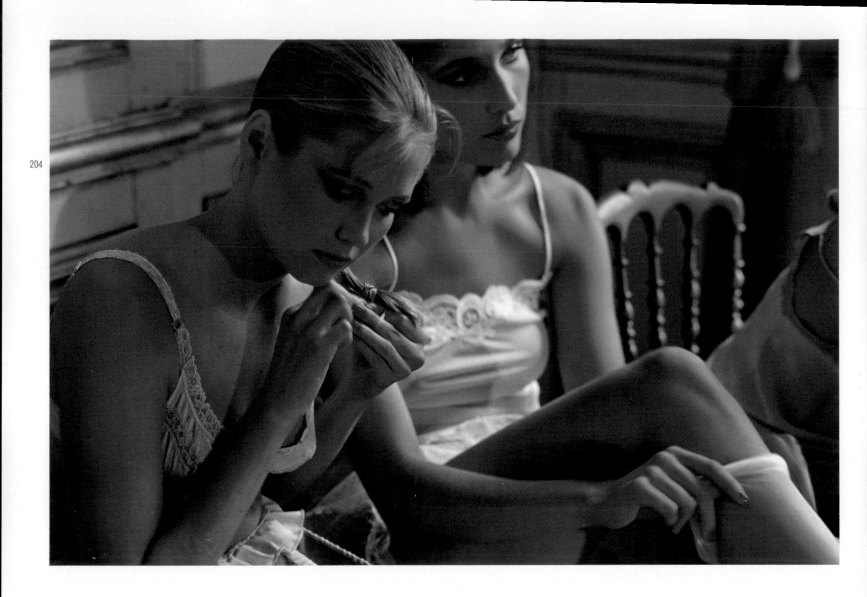

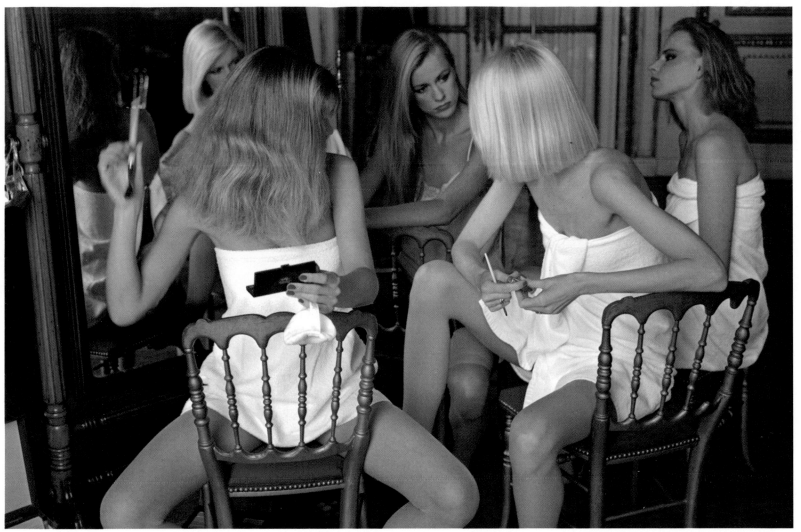

204-207	Photographer TERENCE DONOVAN	Photographe TERENCE DONOVAN	Fotograf TERENCE DONOVAN
	Designers DAVID HILLMAN/VICKY GORNALL	Maquettistes DAVID HILLMAN/VICKY GORNALL	Gestalter DAVID HILLMAN/VICKY GORNALL
	Art Director DAVID HILLMAN	Directeur Artistique DAVID HILLMAN	Art Direktor DAVID HILLMAN
	Design Group PENTAGRAM DESIGN	Equipe de Graphistes PENTAGRAM DESIGN	Design-Gruppe PENTAGRAM DESIGN
	Client BRITISH AMERICAN TOBACCO LIMITED	Client BRITISH AMERICAN TOBACCO LIMITED	Auftraggeber BRITISH AMERICAN TOBACCO LIMITED
	Series of photographs taken in Paris for the John Player Special Calendar, 1982.	Série de photographies prises à Paris pour le calendrier des Cigarettes John Player Special, 1982.	Foto-Serie, aufgenommen in Paris, für den John Player Special Kalendar 1982.

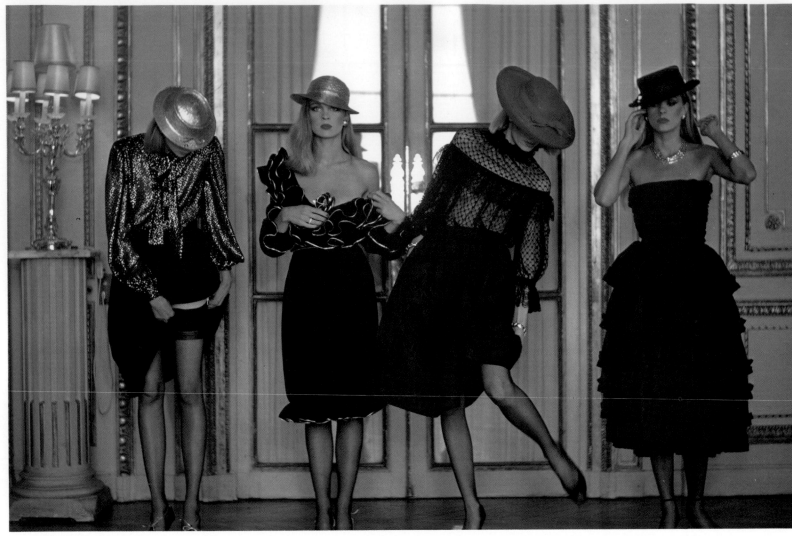

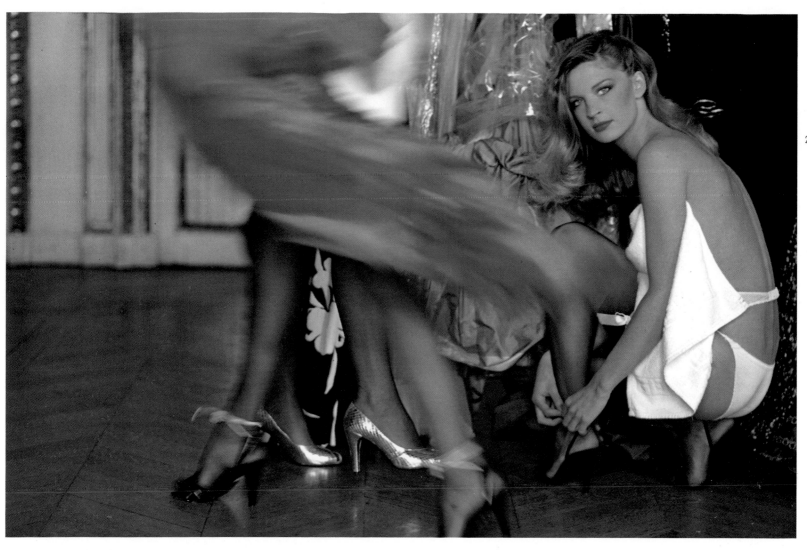

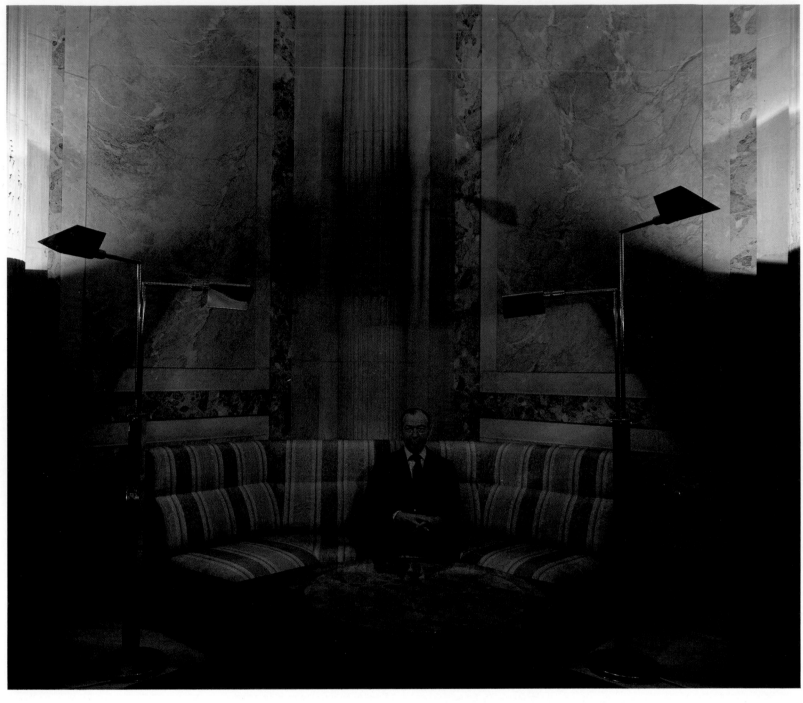

208 Photographer ROLPH GOBITS

Designer JOHN BROCKLISS

Art Director ROLPH GOBITS

Portrait of Sir Maxwell Joseph in the Hotel Meurice, Paris, used on a self-promotional poster by the photographer published in March 1981.

Photographe ROLPH GOBITS

Maquettiste JOHN BROCKLISS

Directeur Artistique ROLPH GOBITS

Portrait de Sir Maxwell Joseph à l'Hotel Meurice, Paris, utilisé comme affiche autopromotionnelle par le photographe, publié en mars 1981.

Fotograf ROLPH GOBITS

Gestalter JOHN BROCKLISS

Art Direktor ROLPH GOBITS

Portrait von Sir Maxwell Joseph im Hotel Meurice, Paris, für ein Plakat zur Eigenwerbung des Fotografen, veröffentlich im März 1981.

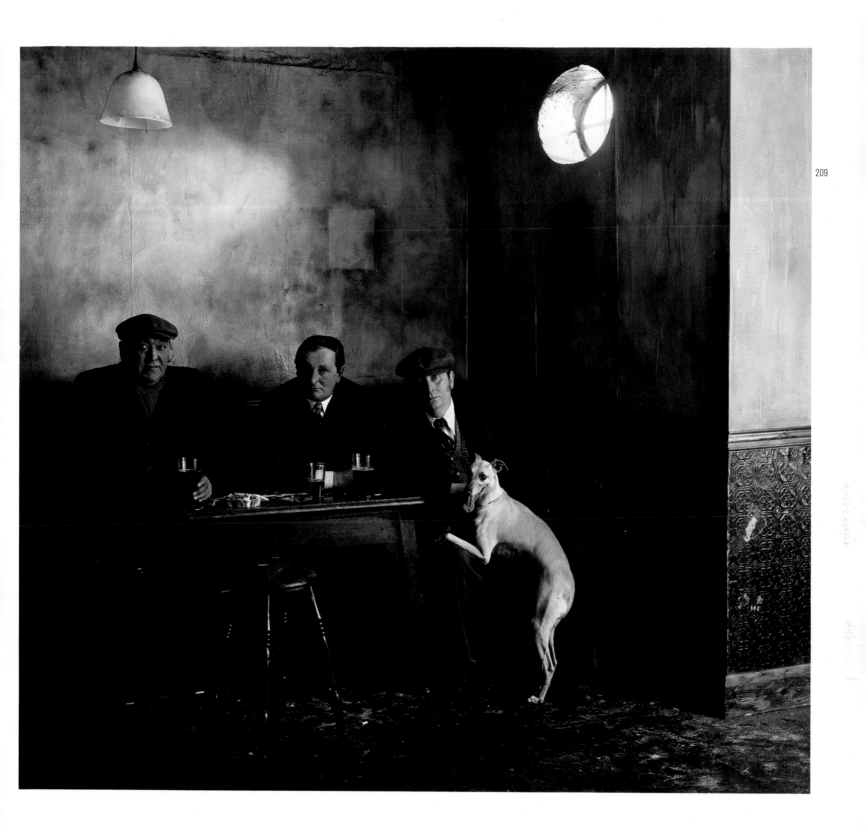

Photographer DEREK RICHARDS

Photographe DEREK RICHARDS

Fotograf DEREK RICHARDS

Designer DEREK RICHARDS

Maquettiste DEREK RICHARDS

Gestalter DEREK RICHARDS

Character study of three men shot as part of a series
on working men and used as a self-promotional poster.

Etude photographique de trois hommes prise dans le
cadre d'une série sur les ouvriers et utilisée comme
affiche autopromotionnelle.

Charakter-Studie von drei Männern, als Teil einer Serie
über Arbeiter für ein Plakat zur Eigenwerbung.

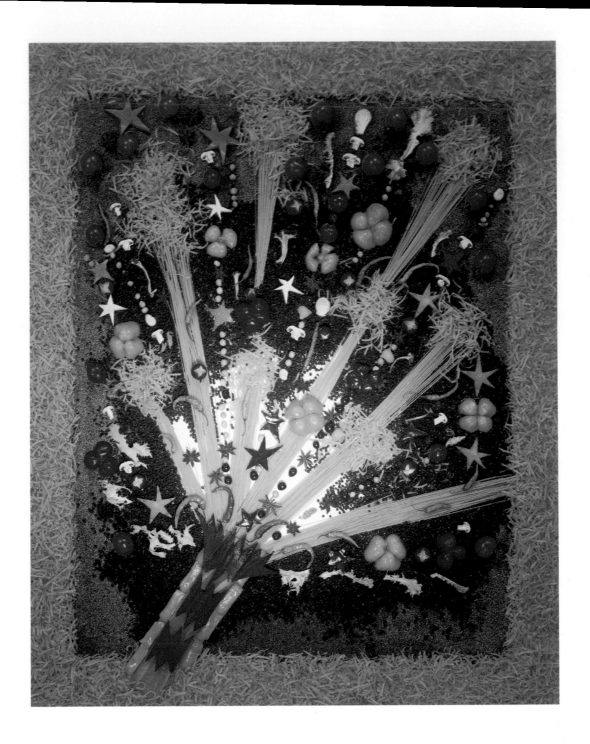

Photographer TESSA TRAEGER

Photographe TESSA TRAEGER

Fotograf TESSA TRAEGER

Designer TESSA TRAEGER

Maquettiste TESSA TRAEGER

Gestalter TESSA TRAEGER

Art Director DOMINIC LAURENT

Directeur Artistique DOMINIC LAURENT

Art Direktor DOMINIC LAURENT

Advertising Agency BELIER CONSEIL

Agence de Publicité BELIER CONSEIL

Werbeagentur BELIER CONSEIL

Client LUSTUCRU

Client LUSTUCRU

Auftraggeber LUSTUCRU

"Pasta Party"—cover of a booklet promoting pasta. One of a series of five photographs relating to the seasons of the year. Arranged and photographed in London.

"Pasta Party" (Fête de pâtes)—couverture d'une brochure de publicité pour les pâtes. Photographie d'une série de cinq relatives aux saisons de l'année. Organisée et photographiée à Londres.

"Pasta Party"—Titelseite einer Bröschüre zur Promotion von Teigwaren innerhalb einer Serie von fünf Fotos bezogen auf die Jahreszeiten. Arrangiert und fotografiert in London.

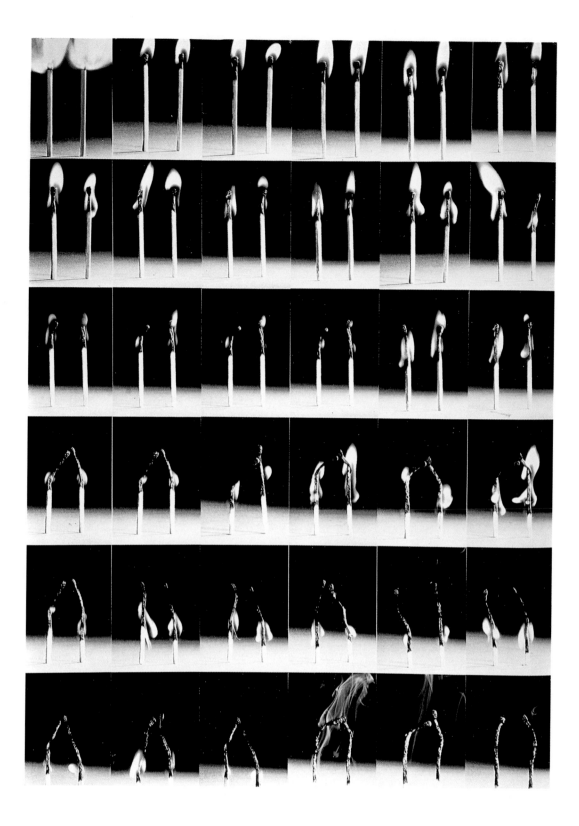

211 Photographer REIJO NYKÄNEN

Designer REIJO STRÖM

Art Director REIJO STRÖM

Self-promotional poster with the theme "Save Energy".

Photographe REIJO NYKÄNEN

Maquettiste REIJO STRÖM

Directeur Artistique REIJO STRÖM

Affiche autopromotionnelle avec le thème "Save Energy" (Economisez l'Energie).

Fotograf REIJO NYKÄNEN

Gestalter REIJO STRÖM

Art Direktor REIJO STRÖM

Plakat zur Eigenwerbung mit dem Thema "Save Energy" (Energie sparen).

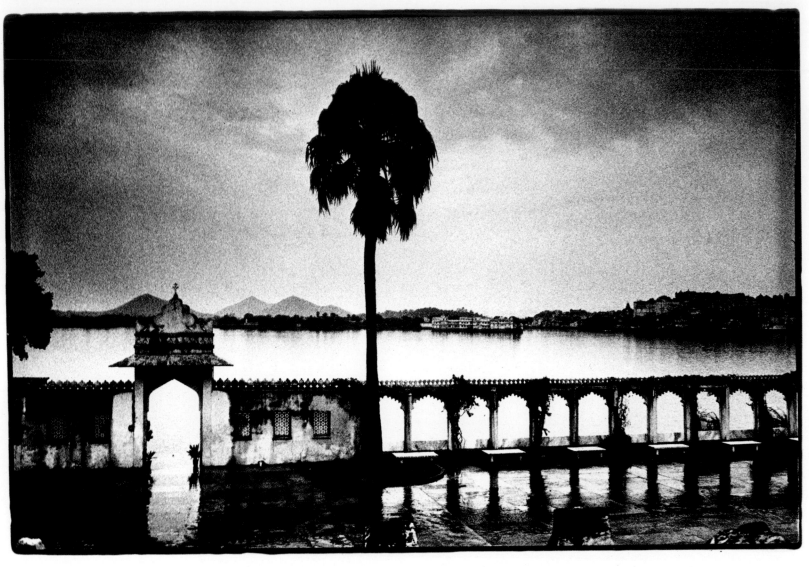

212 Photographer JOHN CLARIDGE

Designer ROGER COOPER

Design Group SUTTON COOPER

Photograph taken during the monsoon in Rajasthan Province, India, used as a poster to publicise an exhibition of work by the photographer.

Photographe JOHN CLARIDGE

Maquettiste ROGER COOPER

Equipe de Graphistes SUTTON COOPER

Photographie prise pendant la mousson au Rajasthan, Inde, utilisée comme affiche de publicité d'une exposition des oeuvres du photographe.

Fotograf JOHN CLARIDGE

Gestalter ROGER COOPER

Design-Gruppe SUTTON COOPER

Foto, aufgenommen während des Monsuns in Rajasthan, Indien, erschienen als Plakat für eine Ausstellung von Arbeiten des Fotografen.

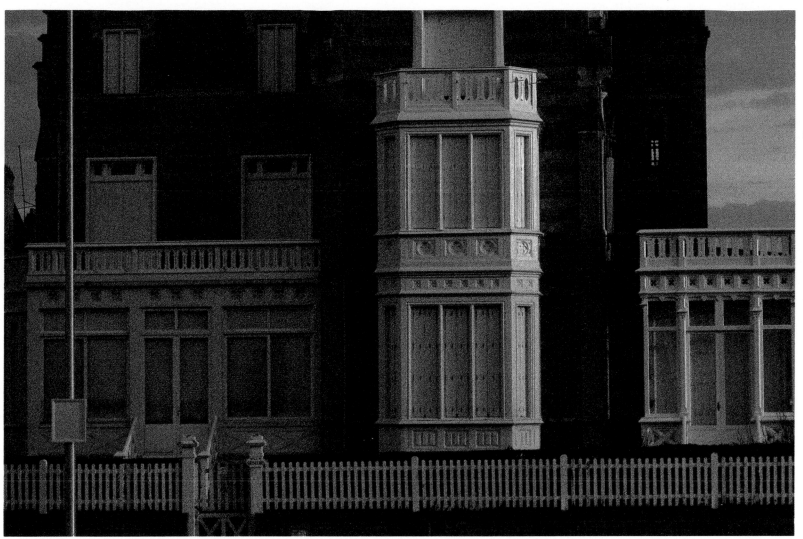

Photographer H.P. HOFFMANN	Photographe H.P. HOFFMANN	Fotograf H.P. HOFFMANN
Art Director H.P. HOFFMANN	Directeur Artistique H.P. HOFFMANN	Art Direktor H.P. HOFFMANN
Photograph taken in Normandy, France, for use in a self-promotional calendar.	Photographie prise en Normandie, France, pour utilisation dans un calendrier autopromotionnel.	Foto, aufgenommen in der Normandie, Frankreich, für einen Kalender zur Eigenwerbung.

E U R O P E A N

P H O T O G R A P H Y

U N P U B L I S H E D

This section consists of commissioned but unpublished photography, personal work produced by professional photographers, and the work of students.

OEUVRES NON PUBLIÉES Cette section comprend des travaux personnels de professionnels et d'étudiants, et des photographies commandées mais non publiées.

UNVERÖFFENTLICHTE ARBEITEN Dieser Abschnitt umfaßt persönliche Arbeiten von Berufskünstlern und Studenten, und in Auftrag gegebene, aber nicht veröffentlichte Fotografie.

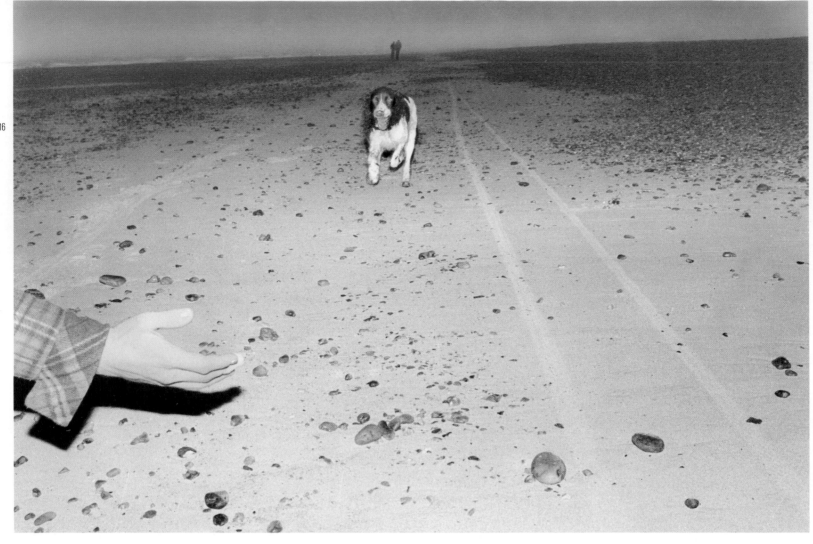

216 Photographer JAN BALDWIN

Unpublished work taken on location in Norfolk, England.

Photographe JAN BALDWIN

Oeuvre non publiée prise sur place dans le Norfolk, Angleterre.

Fotograf JAN BALDWIN

Unveröffentlichtes Foto, aufgenommen in Norfolk in England.

217 Photographer RICHARD WAITE

Photograph taken at New Quay Bird Hospital, West Wales, for the jacket of an unpublished book, "A Second Chance."

Photographe RICHARD WAITE

Photographie prise à l'hôpital des oiseaux de New Quay, Pays de Galles, pour la jaquette d'un livre non publiée "A Second Chance" (Une seconde chance).

Fotograf RICHARD WAITE

Foto, aufgenommen im Vogel-Hospital in New Quay, West Wales, für den Umschlag eines unveröffentlichten Buchs "A Second Chance" (Eine zweite Chance).

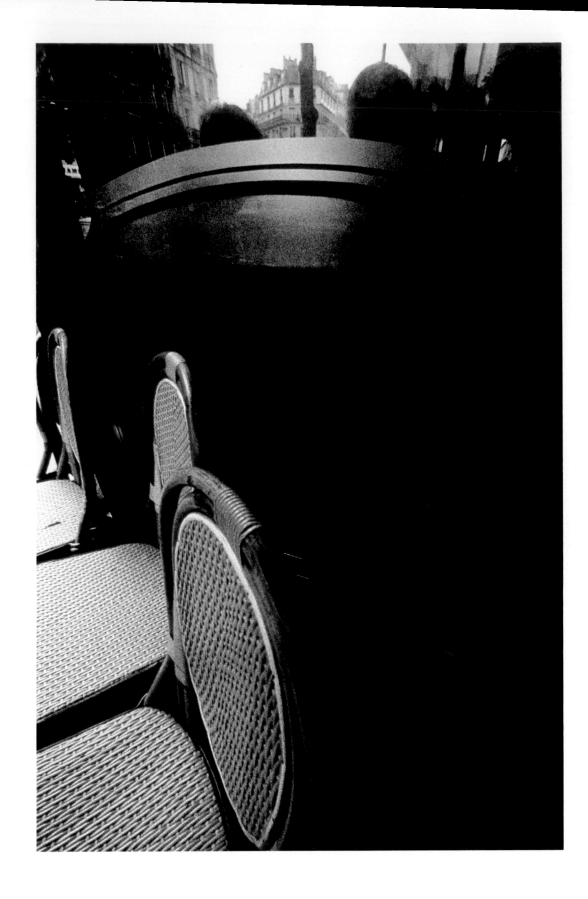

Photographer JOHN CLARIDGE

Photographe JOHN CLARIDGE

Fotograf JOHN CLARIDGE

Unpublished photograph of the interior of a Parisian café.

Photographie non publiée de l'intérieur d'un café parisien.

Unveröffentlichte Innenaufnahme eines Cafés in Paris.

219 Photographer PAUL WAGNER	Photographe PAUL WAGNER	Fotograf PAUL WAGNER	
Unpublished photograph taken in the Seychelles.	Photographie non publiée prise aux Seychelles.	Unveröffentlichtes Foto, aufgenommen in den Seychellen.	
Photographer DENIS WAUGH	Photographe DENIS WAUGH	Fotograf DENIS WAUGH	**220, 221 ▶**
Unpublished photograph of the River Arno, Florence, taken while on location.	Photographie non publiée de l'Arno à Florence, prise pendant un tournage.	Unveröffentlichtes Foto des Arno Flusses in Florenz.	

Photographer STEVE HIETT Photographe STEVE HIETT Fotograph STEVE HIETT

Designer JAMES GROSELFINGER Maquettiste JAMES GROSELFINGER Gestalter JAMES GROSELFINGER

Unpublished photograph taken at car wash in Nice. Photographie non publiée prise sur une aire de lavage voiture à Nice. Unveröffentlichtes Foto, aufgenommen in einer Autowäsche in Nizza.

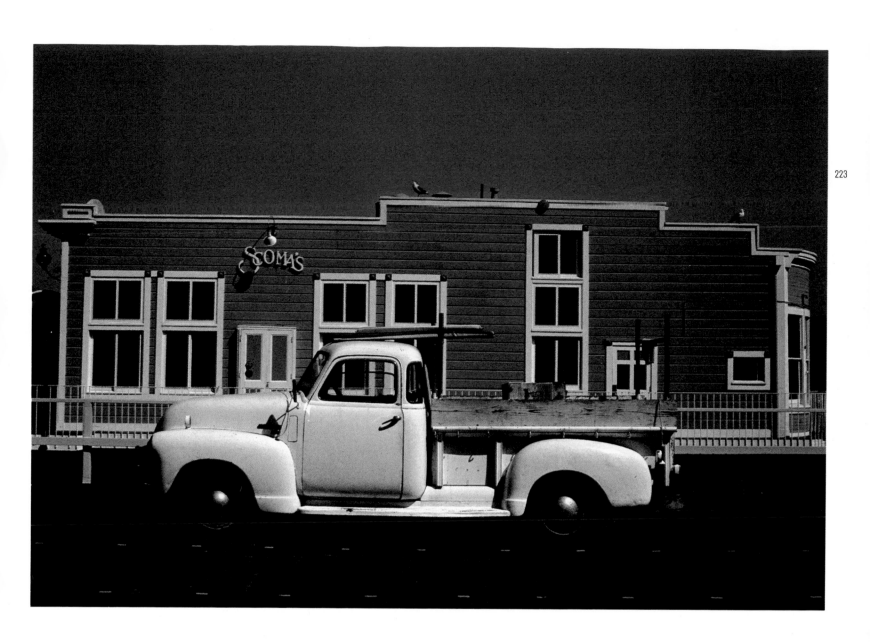

223 Photographer MAX FORSYTHE Photographe MAX FORSYTHE Fotograf MAX FORSYTHE

Designer IAN POTTER Maquettiste IAN POTTER Gestalter IAN POTTER

Unpublished photograph taken in California. Photographie non publiée prise en Californie. Unveröffentlichtes Foto, aufgenommen in Kalifornien.

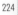

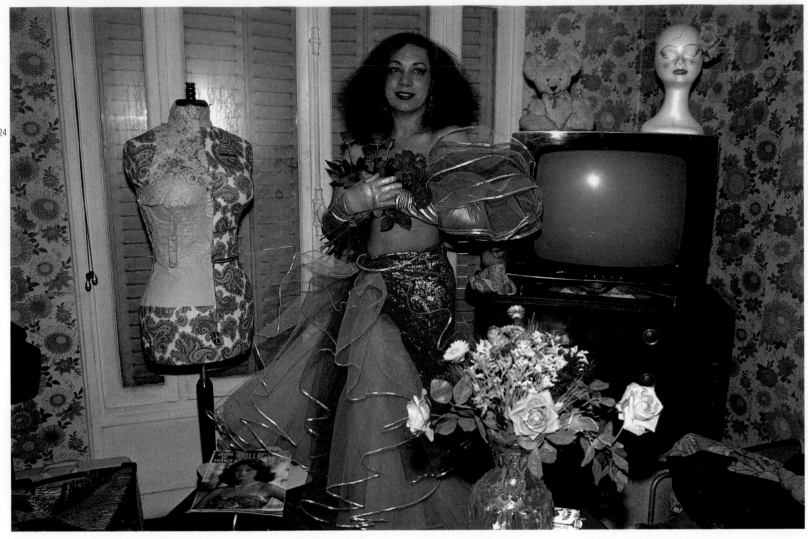

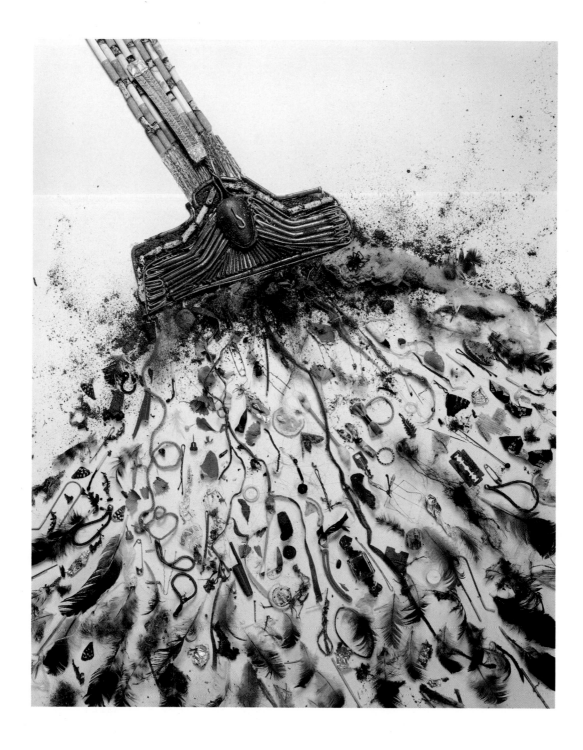

Photographer TESSA TRAEGER | Photographe TESSA TRAEGER | Fotograf TESSA TRAEGER

Designer TESSA TRAEGER | Maquettiste TESSA TRAEGER | Gestalter TESSA TRAEGER

Art Director DAVID HILLMAN | Directeur Artistique DAVID HILLMAN | Art Direktor DAVID HILLMAN

Unpublished cover photograph to illustrate 'dirt' for an article on house cleaning in a new German magazine. | Photographie de couverture non publiée illustrant 'saleté' pour un article sur le ménage dans un nouveau magazine allemand. | Unveröffentlichtes Titel-Foto über 'Schmutz' für einen Artikel über den Hausputz in einer neuen deutschen Zeitschrift.

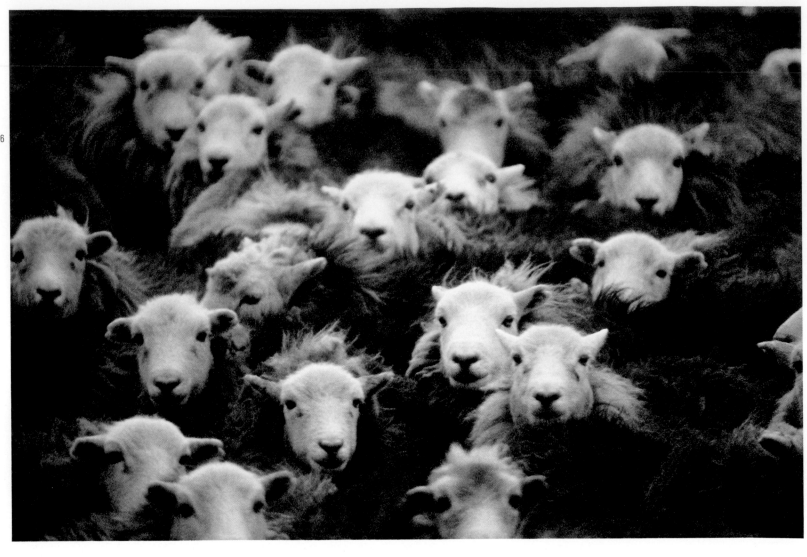

Photographe JOHN CLARIDGE

Fotograf JOHN CLARIDGE

Unpublished photograph taken in the English Lake
District of sheep on the way to market.

Photographie non publiée, prise dans la région des
lacs au nord ouest de l'Angleterre, de moutons en
route pour le marché.

Unveröffentlichtes Foto von Schafen auf dem Weg
zum Markt, aufgenommen im Lake District in England.

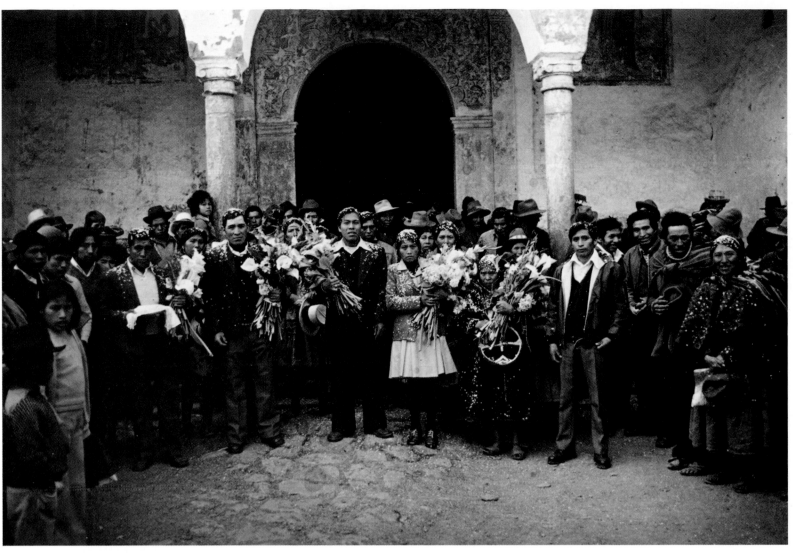

227 Photographer PAUL YULE

Photographe PAUL YULE

Fotograf PAUL YULE

Unpublished photograph of a wedding at Chincheros, near Cuzco, Peru, taken from a proposed book "The New Incas".

Photographie non publiée d'un mariage à Chincheros, près de Cuzco, Pérou, tirée d'un livre inédit "The New Incas" (Les Nouveaux Incas).

Unveröffentlichtes Foto einer Hochzeit in Chincheros, in der Nähe von Cusco, Peru, aus dem geplanten Buch "The New Incas" (Die neuen Inkas).

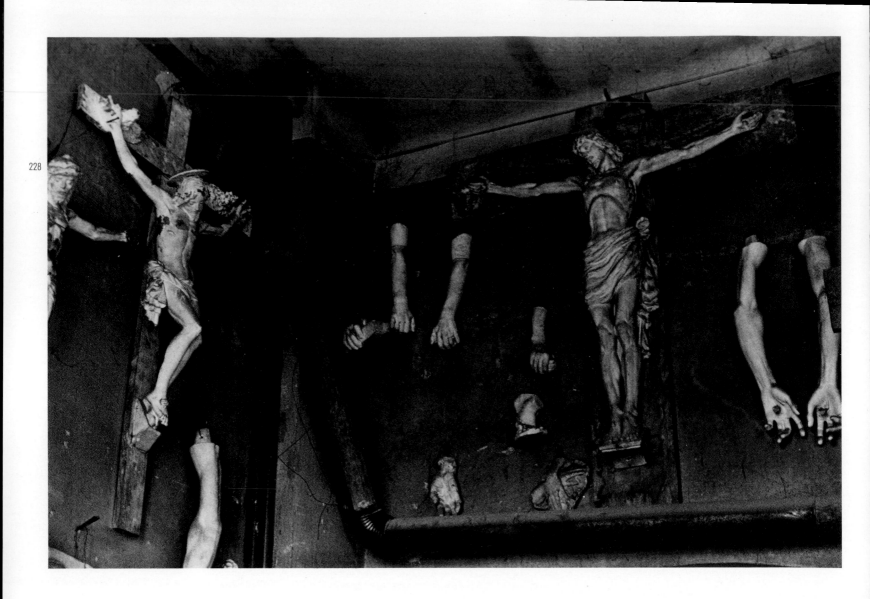

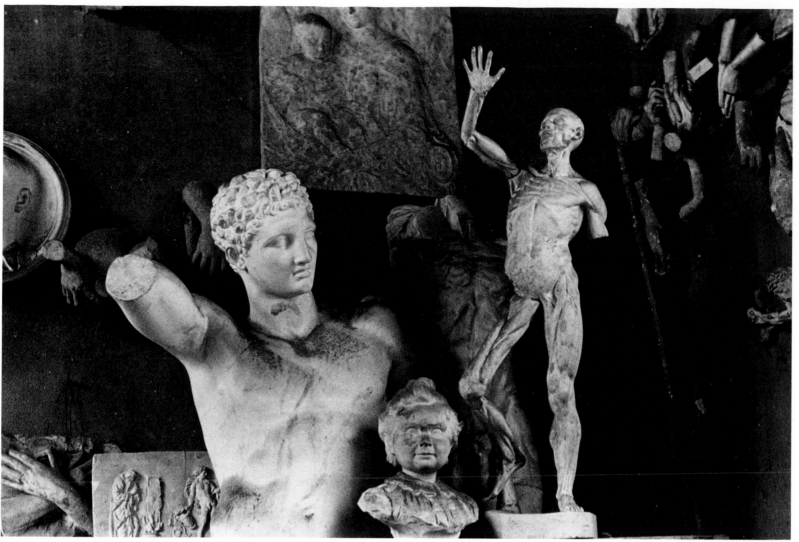

228-231 Photographer BRIAN E. RYBOLT Photographe BRIAN E. RYBOLT Fotograf BRIAN E. RYBOLT

A series of unpublished photographs taken while travelling through Italy illustrating curious religious symbols discovered in traditionally non-religious places.
228, 229 and 231 were taken in artisans' workshops at Pietrasanta.
230 was shot at night in a garden ornamental shop in Rome.

Série de photographies non publiées prises pendant un voyage en Italie, montrant de curieux symboles religieux découverts dans des endroits traditionnellement non religieux.
228, 229 et 231 ont été prises dans des ateliers d'artisans à Pietrasanta.
230 a été prise la nuit dans un magasin d'ornements de jardin à Rome.

Eine Serie von unveröffentlichten Fotos, aufgenommen während einer Reise durch Italien, von seltsamen religiösen Symbolen, entdeckt in traditionell non-religiösen Orten.
228, 229 und 231 wurden aufgenommen in Handwerksbetrieben in Pietrasanta.
230 wurde aufgenommen bei Nacht in einem Geschäft für Gartenornamente in Rom.

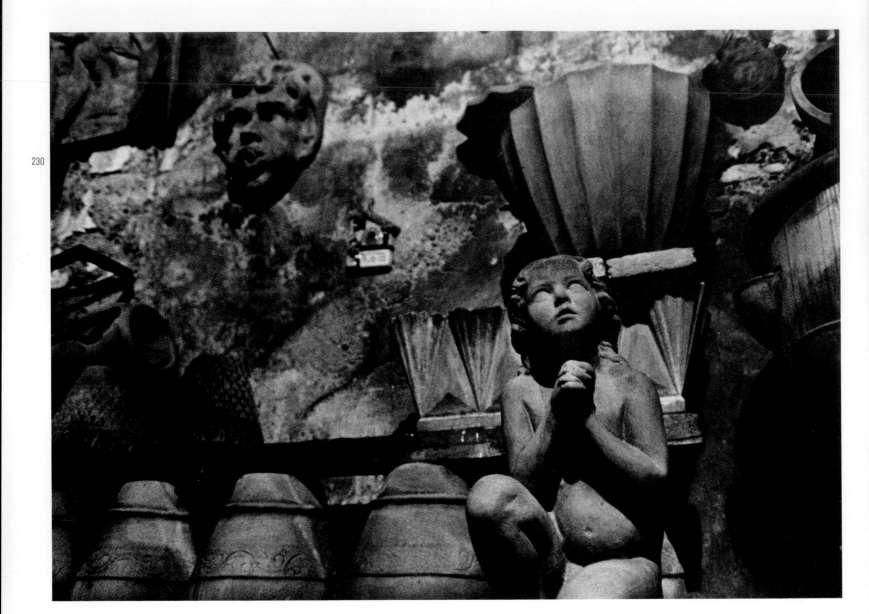

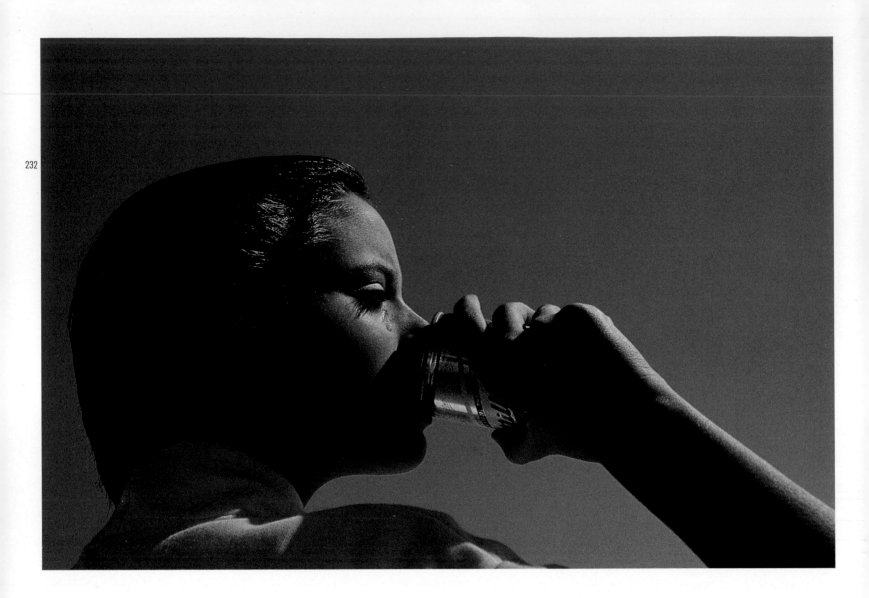

232 Photographer STEVE HIETT

Designer MARINA FAUSTI

Unpublished beauty photograph taken at Miami
Beach, Florida.

Photographe STEVE HIETT

Maquettiste MARINA FAUSTI

Photographie non publiée d'une Vénus prise à Miami
Beach, Floride.

Fotograf STEVE HIETT

Gestalter MARINA FAUSTI

Unveröffentlichtes Schönheits-Foto, aufgenommen in
Miami Beach, Florida.

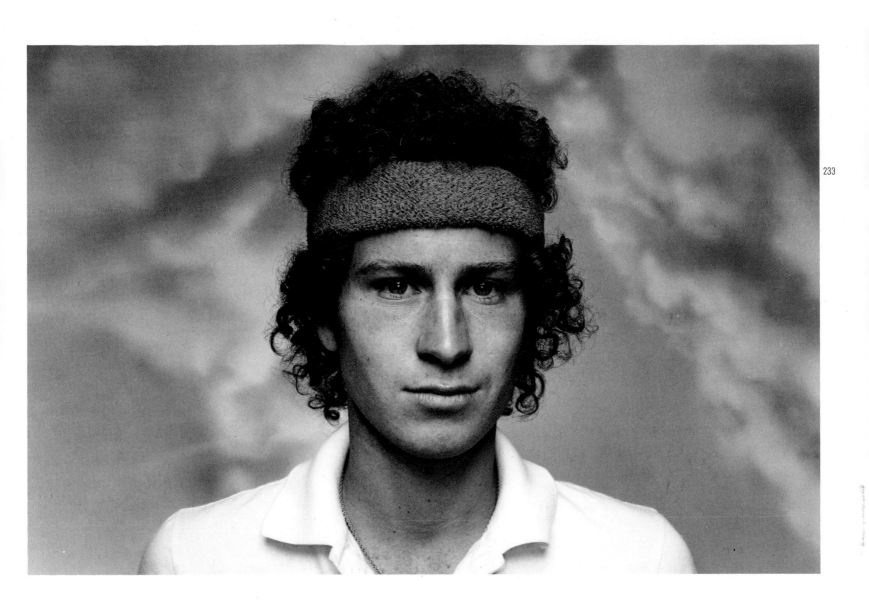

Unpublished portrait of John McEnroe taken in the studio after a promotional photographic session.

Photographe BARNEY EDWARDS

Portrait non publiée de John McEnroe pris dans le studio après une session de photographie promotionnelle.

Fotograf BARNEY EDWARDS

Unveröffentlichtes Portrait von John McEnroe, aufgenommen im Studio im Anschluß an Promotionsaufnahmen.

I N D E X

236

Photographers'
Addresses

Adresses des
photographes

Adressen der
Fotografen

CLIVE ARROWSMITH 82
C/o The Sunday Times Magazine
200 Gray's Inn Road
London WC1
England

JAN BALDWIN 216
34A The Mansions
252 Old Brompton Road
London SW5
England

BRUNO BARBEY 148-154
C/o Magnum Photos
2 Rue Christine
75006 Paris
France

WILFRIED BAUER 41, 42-45
C/o Stern Magazine
Warburgstrasse 50
2 Hamburg 36
West Germany

WOLFGANG BEHNKEN 129
Papenhuderstrasse 53
2000 Hamburg 76
West Germany

CHRIS BONNINGTON 167
C/o Olympus Optical Co. U.K. Limited
2-8 Honduras Street
London EC1
England

BRUCE BROWN 180
C/o Julian Seddon
183A Kings Road
London SW3
England

KNUT BRY 165
C/o Bill Evans
18 Rue Guersant
75017 Paris
France

GARY BRYAN 164
56 Whitfield Street
London W1
England

RENÉ BURRI 78
C/o Stern Magazine
Warburgstrasse 50
2 Hamburg 36
West Gemany

HENNING CHRISTOPH 70
Kortumstrasse 61
43 Essen
West Germany

JOHN CLARIDGE 66, 67, 104, 105, 162,
163, 177, 179, 200, 201, 212, 218, 226
47 Frith Street
London W1
England

TERENCE DONOVAN 175, 204-207
47 New Bond Street
London W1
England

JOHN DOWNING 174
The Daily Express
Express Newspapers Limited
Fleet Street
London EC4
England

BARNEY EDWARDS 233
12 Burlington Lodge Studios
Rigault Road
London SW6
England

REINHARD EISELE 54
Weisse Gasse 4
89 Augsburg
West Germany

ARTHUR ELGORT 110, 111
C/o Vogue
1 Hanover Square
London W1
England

HANS-JOACHIM ELLERBROCK 85
Weidenallee 59
2 Hamburg 6
West Germany

GEORG FISCHER 73
C/o Visum
Jarrestrasse 80
2000 Hamburg 60
West Germany

RICHARD FISCHER 91
Hasselbrookstrasse 126A
2000 Hamburg 76
West Germany

ADRIAN FLOWERS 173
46 Tite Street
London SW3
England

GRAHAM FORD 168, 178
23-39 Woodfield Road
London W9
England

RENATE VON FORSTER 156, 157
Morgensternstrasse 12
6000 Frankfurt/Main 70
West Germany

MAX FORSYTHE 223
18 Marylebone Mews
London W1
England

JAMES A. FOX 46
45 Rue de Lourmel
Paris 15
France

JOE GAFFNEY 141
25 Rue Saulnier
75009 Paris
France

ALAIN LE GARSMEUR 55, 90
91 Chetwynd Road
London NW5
England

ROLPH GOBITS 96, 97, 99, 169, 208
23 Lytton Grove
Putney
London SW15
England

EBERHARD GRAMES 74-77
Etzweilerstrasse 1
5013 Elsdorf
West Germany

BRIAN GRIFFIN 112
121-123 Rotherhithe Street
Rotherhithe
London SE16
England

KEN GRIFFITHS 185, 187
123 King Henry's Road
London NW3
England

STEVE HIETT 140, 144, 145, 222, 232
4 Rue des Anglais
75005 Paris
France

Photographers' Addresses
Adresses des photographes
Adressen der Fotografen

VOLKER HINZ 80, 81
C/o Stern Magazine
Warburgstrasse 50
2 Hamburg 36
West Germany

H. P. HOFFMANN 213
Bockumer Strasse 309
4 Düsseldorf 31
West Germany

GRAHAM HUGHES 198
9 Rathbone Place
London W1
England

MARK IZIKOWITZ 71
C/o Stern Magazine
Warburgstrasse 50
2 Hamburg 36
West Germany

CAMILLA JESSEL 48
Riverside House
Twickenham
Middlesex TWL 3DJ
England

ANNE KOCH 56, 57
C/o Stern Magazine
Warburgstrasse 50
2 Hamburg 36
West Germany

MICHAEL LANGE 68, 69
C/o Fox-Reportagen
Carstenrehder Strasse 51
2000 Hamburg
West Germany

BARRY LATEGAN 132-139, 192-197
502 La Guardia Place
New York NY 10012
USA

ROBERT LEBECK 62, 63
C/o Stern Magazine
Warburgstrasse 50
2 Hamburg 36
West Germany

STEFAN LIEWEHR 202, 203
Linke Wienzeile 178/1
A-1060 Vienna
Austria

GERD LUDWIG 47
C/o Visum
Jarrestrasse 80
2000 Hamburg 60
West Germany

GUIDO MANGOLD 49
Ginsterweg 7
8012 Ottobrunn
West Germany

PETER MARLOW 60, 61
C/o Magnum Photos
145 Fleet Street
London EC4
England

DON McCULLIN 32, 33
C/o The Sunday Times Magazine
200 Gray's Inn Road
London WC1
England

BARRY MEEKUMS 189
1 Marylebone Mews
London W1
England

BOB MILLER 176
83 Disraeli Road
Putney
London SW15
England

DAVID MONTGOMERY 101
C/o The Sunday Times Magazine
200 Gray's Inn Road
London WC1
England

JEAN MOUNICQ 29
C/o ANA Agence
6 Avenue René Coty
75014 Paris
France

KONRAD R. MÜLLER 118
Zur Mühle 21
5330 Königswinter 21
West Germany

HARALD NADOLNY 18-21
C/o Stern Magazine
Warburgstrasse 50
2 Hamburg 36
West Germany

BYRON NEWMAN 224
71 Redcliffe Gardens
London SW10
England

HELMUT NEWTON 102, 120, 121, 122, 123, 124-127, 130, 131
Rue de L'Abbé de L'Epée
Paris 14
France

REIJO NYKÄNEN 211
Satamakatu 4
Espoo
Finland

THOMAS PAULUS 142, 143
Düsseler Strasse 20
5603 Wülfrath
West Germany

GILLES PERESS 58, 59
C/o Magnum Photos
2 Rue Christine
75006 Paris
France

ROGER PERRY 52, 53
11 St. Mary's Terrace
London W2
England

DUDLEY REED 113-117
Studio 3
79 Bedford Gardens
London W8
England

ANDREJ REISER 155
Isestrasse 17
2000 Hamburg
West Germany

DEREK RICHARDS 209
1 Alma Studios
32 Stratford Road
London W8
England

MICHAEL RUETZ 158, 159
Gneisenaustrasse 5
2000 Hamburg 20
West Germany

BRIAN E. RYBOLT 228-231
48 Bushwood Road
Kew
Surrey TW9 3BQ
England

SEBASTIAO SALGADO JR. 34-40
C/o Magnum Photos
2 Rue Christine
75006 Paris
France

RED SAUNDERS 83
Rembrandt Bros.
19 Fleet Road
London NW3
England

PHILIP SAYER 26, 27, 103
28 Compton Road
London N1
England

GERD SCHAFFT 85
Marktstrasse 1A
2 Hamburg 6
West Germany

WALTER SCHMITZ 72, 84
Oettinger Strasse 33
8 München 22
West Germany

ALFRED SCHULZE RIEPING 199
Gustav-Falke Strasse 11
2000 Hamburg 13
West Germany

BOB SENNETT 79
C/o Stern Magazine
Warburgstrasse 50
2 Hamburg 36
West Germany

HANS SILVESTER 24, 25, 30, 31, 64, 65
C/o Agence Rapho
8 Rue D'Alger
75001 Paris
France

JEFF SIMON 86, 87, 88
C/o Stern Magazine
Warburgstrasse 50
2 Hamburg 36
West Germany

SHAUN SKELLY 186
14 Cresswell Gardens
London SW5
England

MAURICE SMITH 89
36 Rue Amelot
75011 Paris
France

PETER SMITH 184
12A Vauxhall Bridge Road
London SW1
England

SNOWDON 100
C/o European Photography
12 Carlton House Terrace
London SW1
England

STAK 172, 181, 188
10 Bourdon Street
London W1
England

PHILIP STARLING 119, 128
12 Anton Street
London E8
England

DENNIS STOCK 22, 23
C/o Magnum Photos
2 Rue Christine
75006 Paris
France

ALEXIS STROUKOFF 166
233 Faubourg St. Honoré
Paris 8
France

HEINZ TEUFEL 28
Haus Kramersmark
Schubyfeld
2341 Dörphof
West Germany

TESSA TRAEGER 94, 95, 210, 225
7 Rossetti Studios
72 Flood Street
London SW3
England

MANFRED VOGELSÄNGER 182, 183
Bonifatiusstrasse 55
4000 Düsseldorf 11
West Germany

PAUL WAGNER 219
168 Rue de Grenelle
Paris 7
France

RICHARD WAITE 217
43 Selwyn Avenue
Richmond
Surrey
England

DENIS WAUGH 92, 93, 106, 107, 108, 109, 220, 221
5 Hillier Road
London SW11
England

PER WIKLUND 170, 171
Rådmansgatan 8
114 25 Stockholm
Sweden

IAN YEOMANS 50, 51
17 Victoria Grove
London W8
England

PAUL YULE 227
32 Berwick Street
London W1
England

238 **Designers**

Maquettistes

Gestalter

Peter Appelt
156, 157

David Ashmore
55

Franz Braun
24, 25, 54

John Brockliss
208

Ron Brown
176

Hartmut Brückner
148-154, 155

Cerruti 1881, Paris
165

Bob Ciano
92, 93, 108

Roger Cooper
212

Graham Cornthwaite
167

Wolf Dammann
56, 57, 71

Peter Dasse
22, 23, 49

Klaus Detjen
158, 159

Johannes Dönges
70, 84, 85

Erwin Ehret
24, 25, 30, 31

Franz Epping
42-45

Marina Fausti
232

Bernard Fiévé
180

Karin Gerlach
47

Jan Görlich
41, 68, 69

Vicky Gornall
204-207

Ingo Götze
91

Roger Gould
186

James Groselfinger
222

Peter Hayward
66

Steve Hiett
140

David Hillman
96, 97, 99, 204-207

Graham Hughes
198

Norbert Kleiner
18-21

Andreas Krell
28, 29

Max Lengwenus
86-88, 142, 143

Stefan Liewehr
202, 203

Susan Mann
110, 111, 132-139

Gerlinde Missner
118

Jeremy Pemberton
192-197

Yan D. Pennors
89

Ian Potter
223

Robert Priest
83

Derek Richards
209

Muney Rivers
103

Michael Ruetz
158, 159

Dietmar Schulze
72, 78, 79

April Silver
102, 112

Lucy Sisman
101, 109

Gerard Stamp
174

Walter Strenge
80, 81

Reijo Ström
211

Herbert Suhr
62, 63

John Tennant
32, 33, 50, 51, 52, 53, 60, 61, 82, 98, 100

Tessa Traeger
94, 95, 210, 225

Peter Voigt
73

Paul Wagner
120, 121, 122, 123, 124-127, 166

Per Wiklund
170, 171

Art Directors

Directeurs Artistiques

Art Direktoren

Paul Arden
175

Digby Atkinson
178

Wolfgang Behnken
56, 57, 68, 69, 129, 142, 143

Rob Bennett
113-117

Angelica Blechschmidt
145

Ron Brown
176

Francesco Carrozzini
182

Bob Ciano
92, 93, 108

Glenn Clark
173

Maurice Coriat
67

Graham Cornthwaite
167

Gwyn Davies
200, 201

Marina Fausti
144

Allessio Ferlizza
177

Rolf Gillhausen
18-21, 41, 42-45, 62, 63, 71, 72, 78, 79, 80, 81, 86-88

Rolph Gobits
208

Jayne Gould
113-117

Michael Hardy
48

Richard Hayden
189

David Hillman
96, 97, 99, 204-207, 225

H. P. Hoffmann
213

Gary Horner
179

Jocelyn Kargère
120, 121, 122, 123, 124-127, 130, 131, 140, 166

Dominic Laurent
210

Paul Leeves
173

Oda Lindig
183

Manfred Manke
47, 91, 118

Susan Mann
94, 95, 110, 111, 132-139

John Merriman
168

Graeme Murdoch
90, 106, 107

Yan D. Pennors
89

Christopher Perkis
184

Ian Potter
185, 187

Mike Preston
172

Robert Priest
26, 27, 83, 102, 103, 112

Michael Rand
32, 33, 50, 51, 52, 53, 60, 61, 82, 100, 101

Nigel Rose
181

Christian Reuilly
180

John Scott
163, 188

Eric Spires
164

Gerard Stamp
174

Brian Stewart
169

Reijo Ström
211

Alan Tannenbaum
119, 128

Adrian Taylor
104, 105

Alan Waldie
162

Susanne Walsh
74-77

Writers
Auteurs
Autoren

Paula Almquist
71

Jessica Berens
113-117

Arabella Boxer
94, 95

Diane de Braux
122, 123

Dobby Dutler-Gloss
113-117

Carol Caldwell
102

Maureen Cleave
106, 107

Jilly Cooper
101

Roger Cooper
60, 61

Craig Copetas
83

Charlotte Curtis
105

Louis Dandrel
89

James Danziger
98

Karl Dedecius
148-154

Michael Disend
74-77

Emanuel Eckart
80, 81

Harry Fieldhouse
48

Alain Finkielkraut
103

Alexander Frater
90

Judith Friedberg
104

Rachel Gould
97

Angelica Griem
91

Peter Grubbe
22, 23

Ruth Hall
109

Klaus Harpprecht
29

Peter Hays
70

Evelyn Holst
56, 57

Brian Inglis
96

Ian Jack
32, 33

Benno Kroll
30, 31

Günter Kunert
28

Rolf Kunkel
72, 84, 85

Barbara Larcher
142, 143

Norman Lewis
55

Willy Lützenkirchen
73

Neil Lyndon
52, 53

Michel Maingois
67

Guy Martin
26, 27

Barrie Penrose
50, 51

Gail Ridgwell
92, 108

Frank Rose
112

Alexander Rost
24, 25

Gerhard Roth
118

Jürgen Roth
156, 157

Peter Sager
47

Johannes Schaaf
49

Jurgen Serke
42-45

Nigel Skelsey
66

Andrew Stephen
100

John Walker
99

Hans Werner
78, 79

Fee Zschocke
155

Copywriters
Rédacteurs
Texter

David Abbott
176

Digby Atkinson
178

Jean Louis Blanc
163

Jean Michel Boissier
180

Tony Brignull
181

Patrick Collister
174

Richard Cook
169

Mike Cozens
162

Simon Dicketts
175

Ian Mayes
177

John O'Donnell
167

Christopher Perkis
184

Indra Sinha
179

Richard Sloggett
172

Alan Tilby
173

Peter Wallach
178

Paul Weinberger
168

Barry Whitehead
189

Publishing Companies
Editeurs
Verleger

American Express Publishing Corporation
104, 105

Condé Nast Publications Limited
94, 95, 110, 111, 113-117, 132-139

Condé Nast Verlag GMBH
145

Les Éditions Condé Nast S.A.
120, 121, 122, 123, 124-127, 130, 131, 140

Edizioni Syds
141

Eichborn Verlag
155

Esquire Publishing Co.
26, 27, 83, 102, 103, 112

Grube und Richter
156, 157

Gruner & Jahr AG & Co
18-21, 22, 23, 24, 25, 28, 29, 30, 31, 41, 42-45, 49, 54, 56, 57, 62, 63, 68, 69, 70, 71, 72, 73, 78, 79, 80, 81, 84, 85, 86-88, 129, 142, 143

Carl Hanser Verlag
158, 159

Haymarket Publishing Limited
66

Hoffmann und Campe Verlag
148-154

Knapp Communications Corporation
74-77

Arnoldo Mondadori Editore
144

Le Monde de la Musique Telerama
89

The Observer Magazine
55, 90, 106, 107

Publications Paul Montel
34-40, 46, 58, 59, 64, 65

SoHo Weekly News Inc.
119, 128

Sunday Express Newspapers Limited
96, 97, 99

The Sunday Telegraph Limited
48

Time-Life Inc.
92, 93, 108

Times Newspapers Limited
32, 33, 50, 51, 52, 53, 60, 61, 82, 98, 100, 101, 109

Zeitverlag Gerd Bucerius KG
47, 91, 118

Zoom Magazine
67